READING ART

ART FOR BOOK LOVERS

READING ART

ART FOR BOOK LOVERS

DAVID TRIGG

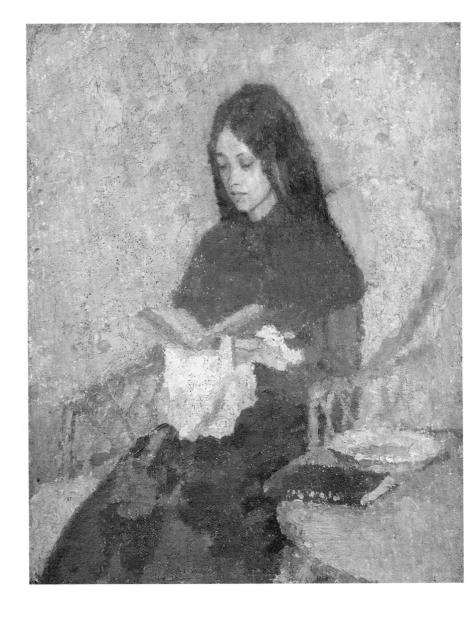

The Precious Book
Gwen John
c.1910–26, oil on canvas laid on panel
26.4 × 21 cm (10 ⅜ × 8 ¼ in)
Private collection

Preface

Reading Art: Art for Book Lovers is a celebration of a revolutionary yet everyday object, represented here in almost three hundred artworks from museums and collections around the world. The image of the reader appears throughout history, in art made long before books as we now know them came into being. While paintings and sculptures of the past often highlight the ways in which life has changed – in clothing, food and homes for instance – artworks can also reveal things that are as recognisable now as when they were first depicted. In artists' representations of books and reading we see moments of shared humanity that transcend culture and time.

In this 'book of books', artworks are selected and arranged in a way that emphasizes these connections between different eras and cultures. We see scenes of children learning to read at home or at school, with the book as a focus for relations between the generations. Adults are portrayed alone in a multitude of settings and poses – absorbed in a volume, deep in thought or lost in a moment of leisure. Others gaze away from the page, or stare directly at the viewer. Some readers squint at words close-up, or hold a book at arm's length, while others appear in some of the earliest depictions of people wearing spectacles. Readers young and old are seen dozing over open leaves. These scenes may have been painted hundreds of years ago, but they capture moments to which we can all relate.

Books themselves may be used symbolically in portraits and still lifes to demonstrate the intellect, wealth or piety of the subject or patron. Before the proliferation of the printing press and mass production, books were treasured objects and could be elaborate works of art in their own right. More recently, as books have become inexpensive or even throwaway, artists have used them as the raw material for artworks – transforming covers, pages or even complete volumes into paintings, drawings, sculptures and installations.

Continued developments in communication technologies were once believed to render the printed page obsolete, but the book is a technology of remarkable endurance. From a twenty-first century perspective, the analogue medium of the printed book is certainly ancient but not out-dated and it remains as interactive as any battery-powered e-reader. To fulfil its function, a book must be activated by a user: the cover opened, the pages parted, the contents reviewed, perhaps notes scribbled or words underlined. And in contrast to our increasingly networked lives where the information we consume is monitored and tracked, a printed book still offers the chance of a wholly private, 'off-line' activity. The book again seems ahead of its time.

In her final novel, *Between the Acts* (1941), Virginia Woolf wrote that 'books are mirrors of the soul', revealing the whole range of emotions, attitudes and desires. The art inspired by books and reading offers multiple reflections on human experience: moments of transcendence and boredom, pleasure and frustration, frivolity and passionate engagement, creativity and destruction. All of this is seen here, where the written word meets the visual world.

The Art of Reading

Imagine the consternation when the vain and pompous pseudo-scholar Wolfgang Lazius first laid eyes on a satirical portrait depicting him as a pile of books (p.329). Painted in 1566 by the Italian artist Giuseppe Arcimboldo (1527–93), *The Librarian* is believed to mock the Austrian bibliophile, who was head of the Habsburg imperial collections. The painting also communicates much about the way books were produced, how they were used, and their place in sixteenth-century society. For instance, the majority of volumes forming the figure's body are lying horizontally, indicative of the way books were stored during this period. The ornate gold tooling decorating their covers conveys that they are expensive editions, while the figure's spectacles and beard, formed respectively from book-chest keys and dusters, indicates their status as precious objects worthy of protection. Lazius is thus portrayed as a collector of fine books, particular about their care and preservation. But the assortment of pristine leather bindings looks barely read. Indeed, the only open volume rests on his head, above his line of sight, an idea explored at the beginning of that century by the Dutch artist Hieronymus Bosch (p.106). The implication is that, despite this man's love for books, he seldom reads any of them.

To modern viewers, it hardly seems imprudent to let unread books accumulate on the living room shelf. Yet in the sixteenth century such behaviour was considered foolish and worthy of ridicule. In some ways, Arcimboldo's librarian is not unlike the modern book lover: a hoarder of good books with an ever expanding 'to read' list. When Arcimboldo devised this painting, he may have had in mind Sebastian Brant's 'book fool' from the 1494 satirical poem *The Ship of Fools* (p.108). The early Renaissance period saw a new enthusiasm among intellectuals for accumulating books based not on their contents but as objects in their own right. It is this attitude towards book collecting that *The Librarian* lampoons.

Perhaps the most fascinating aspect of the painting is that Lazius was so closely identified with books that he could be represented by them. Similarly, today's average book collection has much to say about the owner's interests, tastes, education and even social status. The books we own are like extensions of our personalities. Vincent van Gogh (1853–90) explored this notion when he chose a paperback novel to represent himself (p.200). Similarly, the German artist Hans-Peter Feldmann (b.1941) has exhibited a life-size photograph of his personal book collection as a kind of self-portrait (pp.312–13). But the likening of the self to books is actually an ancient idea, one that became increasingly common during the Middle Ages with the notion of the 'book of the heart'. The metaphor of the psyche being akin to a book containing one's thoughts and feelings was conveyed in medieval art by depictions of heart-shaped books, and even actual manuscripts made to look like hearts (p.57). Today we talk of 'reading someone like a book', of taking 'mental notes' and of 'turning over a new leaf', metaphors that demonstrate the extent to which book culture has shaped the way we relate to the world and each other.

The book is one of the most influential objects in all of human history. A rich visual record of its shifting status has been provided by artists, especially in the traditions of Western art, from medieval paintings showing the book as a revered object accessible to only a few, to contemporary installations that emphasize its ubiquity as a mass-produced commodity. Sometimes books depicted in a portrait identify specific people, such as Christian saints, or convey their intellectual status; at other times they remind viewers of their mortality, or caution against idleness. But in every painting, sculpture or installation, something is conveyed either about a culture's prevailing attitude towards books or to those who read them.

Saints and scribes

It goes without saying that Christianity, like Judaism and Islam, is a religion of the book. More specifically, it is a religion of the codex, the technology that superseded the papyrus scroll in the early Middle Ages. Unlike scrolls, which were made from long series of papyrus sheets pasted together, the codex comprised multiple pages bound together and given a cover. Not only did this format transform the physical shape of books, but it has been central to the shaping of Western culture and the dissemination of its values and beliefs for nearly two thousand years. Early Christians adopted the format for their Bibles, and by the sixth century it had completely replaced the scroll in the Greco-Roman world. The image of a codex representing the Holy Scriptures soon became a firmly established symbol in Christian art. In illuminated manuscripts, such as psalters and prayer books, saints are often seen holding or reading them, perhaps mirroring the pious activity of the books' readers. In the context of church frescos and altarpieces, images of Bibles were included as symbols of the clergy's power and authority. By the thirteenth century, books had become one of the most frequently used motifs in medieval church art, and were often painted with great detail and vivid colours.

Depictions of books appear in some of the earliest surviving Christian manuscripts, where they are the standard attribute of the four Gospel writers, Matthew, Mark, Luke and John. Of course, the Evangelists themselves would have written on papyrus scrolls, but by the early eighth century they were frequently depicted as contemporary medieval scribes, reflecting the monastic scriptoriums of the day where books were transcribed and illustrated by hand (p.217). In the Codex Amiatinus, the oldest surviving Latin Bible in the world, there appears an image of Ezra, the compiler of the Hebrew Bible, who is shown, pen in hand, writing in a codex (p.210). Saint Matthew is pictured similarly in the Lindisfarne Gospels, which date from the same period (p.212). The portrayal of the Evangelists as scribes reflected the notion that they were in fact copyists, not authors. Taking dictation from Christ and his Holy Spirit, these saints were considered to have faithfully copied out God's word by hand. In art, this convention prevailed for centuries, although after Johannes Gutenberg's invention of the printing press around 1439 (p.71) the Evangelists became readers rather than writers.

An easel painting by the Dutch artist Pieter Aertsen (1508–75) reflects the new mass culture of reading that emerged during the sixteenth century (p.211). The four Evangelists appear to be located in the reading room of a heavenly library, poring over large printed books that would have been familiar to contemporary viewers, many of whom would have been readers themselves. There is no doubt that these luxurious tomes are meant to represent the books of the Bible, and the Gospel writers are shown here as readers receiving Heaven's revelation by way of the printed word. The dove perching on a luminous cloud denotes the presence of the Holy Spirit, emphasizing the spiritual significance of the scene. In the next century, heavenly trappings are removed altogether by the Dutch painter Frans Hals (1582–1666). His painting of Saint Matthew portrays the Evangelist as a grandfatherly figure reading to a small boy (p.145). The book's status here is ambiguous, and were it not for the painting's title the religious theme would easily be missed. Indeed, Matthew appears here like a casual reader rather than a diligent scribe or a studious scholar.

Literary lessons

Until the establishment of the universities at the end of the twelfth century, the monasteries had monopolized European book production. The releasing of intellectual life from the grasp of the Church had a significant impact on the way books came to be written, copied and distributed. With the rise of university education in the West came an increased demand for appropriate resources; consequently, a vibrant book trade emerged, catering for the needs of scholars, teachers and students.

A university lecture from the fourteenth century is depicted on the tomb of Giovanni da Legnano, an esteemed Italian jurist who taught at the University of Bologna (p.138). Sculpted by Jacobello and Pierpaolo dalle Masegne (active c.1383–1403), the scene shows three students sitting at desks while behind

them seven more listen intently to Legnano's lesson. The seated men all have books; one aspiring scholar carefully searches his text, while another gives his a quizzical look. The middle student pays no attention at all; resting his head on his hand, he appears caught in the midst of a daydream. The university most likely owned these volumes, since very few individuals were wealthy enough to buy their own copies. Access to books came mostly through the academic libraries, which unlike the monasteries did not lock their manuscripts away in cabinets, but made them readily available.

New collectors began emerging during the early Renaissance period. Professional scribes and bookbinders increasingly worked outside the monasteries, and as manuscripts became less expensive, private book ownership rose dramatically. Adding to this trend was the invention of the printing press, which enabled knowledge and information to be distributed not only more widely, but also more affordably. By the early 1500s most respectable people had accumulated a small collection of books. On their bookshelves might be psalters, breviaries and popular theological tomes, as well as histories and ancient epics. As the humanist movement placed increasing emphasis on the value of studying classical Greek and Roman texts, the content of these personal libraries gradually became more secular. Italian humanism represented a desire to promote erudition by reviving the cultural, literary and philosophical legacy of antiquity. Books, for which the humanists had an insatiable appetite, were seen as conduits to ancient wisdom.

In Renaissance portraiture, the works of classical writers are often seen in the hands of humanist scholars. For example, Bernardino Loschi (1460–1540) depicts Alberto Pio, Prince of Carpi, holding a copy of Virgil's epic poem the *Aeneid* (p.19). Similarly, in the portrait of Ugolino Martelli by Agnolo Bronzino (1503–72), the Florentine aristocrat points to a passage from Homer's *Iliad* (p.251). His intellectual status is further emphasized by a partially visible volume of Virgil's writings and, in his left hand, a collection of sonnets by the contemporary poet Pietro Bembo, who helped revive interest in the works of Petrarch. Advertising the intellectual prowess of the sitter was not, however, the sole intention of such portraits; they were designed also to convey something of the subject's inner virtue. Bronzino's painting of the female poet Laura Battiferri, for instance, shows her holding a collection of Petrarch's sonnets (p.43). By highlighting a particular passage, the artist invites viewers to draw parallels between the lines of poetry dedicated to Petrarch's beloved and semi-mythical Laura, and the character of the sitter. In this and similar works, artists employed books to demonstrate the sitter's commitment to the virtues of intellectual freedom and individual expression.

The model scholar

Employing an elastic definition of antiquity, the humanists celebrated a vast range of artistic and literary works that spanned a period from several centuries before to a few hundred years after Christ. Not only were eminent Roman and Greek figures venerated, but also individuals from early Christian history such as Saint Jerome, who came to epitomize the image of the diligent scholar during the late medieval and early Renaissance period. Jerome, a fourth-century priest and theologian, is best known for his translation of the Bible into Latin (known as the Vulgate) and is celebrated as a Doctor of the Catholic Church (a title given to eminent saints recognized for their significant contribution to theology). Paintings of Jerome invariably take their cues from the *Golden Legend*, a popular collection of saints' biographies compiled by the Italian chronicler and archbishop Jacobus da Varagine in the thirteenth century. Jerome is described in this book as a Church cardinal, even though this office was not established until after his death. Artists nevertheless almost always dress him in the distinctive red *galero* hat and cloak worn by the senior Church leaders. Likewise, the idea of Jerome holed up in a small room surrounded by books is also inspired by the *Legend*, which characterizes his stay in Bethlehem as one of intense study as he translated the Bible into Latin from the original languages.

Images of Jerome surrounded by books and manuscripts have carried various meanings. In a painting attributed to the Flemish painter Jan van Eyck (c.1390–1441), Jerome is pictured as a humanist scholar absorbed in his studies (p.96). Books are piled up on a shelf while all around are objects related to contemporary

intellectual pursuits. In collapsing the present with the past, van Eyck holds Jerome up as an idealized scholar worthy of emulation. Nearly a hundred years later, in a painting by the Dutchman Marinus van Reymerswaele (1490–1546), Jerome has paused his studies; looking away from his books he now points to a skull, reminding viewers of their mortality (p.94). Moreover, an illustration of the Last Judgement can be seen open on his bookstand, emphasizing the Christian belief that after death, one would inherit either eternal life or eternal damnation. The theme of this work, known as *memento mori*, meaning 'remember you must die', is revisited at the start of the seventeenth century by Caravaggio (1571–1610), who depicts the saint in the act of translating, undeterred by the spectre of death, which is again represented by a skull (p.100).

Echoes of Jerome sitting in his study can be seen throughout art history, in numerous portraits of writers, poets, scholars and intellectuals. The Mexican artist Miguel Cabrera (1695–1768) nods to the saint in his portrait of the tragic seventeenth-century nun Sor Juana Inés de la Cruz, who belonged to the order of the Hermits of Saint Jerome in Mexico City (p.95). The Jerome archetype continues to be evoked in the nineteenth century, by Gustave Courbet's (1819–77) portrait of the French poet Charles Baudelaire (p.216) and also in the painting of Gustave Geffroy in his study by Paul Cézanne (1839–1906), an image that was celebrated by the Cubists, who took inspiration from the skewed geometry of the critic's books (p.219). Indeed, the higgledy-piggledy library appears to have particularly captivated the attention of Cézanne, who, like so many artists before him, was seduced by the aesthetic qualities of books.

The absent reader

The physical form of books has long fascinated artists. The Italian Renaissance painter Carlo Crivelli (1430–95) was a careful observer of large, expensive manuscripts and often included them in his pictures of saints. A section of his 1476 Demidoff Altarpiece shows Saint Andrew carrying a cross while reading from an open book, the crinkled pages of which are about to shut on his hand (p.238). Another artist to appreciate fine bindings was the Spaniard Pedro Berruguete (1450–1504), who gave books a prominent position in many of his works. His 1493–9 painting *Saint Dominic and the Albigensians* includes a sumptuous selection of manuscripts reflecting contemporary bookbinding practice (p.289); several feature metal bosses, while a few ornate tomes display gilt and gauffered page edges, the latter a technique of applying patterns to the paper with heated finishing tools. Books of a more modest type appear in the *Aix Annunciation* of 1443–5, an altarpiece attributed to the Flemish artist Barthélemy d'Eyck (c.1420–70). The proliferation of books in society is reflected by all three panels, but especially in the isolated arrangement of books above the prophet Jeremiah's head (p.41). Its appearance is significant, for as with the bookshelf in van Eyck's portrayal of Saint Jerome's study, it foreshadows still life as an independent genre.

Until the seventeenth century, images of books in art were broadly associated with learning, wisdom, holiness, authority and wealth. More sobering connotations were introduced by the *vanitas* genre, which flourished in Flemish and Dutch painting of the seventeenth-century. Literally meaning 'emptiness', the Latin noun *vanitas* appears frequently in Jerome's translation of the biblical book of Ecclesiastes, which opens with the lines: 'Vanity of vanities, saith the Preacher, vanity of vanities; all is vanity'. Skulls and hourglasses reminded viewers of life's transience in *memento mori* paintings, but *vanitas* art specifically referenced the vanity of worldly pleasures and goods in the face of death. Artists working in this genre often made their point using objects such as flowers or fruit, but there also emerged a distinct subgenre focused on books, allowing them to further explore the physical qualities of this by now common object.

That books are subject to decay just as people are was a notion explored by the Dutch painter Jan Davidsz. de Heem (1606–84). In his 1628 canvas *Still Life with Books*, the transience of knowledge is represented by a tattered collection of literature arranged haphazardly on a table (p.140). Some of the book's titles are legible, including a dilapidated copy of Gerbrand Bredero's play *Rodd'rick ende Alphonsus* (c.1611), the central theme of which is fate. Educated viewers recognizing such manuscripts would have immediately grasped their significance as reminders of

the ultimate futility of worldly study and the ephemerality of all things. Similar ideas can be seen in late seventeenth-century paintings such as *Still Life with Old Books* (p.223) by the Flemish artist Charles Biset (1633–c.1700), one of several he produced on this theme; unlike de Heem's compositions, not a single edition can be identified, since no titles or authors' names have been included. In this way the artist emphasizes their inevitable obsolescence: the knowledge they contain will one day, like their readers, fade away to nothing.

Though the trend for still lifes with books continued well beyond the seventeenth century, artists became less interested in the notion of *vanitas* and began exploring the image of the book for a range of different and often personal reasons. A love of books is evident in Van Gogh's 1887 canvas *Still Life with French Novels and a Rose*, where a selection of distinctive yellow books is shown piled up and scattered across a tabletop (p.221). To French viewers, these familiarly pack-aged paperbacks would have been instantly recognizable as the latest in modern fiction, their yellow covers emphasizing the innovative nature of the avant-garde writing they contained. For Van Gogh, these books symbolized the spirit of the age and a rejection of the moral rigidity of his parents' Calvinist values. Although no titles are visible, the collection likely features material by Émile Zola and the Goncourt brothers, authors whose work he greatly admired. The artist's inclusion of an open book in the foreground invites viewers to sample his latest literary discoveries. However, outside France, and especially in Britain, such publications were regarded as at best sensationalist and at worst scandalous. Nevertheless, British publishers adopted their vivid yellow packaging as a wily marketing device, and 'yellowbacks', as they were known, became associated with modernity and *fin de siècle* decadence.

A contemporary take on the still life theme is seen in the work of the Irish-British artist Michael Craig-Martin (b.1941), whose 2014 painting *Untitled (book)* depicts an anonymous volume isolated against a monochrome background (p.207). The book's open pages do not lie flat but have an animated quality like those in Crivelli's works (p.238). A closer forerunner is perhaps the spellbinding painting attributed to the German artist Ludger tom Ring the Younger (1522–84) titled *The Open Missal* (p.206). This remarkably realistic image shows the pages of an illuminated manu-script being blown by a sudden breeze. Dispensing with detail, Craig-Martin's book is conversely blank and non-specific. Rendered in a stark, graphic style, this generic tome becomes a symbol for books in general, inviting viewers to 'read' it however they wish. Though it is spare, the painting evokes an entire history of artists looking at and thinking about books.

Women readers

Prompted by Martin Luther's criticisms of Catholicism in 1517, the Protestant Reformation defied the Church authorities by emphasizing personal engage-ment with the word of God. Following the growth of vernacular Bible translations in Europe came an increase in paintings showing ordinary people engaged in pri-vate reading, whether studying the Scriptures or secular books. Frequently these readers were female. The shift towards private Bible reading engendered by the Reformation is reflected in the work of the Dutch Golden Age painter Gerard Dou (1613–75). His *Old Woman Reading* of 1631 shows an elderly female reader holding a Bible close to her failing eyes (p.117). Painting with remarkable detail, Dou makes it clear that she is reading from chapter nineteen of Luke's Gospel, and specifi-cally the story of Zacchaeus, a thieving tax collector who repented of his sins after encountering Jesus. The artist's message is evident: just as the old woman is encour-aged to repent and receive forgiveness like Zacchaeus, so too are those who gaze on the painting.

Such imagery has its roots in earlier Annunciation scenes that portray the Virgin Mary reading while the angel Gabriel announces to her the impending birth of Christ, the Incarnate Word of God. Reinterpreted by Protestant artists, the act of reading God's written word is presented as an activity unmediated by clerical authority and accessible to all. One example of the earlier tradition, by the French illustrator Jean Bourdichon (1457–1521), shows Mary interrupted from her reading by a curiously sullen angel (p.160). Although Bourdichon gives prominence to the open Bible, no attempt has been made to identify the passage, rendering the holy

text as quasi-abstract marks. However, it was a widely held belief that Mary was reading Isaiah's prophecy about herself: 'Behold, a virgin shall conceive, and bear a son' (Isaiah 7:14). Original viewers of this illustration and others like it would have made the connection immediately. Bourdichon insists that Mary requires the assistance of a divine expositor, whereas Dou emphasizes the Protestant principle of personal interpretation.

The Annunciation was also a popular theme for altarpieces, found both in churches and in domestic chapels. A particularly well-preserved example of a private altarpiece is the fifteenth-century *Annunciation Triptych* (also known as the Mérode Altarpiece) from the workshop of Robert Campin (1375–1444) (p.62). In this Early Netherlandish scene, Mary is shown engrossed in her Bible and does not seem to notice the large angel that has appeared beside her. On a table are a scroll and another book, representing the Old and New Testaments. The pages of this book are in motion as if blown by a breeze from the open window, or perhaps by the appearance of the angel. While the books and other domestic items all carry symbolic meanings, they also mirror the kind of objects that would have been found in the home of the painting's wealthy owners, allowing them to identify more easily with the holy scene. In the seventeenth century, private reading began to be presented as a purely secular activity. Take for example *Reading Woman* by Pieter Janssens Elinga (1623–82), which shows a young Dutch woman seated before a partially shuttered window (p.156). Facing away from the viewer, she is engrossed in an open book, the identity of which remains hidden. The intimacy of the reading experience is emphasized by the pair of shoes in the foreground, which may even have erotic overtones. Reading for pleasure, rather than devotion or edification, was still a relatively new idea at this time, but it soon paved the way for the emergence of the modern novel in the following century and, along with it, a slew of women portrayed preoccupied by books.

In the eighteenth and nineteenth centuries, more and more women were experiencing a new sense of self-awareness and independence through reading. Via the pages of novels, many of which were marketed specifically at female readers, they entered into a private realm beyond the scrutiny and surveillance of patriarchal society. But with the rise of inexpensive, expendable books that encouraged readers to immerse themselves in a world of fantasy came warnings from conservative observers. Reading, it was feared, was now more about pleasure-seeking than moral edification, a trend that threatened society's moral fibre. The novel therefore became the object of widespread criticism. Several artists working in the late nineteenth century captured the social anxiety about the corrupting influence of reading. In her 1875 canvas *Farmhouse Interior,* the Norwegian painter Johanne Dietrichson (1837–1921) shows the distracting power of a novel upon a young housemaid, whose domestic work is left unattended (p.166). Some commentators worried that in addition to promoting idleness, the new literature could corrupt a woman's virtue. Italian artist Federico Faruffini (1833–69) picks up on this theme in *The Reader* by depicting such escapism as a sensuous and morally questionable activity (p.161). In this oil painting, a woman dressed in loose-fitting clothing rests in a chair, smoking a cigarette; a carafe on the table suggests that she might also be enjoying a glass of wine or liqueur. A sense of moral disorder is conveyed by the table of messy books before her, which also contains elements evoking the *vanitas* genre. Théodore Roussel (1847–1926) alludes to the perceived immorality of novel reading by dispensing with clothes altogether in *The Reading Girl* (p.185), while in *The Librarian* by Félicien Rops (1833–98) a naked female engrossed in erotic literature is having her stash replenished by none other than the Devil himself (p.104).

Building with books

By the twentieth century, books were firmly established as a mass-market product. No longer were they the precious and sacred objects they had once been; now they were cheap, ephemeral and even disposable. In the hands of contemporary artists, discarded and unwanted books became a raw material from which sculptures, installations and paintings could be created. For some artists, the abundance of second-hand literature has allowed them to produce works that probe the place of books in late capitalist culture. For others, books are a starting point from which new and unexpected transformations emerge.

The British sculptor Richard Wentworth (b.1947) exploits the ready availability of books in his 'False Ceiling' installations, the first of which was created in 1995 at London's Lisson Gallery, where he suspended hundreds of old books from the ceiling to create an expanse of floating literature (p.303). Since then, the artist has remade the work at many locations, including the City of London's historic Leadenhall Market and the Indianapolis Museum of Art. The many hundreds of paperbacks and hardbacks required for these installations are often donated by members of the public, further highlighting the extent to which books have become expendable objects.

Working in similar territory to Wentworth is the Spanish artist Alicia Martín (b.1964), whose sculptural installations involve the transformation of thousands of unwanted books into torrents of literature gushing forth from the windows of buildings or bursting through their walls (p.225). In 2012, her 'Biografías' series saw books cascading from three historic sites in Madrid, including the grand Palace of Linares, where a flood of volumes spewed from a first-floor window and down onto the pavement below. Martín's installations are also a response to the excess in book production, but whereas Wentworth's celebrate diversity, hers express anxiety towards the oversaturation of information.

For the South African artist William Kentridge (b.1955), whose work explores the ephemeral nature of both personal and cultural memory, old book pages provide the perfect ground for drawing. For instance, *Meeting the Page Halfway*, (2013), is made using pages of an old edition of the *Oxford Shorter English Dictionary* (p.309). Arranging the pages into a grid formation, the artist has covered them with arcane phrases and coloured rectangles. Tomes whose shelf life has long since been exceeded are particularly attractive to Kentridge, who is also interested in the materiality of printed books. The artist regularly scours second-hand bookstores searching for particular editions or volumes with distinct qualities of paper.

While Kentridge uses all manner of books in his work – including encyclopaedias, anatomy books, maps and even ancient Greek tragedies – the British artist Tom Phillips (b.1937) has for fifty years used just one publication: an 1892 novel by W. H. Mallock titled *A Human Document*. Ever since discovering the Victorian book, Phillips has been altering its pages by painting, typing, drawing and collaging onto them to create his celebrated artist's book *A Humument* (pp.324–5). Clusters of Mallock's original text are often left visible, forming a poetic and often surreal narrative that opens with the words: 'The following sing I a book, a book of art, of mind art, and that which he did, reveal I'. As this sentence implies, Phillips's project is about teasing out a new and strange story embedded deep within the original text.

Dismantling and dismemberment are inevitable for many contemporary artists working with books. In most cases, destruction of literature is part of the creative process and rarely a malicious act. A notable exception is found in the work of British artist John Latham (1921–2006). Take for example the unusual destruction of Clement Greenberg's *Art and Culture* (1961), a collection of critical essays with which the artist took issue (p.273), or his 1966 performance *Skoob Tower Ceremony* ('skoob' being backwards for 'books'), in which a tower of stacked *Encyclopaedia Britannica*s was set on fire. However, Latham's art was less about censorship than it was about the fragility of knowledge and the transformation of books from one state to another (p.290). Nevertheless, in 2005 he became embroiled in a censorship row when the 7/7 bombings in London prompted Tate Britain to removed from display *God is Great #2*, his 1991 sculpture in which copies of the Christian Bible, Muslim Koran and Jewish Talmud are sliced through by a large sheet of glass. The museum's branding of the work as 'inappropriate' sparked a public debate on censorship and freedom of expression, perennial issues that have concerned authors for centuries.

Burning books

As the frail, tired bindings of the vanitas paintings remind us, books – like their readers – are not immortal. Mould, mildew and lice, as well as over-handling and inappropriate shelving, all threaten their survival. Another perennial hazard, of course, is fire. Throughout the ages, flames have consumed countless scrolls, manuscripts and printed volumes; personal collections and even vast libraries have been devoured in this way, whether accidentally or otherwise. One of the best known examples

of destruction by fire is the Library of Alexandria, where thousands of scrolls were accidentally set alight during Julius Caesar's civil war in 48 BC (p.285). But there are also numerous examples of books being deliberately burned for reasons of censorship, whether cultural, religious or political. In the New Testament, Saint Paul oversaw the burning of books that he considered antithetical to the Christian faith (p.288), while in the fourth century Emperor Constantine ordered the heretical writings of Arius to be set ablaze (p.287). Saint Dominic is also believed to have burnt books as part of his 'trial by fire'; his own writings, it is claimed, resisted the flames, while heretical texts were burned to cinders (p.289). However, to modern readers, particularly those in Europe and North America, book burning is most readily associated to the activities of Nazi Germany in the 1930s.

In the spring of 1933, as part of a nationwide 'Action against the Un-German Spirit', books perceived as a threat to Nazism were publicly burned across Germany. Included among them were works by Jewish, Christian, socialist and communist authors. Today, Berlin's Bebelplatz is an open-air memorial to the Nazi book burnings: the Israeli artist Micha Ullman (b.1939) has installed an empty, underground library. An accompanying plaque is inscribed with the famous words from Heinrich Heine's 1823 play *Almansor*: 'That was merely a prelude: where they burn books, they will ultimately burn people' (p.293). Although Heine's play preceded Hitler's regime by more than a century, these words are today inextricably linked to the Nazi burnings. Though it might at first seem curious to install a monument to the destruction of books, the inclusion of Heine's epigram is a reminder of the atrocities that followed. In Ullman's work, book destruction is indivisibly associated with the destruction of people.

To many, the deliberate destruction of books is still considered a barbaric act. Books are, after all, symbols of a civilized society: its culture, values and beliefs. To destroy a book is to destroy a part of culture itself. But moreover, it seems that, from the vantage point of the twenty-first century, book destruction has become so closely linked with barbarity that it is akin to physical acts of violence. If there is one thing that can be learned from the history of censorship, however, it is that books – like the human spirit itself – can never be totally destroyed. Individual volumes may be incinerated, but literature endures. Even in the face of new digital technologies, hardbacks and paperbacks remain resilient. As long as books continue to be produced, artists will be exploring their place in society by shedding light on the many ways in which they reflect ourselves back to us.

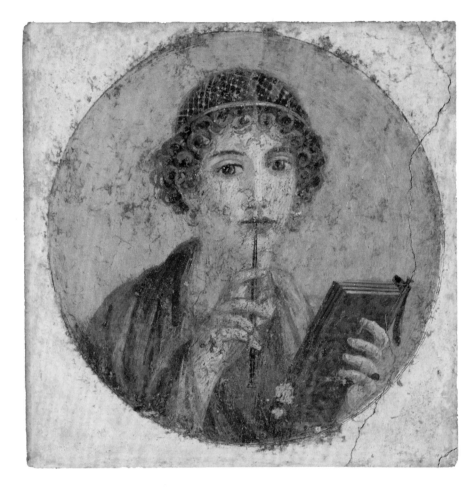

Woman from Pompeii
with wax tablets and stylus
Artist unknown
c.55–79 AD, fresco on gesso, 37 × 38 cm (14 ⅝ × 15 in)
National Archaeological Museum of Naples

The young woman in this fresco appears to have a book in her hand; she is, in fact, holding four wax tablets that are tied together. Made from wood covered with wax, these small, portable devices were very popular in ancient Rome, providing a convenient writing surface long before paper was readily available. The woman also holds a stylus, the implement used for writing, which she places thoughtfully to her lips as if pausing for a moment of reflection. The fresco was discovered in 1760 when the city of Pompeii was excavated. Before it was destroyed by the volcanic eruption of Mount Vesuvius in 79 AD, Pompeii had many frescoes like this one, painted onto the walls of houses and buildings throughout the city. For many years it was assumed that the portrait depicted the archaic Greek poet Sappho, whose lyric poetry was greatly admired in antiquity. However, the tablets shown here are associated with accounting and have nothing to do with poetry. Though the true identity of the woman is unknown, she is from a cultured and affluent family, as evinced by her fashionable gold earrings and hairnet. The portrait is today regarded as a celebration of female literacy.

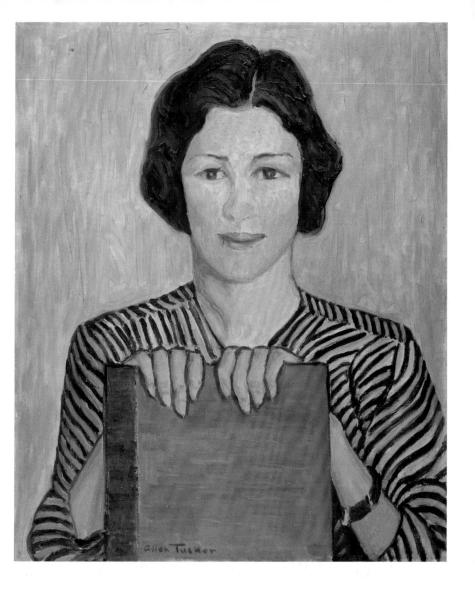

The Orange Book
Allen Tucker
before 1934, oil on canvas, 61 × 50.8 cm (24 × 20 in)
The Phillips Collection, Washington DC

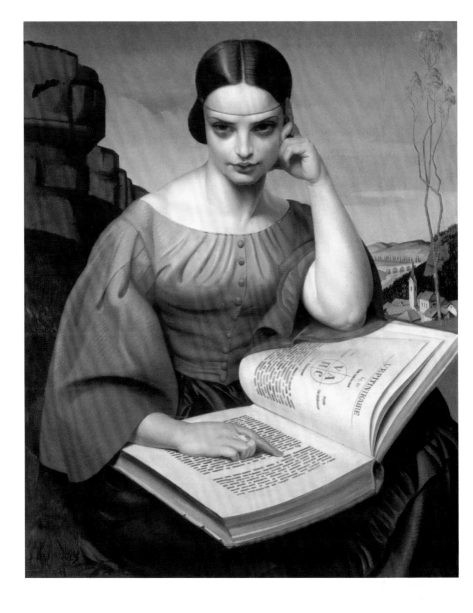

The Thought
Jean Despujols
before 1929, oil on canvas, 100 × 81 cm (39 ⅜ × 31 ⅞ in)
Musée La Piscine, Roubaix, France

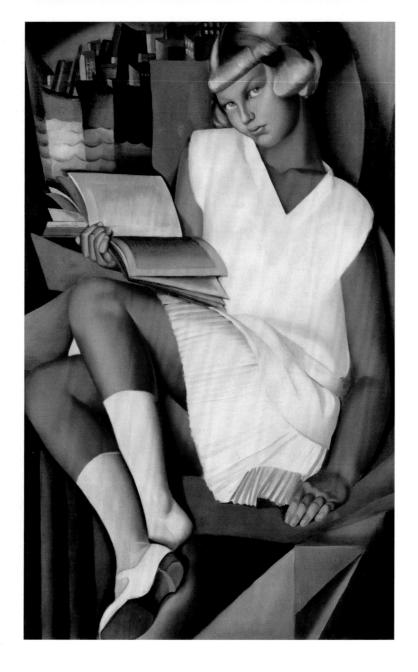

Kizette in Pink
Tamara de Lempicka
1927, oil on canvas, 116 × 78 cm (45 ⅝ × 30 ¾ in)
Musée d'arts de Nantes, France

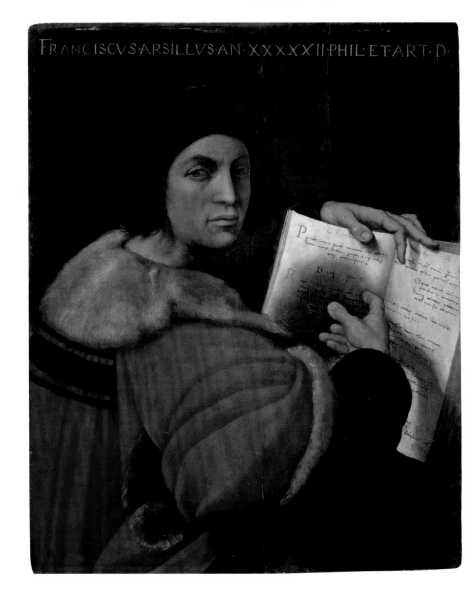

Portrait of Francesco Arsilli
Sebastiano del Piombo
c.1516, oil on canvas, 85 × 69 cm (33 ½ × 27 ⅛ in)
Pinacoteca Civica Francesco Podesti, Ancona, Italy

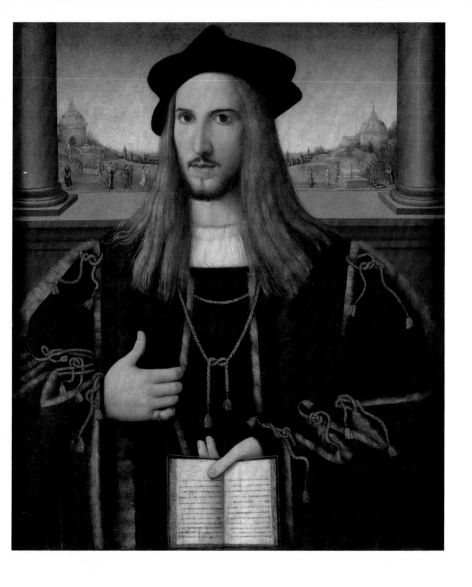

Portrait of Alberto Pio
Bernardino Loschi (attributed)
1512, oil on wood, 58.4 × 49.5 cm (23 × 19 ½ in)
National Gallery, London

'A book is not harmless
merely because
no one is consciously
offended by it.'

T. S. Eliot (1888–1965)

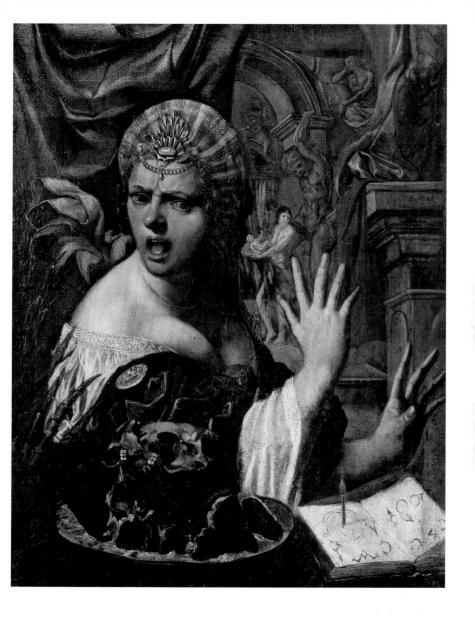

The Sorceress
Angelo Caroselli
17th century, oil on canvas
44 × 35 cm (17 ⅜ × 13 ¾ in)
Pinacoteca Civica Francesco Podesti, Ancona, Italy

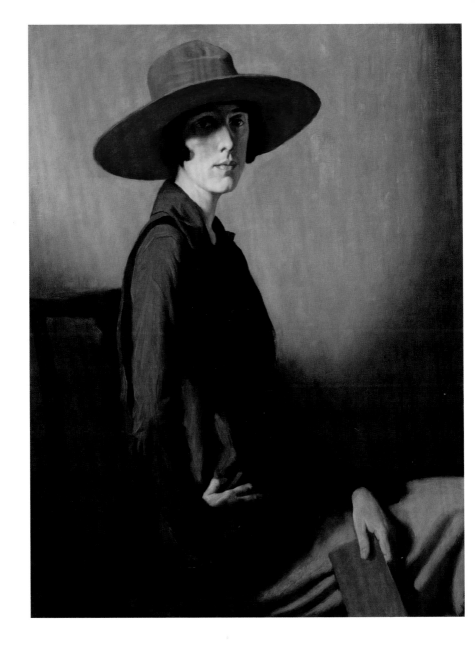

**Lady with a Red Hat
(Portrait of Vita Sackville-West)
William Strang**
1918, oil on canvas, 102.9 × 77.5 cm (40½ × 30½ in)
Kelvingrove Art Gallery and Museum, Glasgow

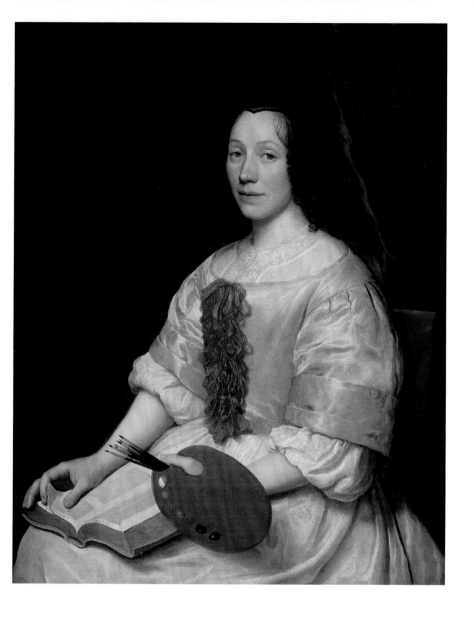

Portrait of Maria van Oosterwijck
Wallerant Vaillant
1671, oil on canvas
96 × 78 cm (37 ¾ × 30 ¾ in)
Rijksmuseum, Amsterdam

Reading Girl
Gustav Adolph Hennig
1828, oil on canvas
42.5 × 36.5 cm (16 ¾ × 14 ⅜ in)
Museum der bildenden Künste, Leipzig

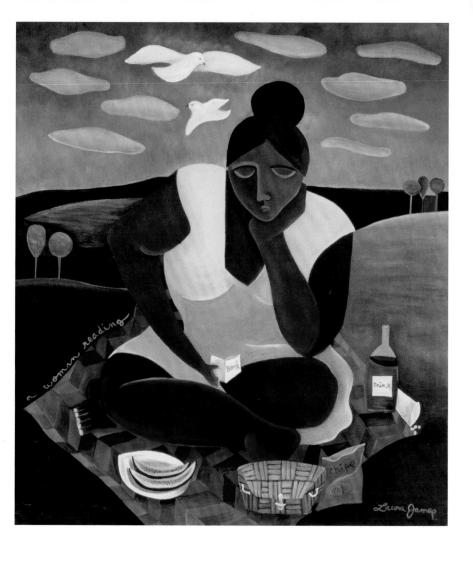

A Woman Reading
Laura James
1997, acrylic on canvas
50.8 × 45.7 cm (20 × 18 in)
Private collection

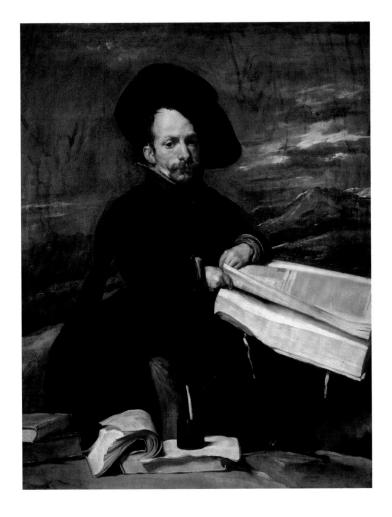

Buffoon with Books
(Portrait of the jester Don Diego de Acedo, 'El Primo')
Diego Velázquez
c.1644, oil on canvas, 107 × 82 cm (42 ⅛ × 32 ¼ in)
Museo Nacional del Prado, Madrid

The huge tome in this portrait serves to accentuate the diminutive stature of Don Diego de Acedo, a dwarf employed at the Spanish court of King Philip IV. Known by the nickname 'El Primo' (The Cousin), de Acedo was a figure of ridicule, a jester whose physical deformity provided entertainment for the King and his court in moments of idleness. However, Velázquez (1599–1660) depicts him not as a buffoon but as an intelligent and learned character. The oversized book on his lap and, in the foreground, the ledgers, inkpot and pen, all convey literacy. This was not overlooked at court; when El Primo was not amusing the King he was tasked with administrative duties, working as a courier and even entrusted with the royal seal. Previously, artists at the Spanish court depicted disabled people with an emotional detachment, but Velázquez, who made several portraits of dwarfs for the King's hunting lodge, paints them with dignity and humanity, just as he did the royal family. Here, El Primo's intense gaze compels viewers to grant him respect, and while the oversized book may initially appear to be a humorous juxtaposition, it is perhaps better understood as a sign of his great intellect, with knowledge at his command.

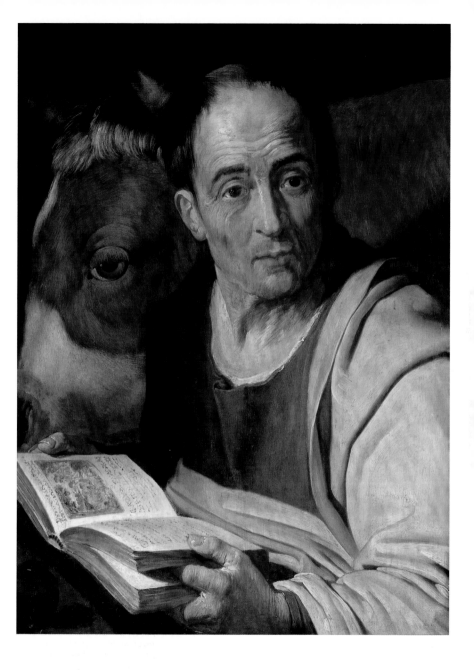

Saint Luke
Artus Wolfordt
early 17th century, oil on panel, 61 × 49 cm (24 × 19 ¼ in)
Museo Nacional del Prado, Madrid

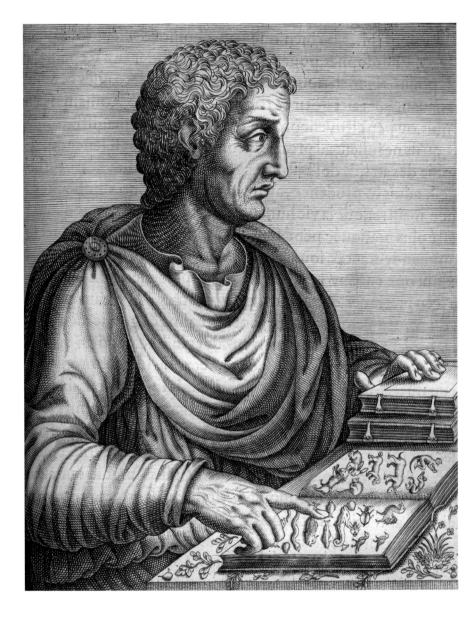

**Pliny the Elder, from 'The True Portraits and Lives
of Illustrious Men' by André Thevet**
Artist unknown
1584, engraving, 20.3 × 15.2 cm (8 × 6 in)
Bibliothèque nationale de France, Paris

'There is no book
so bad that
some good cannot
be got out of it.'

Pliny the Elder (AD 23–79)

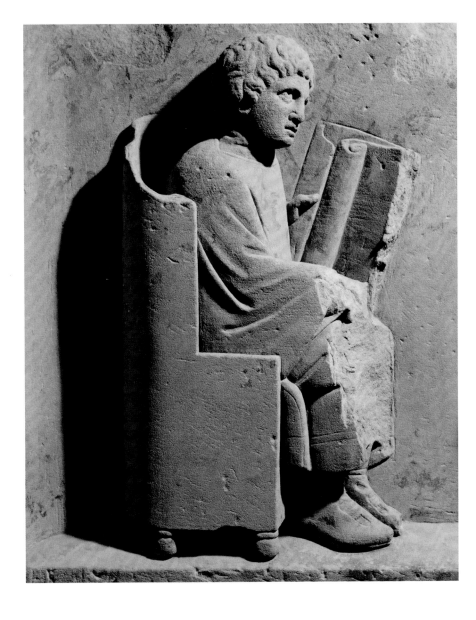

Pupil in a chair holding a copy-book: detail of a school scene
Artist unknown – Roman (Neumagen School)
2nd–3rd century, detail of a stone funeral stele,
with homeschooling scene
Rheinisches Landesmuseum, Trier, Gemany

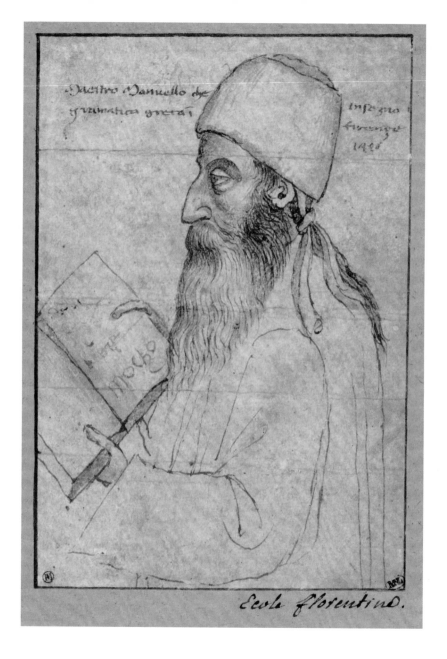

Portrait of Manuel Chrysoloras wearing a hat and holding a book
Paolo Uccello
15th century, pen and brown ink, brown and green wash on paper
13.6 × 9.3 cm (5 ⅜ × 3 ⅝ in)
Musée du Louvre, Paris

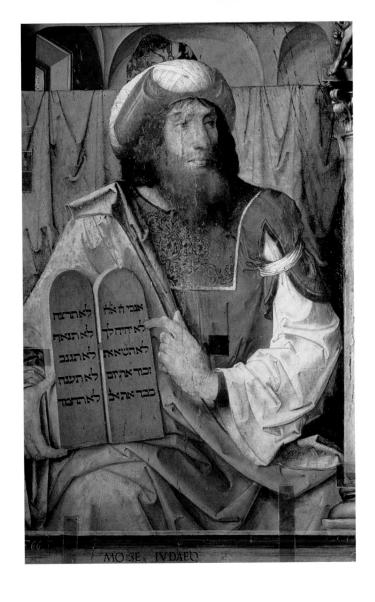

Moses and Solomon
from the series 'Twenty-eight Illustrious Men
for the Studiolo of Federico da Montefeltro'
Justus of Ghent and/or Pedro Berruguete
1470s, oil on wood, each c.100 × 69 cm (39 ⅜ × 27 ⅛ in)
Galleria delle Marche, Urbino, Italy

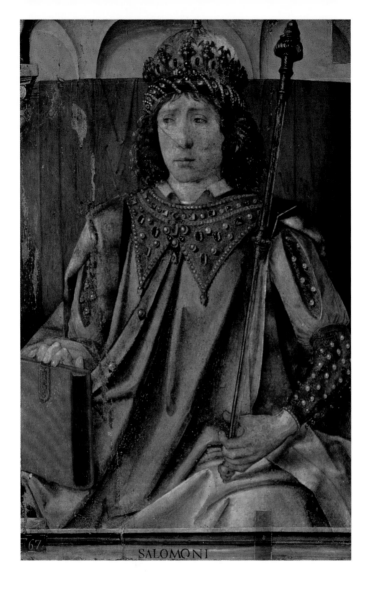

SALOMONI

Moses, the biblical patriarch who led the Israelites out of slavery in Egypt, is shown pointing to the stone tablets of the Law, which are depicted here like an open book. According to the Bible it was God himself who inscribed these pieces of stone with the Ten Commandments. The tablets are contrasted with the leather-bound book held by Solomon, third king of the Israelite monarchy. He is believed to have composed several thousand songs and proverbs, many of which were included in the Jewish scriptures. He is also associated with the biblical books of Ecclesiastes and the Song of Songs. However, the anachronistic book here would have been unfamiliar to Solomon, whose writings would have been transcribed onto scrolls. These paintings belong to a series of twenty-eight portraits depicting 'illustrious men' commissioned for the private study of Federico da Montefeltro, a central figure of the Italian Renaissance. A renowned intellectual and patron of the arts, he built a great library in Urbino that became the largest in Italy after the Vatican. Among the other figures included in this series are Plato, Aristotle, Saint Jerome, Ptolemy, Saint Augustine, Cicero, Homer, Virgil, Thomas Aquinas, Euclid, Hippocrates, Dante and Petrarch.

Vision of Saint Thomas Aquinas
Santi di Tito
1593, oil on panel, 362 × 233 cm (142 ½ × 91 ¾ in)
Church of San Marco, Florence

Falling to his knees, Thomas Aquinas offers his writings to an image of the crucified Christ. His devotion is so earnest that the painted fresco has come to life; the biblical characters emerge from their picture to join the saint in his adoration. Accompanying Jesus beneath the cross are the Virgin Mary, Mary Magdalene, Saint John and Saint Catherine of Alexandria, with her broken wheel the symbol of her martyrdom. Aquinas was a thirteenth-century Dominican friar who is regarded as one of the greatest theologians of the Catholic Church. According to legend, he once heard Christ speaking to him from a fresco in an Italian church. Di Tito (1536–1603) painted the miraculous event for the altarpiece in this Florentine church. His inclusion of a book indicates the significance of Aquinas's prolific writings. The saint's work had an enormous influence not only on Catholicism but also on Western thought more broadly. Much modern philosophy either developed or challenged his ideas, especially in the fields of ethics, metaphysics, natural law and political theory. Today he is recognized as a Doctor of the Church, a title given to saints who have profoundly shaped Christian teaching.

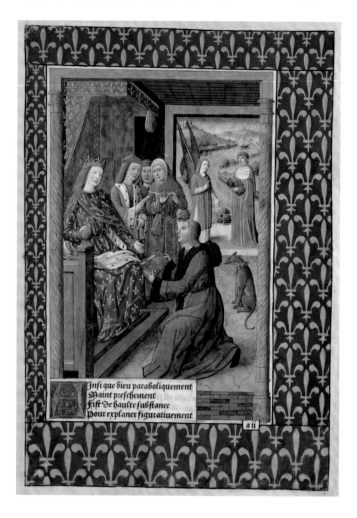

Inſi que dieu paraboliquement
Maint preſchement
fift De haulte ſubſtance
Pour explaner figuratiuement

Presentation of 'Les Paraboles master Alain' to King Charles VIII of France
Master of Jacques de Besançon

1492–93, illuminated printed book, dimensions unknown
Musée Condé, Chantilly, France

The French publisher Antoine Vérard kneels before King Charles VIII of France, presenting him with a book. This engraving appears as the frontispiece of the volume depicted in Vérard's hands: a fifteenth-century translation of the *Liber Parabolarum* (c.1175). Attributed to the twelfth- century theologian Alain de Lille, this is a book of moralizing maxims that was very popular as a medieval school text. Vérard's 1492 edition was one of fourteen books that he dedicated to the king. Working at the turning point between illuminated manuscripts and modern printed editions, the publisher combined the two techniques by including woodcuts and engravings in his printed works, often employing the services of the prolific Parisian illuminator the Master of Jacques de Besançon (active c.1480-1500). For the *Parabolarum*, Vérard included the original Latin text alongside the new vernacular translation and a commentary. Such translations increased in popularity during the later Middle Ages as Latin lost its grip as the language of scholarship. It has been suggested that the book was intended as a moral guide for the young monarch who had succeeded Louis XI in 1483 at the age of thirteen. Relatively unschooled, he was widely regarded as too inexperienced for the responsibilities of kingship.

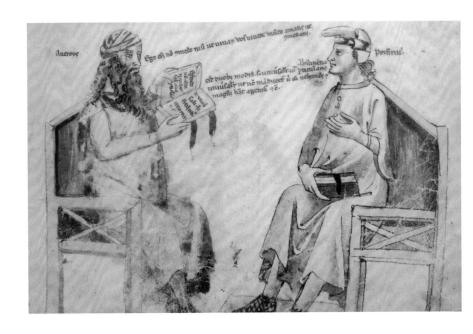

Imaginary debate between Averroes and Porphyry
from 'Liber de herbis et plantis' by Manfred de Monte Imperiale
Artist unknown

14th century, detail from drawing on parchment, dimensions unknown
Bibliothèque nationale de France, Paris

Two philosophers holding books are engaged in debate. On the left is the twelfth-century Islamic polymath Ibn Rushd (also known as Averroes), while on the right is the third-century thinker Porphyry of Tyre. This illustration is from a series of frontispieces introducing a medieval treatise on medicinal plants. The richly illuminated manuscript, known as a herbal, was produced by Manfred de Monte Imperiale, an Italian scholar-physician working in the first half of the fourteenth century. Showing plants with descriptions of their healing properties, the book dates from a time when botany was still a part of medicine. Averroes and Porphyry are included as representatives of philosophy, and are joined in other illustrations of the Arab translator Hunayn ibn Ishaq (also known as Johannitius) and the Greek physicians Galen and Hippocrates; words from their best-known works appear like 'speech bubbles'. The imaginary debates are intended to establish Manfred's credentials; though the content of his herbal does not directly connect to the work of these luminaries, their portraits offer a visual chart of Manfred's own learning, positioning him as part of the knowledge traditions they represent. The portraits thus validate the book as an authoritative resource for medical study.

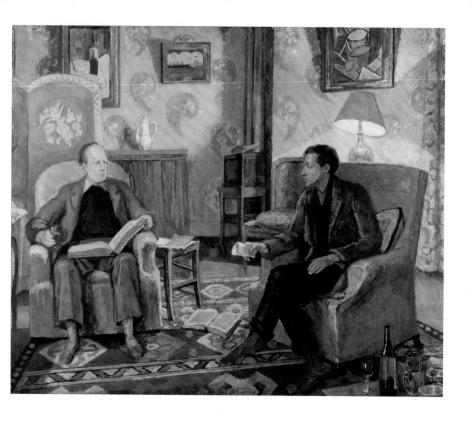

**Interior Scene, with Clive Bell and
Duncan Grant Drinking Wine**
Vanessa Bell
c.1920–25, oil on canvas
122 × 152 cm (48 × 59 ⅞ in)
Birkbeck College, London

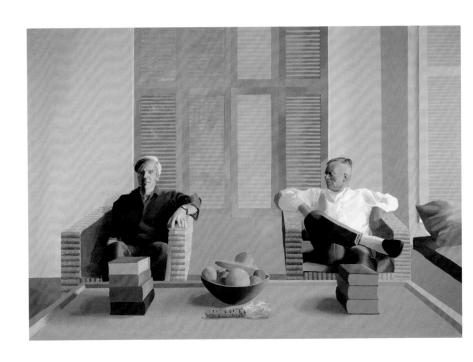

Christopher Isherwood and Don Bachardy
David Hockney
1968, acrylic on canvas
212 × 303.5 cm (83 ½ × 119 ½ in)
Private collection

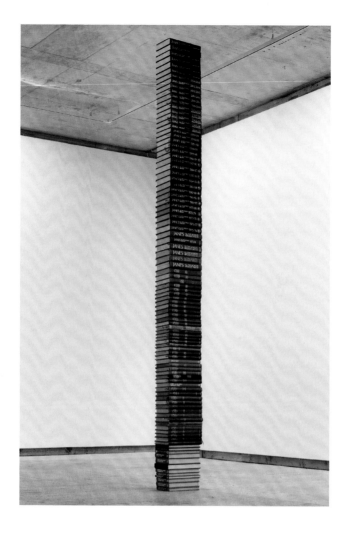

1909–2011
Fiona Banner
2010, 97 'Jane's All the World's Aircraft' books
375 × 22 × 35 cm (147 ⅝ × 8 ⅝ × 13 ¾ in)

This column of books is so tall that it almost touches the gallery ceiling. It comprises ninety-seven volumes of *Jane's All the World's Aircraft*, the famous aviation annual that since 1909 has documented every civil and military aircraft in production. Banner (b.1966) has arranged the books in ascending chronological order; at the bottom of the stack are the earliest volumes, which are significantly thinner than the later editions seen at the top, with volumes becoming noticeably heavier from around 1970. The artist has been compiling this collection for over two decades and each year adds a new volume to the towering sculpture. The collection embodies the entire history of human flight as well as the exponential growth of military technology. However, its content is inaccessible and thus, as a practical resource, useless. Books are a recurrent theme in Banner's work, with the artist also having founded her own publishing house, The Vanity Press. The first of its many publications was *The Nam* (1997), the artist's own thousand-page text describing the plots of six Vietnam films. In 2010 the press republished three obscure science-fiction novels written by Fred T. Jane, founder of the *Jane's* annual.

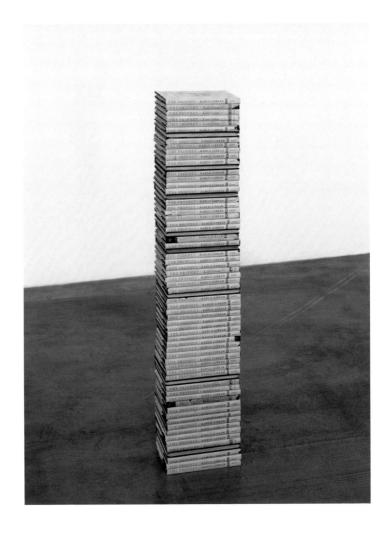

Tower of the Prophet
Carol Bove
2001, 68 vintage pressings of 'The Prophet' by Kahlil Gibran
121.9 × 20.3 × 12.7 cm (48 × 8 × 5 in)

The title of this sculpture evokes the far-flung abode of an ancient mystic. It is, in fact, much more literal: a column of books comprising sixty-eight copies of Kahlil Gibran's *The Prophet* (1923). The book contains twenty-six poetic essays narrated by the prophet Almustafa. It covers an array of topics pertaining to the human condition, including freedom, pleasure, self-knowledge, friendship, love, joy, sorrow, religion and death. In the 1960s its spiritual wisdom was hugely popular in the emerging hippie counterculture and became something of a primer for the movement. Bove (b.1971), who collected these copies from thrift stores, was intrigued to find that their previous owners often underlined the text in exactly the same places, an indication of conformity taken precedence over individual expression. Indeed, her tower of books exposes the contradictions of the counterculture, revealing the mass-produced text to be part of the capitalist system the hippies aspired to transcend. That so many copies now lie discarded speaks to the disillusionment felt by many who once embraced alternative lifestyles. Bove's sculpture is a monument to those abandoned ideals, a testament to the difficulties of sustaining rebellion in late capitalist democracies.

The Prophet Jeremiah, right-hand panel from the Aix Altarpiece
Barthélemy d'Eyck (attributed)
1443–5, oil on wood, 152 × 86 cm (59 7/8 × 33 7/8 in)
Musées royaux des Beaux-Arts, Brussels

Dressed in sumptuous red robes with green lining, the prophet Jeremiah stands on a plinth browsing a blue, leather-bound book. Above his head is a shelf crammed with more books, loose parchments, clay pots and wooden boxes. The lively arrangement of still life objects evokes Jeremiah's literary and spiritual life as one of the great Old Testament prophets. The prophet's statue-like appearance may be an allusion to Claus Sluter's *Well of Moses*, an earlier monastic sculpture in which the prophet appears with a large lifelike book and scroll. This painting, attributed to the Flemish artist d'Eyck (c.1420–70), originally belonged to a triptych produced for the Cathedral of Saint Sauveur in Aix-en-Provence, France. Set in a Gothic church, the other panels of the now dismembered altarpiece feature the prophet Isaiah and an Annunciation scene. All of the characters wear fifteenth-century clothing and each panel contains books; only the well-dressed Jeremiah is shown actively reading, illustrating to the laity the virtue of listening to learned teachers of the church. However, as the Bible attests, few people heeded the original message of repentance that Jeremiah delivered around six hundred years before Christ, and the prophet faced much persecution.

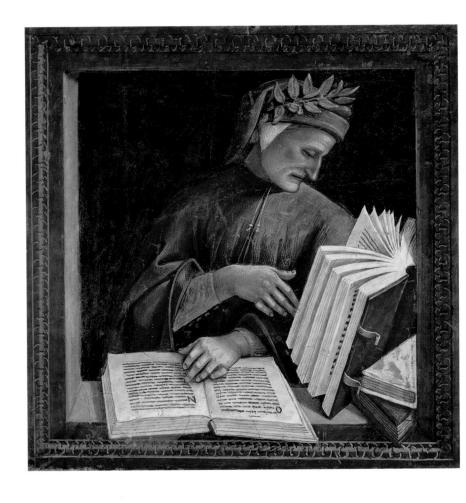

Portrait of Dante Alighieri
from the cycle of seven poets and writers
Luca Signorelli
1499–1504 (detail), fresco, dimensions unknown
Chapel of San Brizio, Duomo, Orvieto, Italy

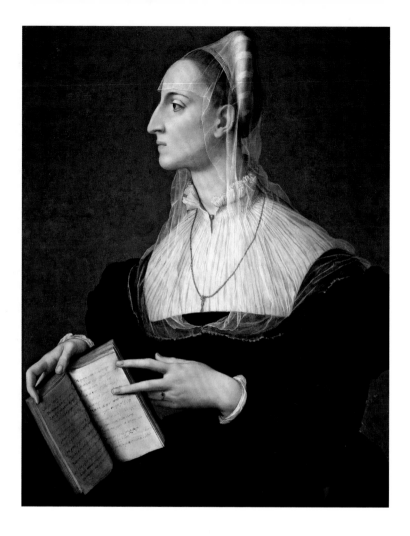

Portrait of Laura Battiferri
Agnolo Bronzino
c.1560, oil on canvas, 83 × 60 cm (32 ⅝ × 23 ⅝ in)
Palazzo Vecchio, Florence

Looking away from the viewer, the woman in this enigmatic portrait draws attention to an open book in her hands. With a distant expression, she seems lost in her thoughts, perhaps contemplating the passage of poetry that her slender fingers have highlighted. The sitter is the poet Laura Battiferri (1523–89), a wealthy intellectual in Florentine artistic circles. She is holding a collection of sonnets by Petrarch, the Italian Renaissance poet widely regarded as the founder of Humanism. Ensuring that the pages of the book are legible, Bronzino (1503–72) has carefully painted the words of two of Petrarch's sonnets dedicated to his beloved, semi-mythical, Laura,

an 'unapproachable, unattainable beauty' whose 'personality is even more elusive than her external appearance'. In reality, these sonnets do not appear on adjacent pages of the *Canzoniere*, the famous collection of Petrarch's works. The artist's intention here is not only to compare his subject to Petrarch's Laura, but also to contrast a visual portrait with a literary one. The unconventional position of Battiferri's head is reminiscent of a coin profile. It has been suggested that Bronzino intended to emphasize his sitter's hooked nose, which would have evoked for viewers Botticelli's famous silhouette of another celebrated Italian poet, Dante.

Two of the Six Immortal Poets
(Kiichi Hōgen and Ōmaya Kisanda)
Keisai Eisen
1829, surimono print, 20.8 × 18 cm (8 ¼ × 7 ¼ in)
Harvard Art Museums, Cambridge, Massachusetts

Sitting on the floor and dressed in traditional costume are what appear to be two renowned Japanese poets. One, positioned in front of an open book on a pedestal, is studying a collection of ancient poems. The other figure, holding a fan, has placed his books in a neat pile and seems poised as if ready to spring up and leave. However, these characters are not in fact poets. Rather, they are figures from the life of Ushiwakamaru (also known as Minamoto no Yoshitsune), one of Japan's most famous tragic heroes. Ushiwakamaru was a twelfth-century nobleman and warrior of the Minamoto clan. The two men in this woodblock print are the military strategists Kiichi Hōgen and Ōmaya Kisanda, whom Eisen (1790–1848) has depicted dressed as two of the Six Immortal Poets, Ōtomo no Kuronushi and Fun'ya no Yasuhide. The Immortal Poets were a popular pictorial theme, featuring six outstanding literary figures of the ninth century. This print, which dates from the late Edo period (1603–1868), belongs to a series of three, which together include all six of the Immortal Poets. Accompanying the convoluted portraits are contemporary verses by the Edo poets Shōutei and Shūchōdō, who may have commissioned the prints.

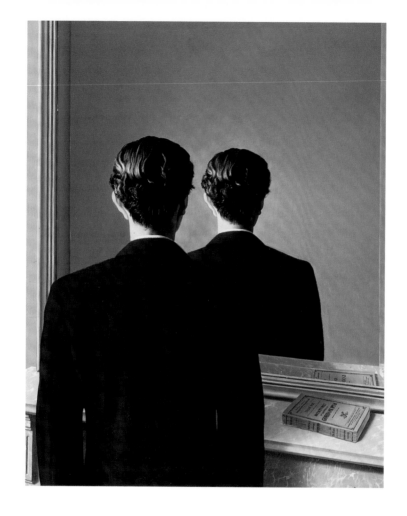

Reproduction Forbidden
René Magritte
1937, oil on canvas
81.5 × 65 cm (32 × 25 ½ in)
Collection Museum Boijmans Van Beuningen, Rotterdam

A man looks into a mirror, but where he expects to see his face reflected he sees only the back of his head. Beside him, on the mantelpiece is a well-worn copy of Edgar Allan Poe's *The Narrative of Arthur Gordon Pym of Nantucket* (1838), the only object reflected correctly by the mirror. The suited figure with slick, Brylcreemed hair is Edward James, a British poet and patron of the Surrealist movement. The painting, which was also commissioned by James, is one of three produced by Magritte (1898–1967) for the patron's London home. Both men greatly admired Poe's writings, and Magritte was fascinated by the author's preoccupation with the relationship between fantasy and reality. The novel depicted purports to be Arthur Gordon Pym's eyewitness account of his adventurous expedition to the South Pole. Pym repeatedly claims to be the true author of the book, noting that 'Mr. Poe' is merely the editor of his work. His concern is that the reader will regard his travelogue as fiction rather than fact. This portrait plays with perceptions of reality in a similar way to Poe's novel: both hinge on concealed identities and both present improbable scenarios as though they were real.

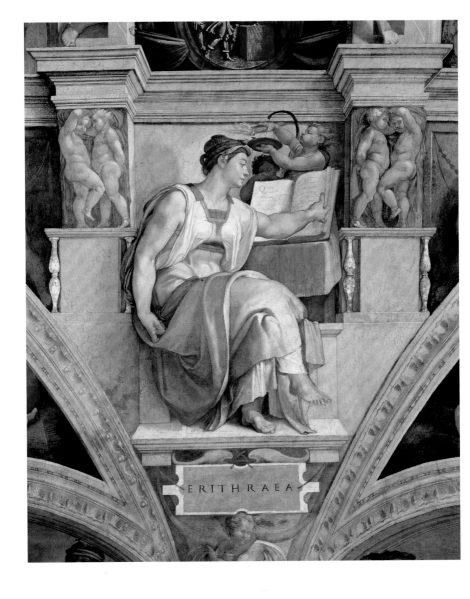

ERITHRAEA

The Erythraean Sibyl
from the ceiling of the Sistine Chapel
Michelangelo
1509, fresco, c.360 × 380 cm (c.140 × 150 in)
Sistine Chapel, Vatican

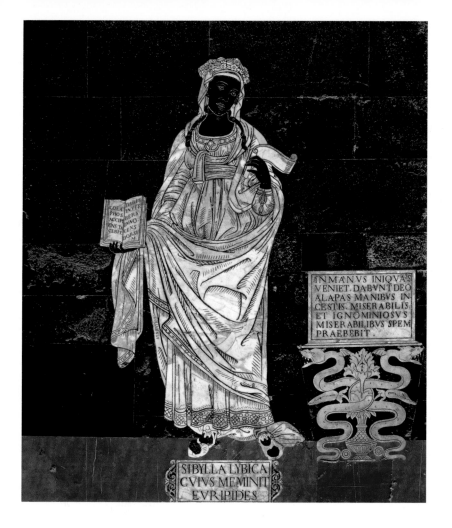

In the image, book text:
COLA
PHOS
ACCIPI
ENS TA
CLEBIT

DABIT
VERAM
BERA
NATO
CENS
DORSV
M

In the image, tablet text:
INMANVS INIQVAS
VENIET DABVNT DEO
ALAPAS MANIBVS IN
CESTIS MISER ABILIS
ET IGNOMINIOSVS
MISER ABILIBVS SPEM
PRAEBEBIT

In the image, plaque text:
SIBYLLA LYBICA
CVIVS MEMINIT
EVRIPIDES

The Libyan Sibyl
Guidoccio Cozzarelli
1483, inlaid mosaic floor, left nave, c.158 × 110 cm (c.62¼ × 43⅜ in)
Cathedral of Santa Maria Assunta, Siena, Italy

A tall black woman dressed in fine drapery and sandals holds a scroll and an open book. She is one of ten ancient prophetesses known as sibyls depicted on the ornate mosaic floor of Siena Cathedral in Italy. Originally Greek pagan figures, the sibyls were women who prophesied at holy sites. Believed to be able to see into the future, they were often consulted prior to important decisions. The Libyan Sibyl was one of two priestesses banished from the temple of Ammon in the ancient Egyptian city of Thebes. After wandering across the desert she arrived at the temple of Ammon at the Siwa Oasis in ancient Libya, where she became its prophetess. Cozzarelli (1450-1517) shows her accompanied by her name and the Latin verses of the prophecy that is attributed to her. For Christians, the sibyls represented the idea that God could speak even through heathen unbelievers. Saint Augustine quotes the Erythraean Sibyl at length, believing that her prophecies spoke about Christ. In Christian art the sibyls are depicted with books and scrolls to signify their prophetic abilities. Michelangelo (1475-1564) includes five sibyls alongside Old Testament prophets in his frescos on the ceiling of the Sistine Chapel.

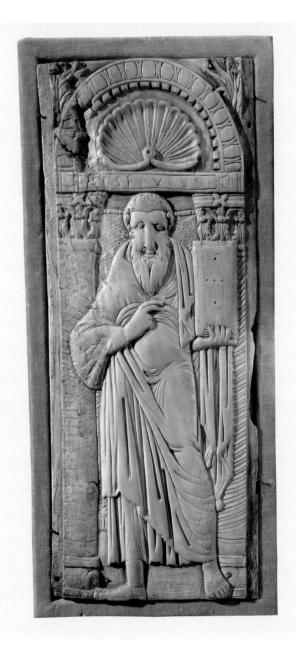

Saint Paul
Byzantine (northern Syria)
early 7th century, ivory, 32 × 13.4 cm (12 ⅝ × 5 ¼ in)
Musée national du Moyen Âge, Paris

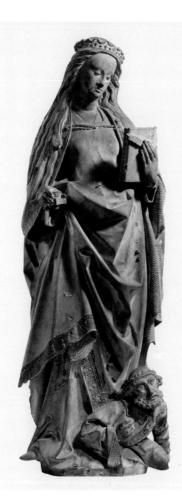

Saint Catherine of Alexandria
Workshop of Jan Crocq
c.1475–1525, limestone with traces of paint
156.2 × 57.2 × 36.2 cm (61½ × 22½ × 14¼ in)
The Metropolitan Museum of Art, New York

Despite being brutally martyred in the early fourth century, Saint Catherine of Alexandria is depicted here as a triumphant figure. She holds a Bible in her hand whilst at her feet a vanquished Emperor Maxentius clenches his fist in frustration. According to legend, Catherine was both a princess and noted scholar who converted to Christianity at the age of fourteen after experiencing a vision of the Virgin Mary and the infant Christ. When the Roman persecution of Christians began under Maxentius, Catherine rebuked him for his savagery. In response, the emperor gathered fifty outstanding pagan philosophers and ordered

them to refute her arguments for the Christian faith. Drawing her inspiration from the Bible, Catherine won the debate with such eloquence and conviction that many of her antagonists were themselves converted to Christianity. Maxentius immediately ordered them all to be put to death. Catherine was first tortured on a spiked wheel; after it was destroyed by a miraculous thunderbolt, she was finally beheaded. The wheel is the motif usually associated with her, but this unknown artist has chosen to highlight her great learning and steadfastness. Absorbed in her Bible, she pays no attention to her spiritually impotent persecutor.

'Beware of the person of one book.'

Thomas Aquinas (1225–74)

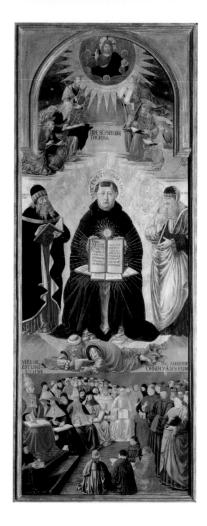

The Triumph of Saint Thomas Aquinas
Benozzo Gozzoli
c.1470–75, tempera on panel, 230 × 102 cm (90 ½ × 40 ⅛ in)
Musée du Louvre, Paris

The figure of Thomas Aquinas, his lap filled with books, dominates this painting. He is holding an open volume of one of his best-known works, the *Summa contra Gentiles* (1259-65), which was written to aid Catholic missionaries in converting Muslims and Jews in Spain. Its left page displays the Latin text of Proverbs 8:7: 'My mouth will meditate on truth, and my lips will detest the impious man'. Also holding books are Aristotle and Plato, who appear subservient, flanking Thomas on either side. Lying trampled at his feet is a turbaned Ibn Rushd (Averroes), the medieval Arabic philosopher-polymath whose Islamic theology Aquinas vehemently opposed

yet which decisively shaped his own philosophical style. In the lower section of the painting we see the Pope sitting in council, declaring to his bishops and cardinals that Aquinas is the 'light of the Church'. The upper section shows the four Evangelists writing in their Gospel books; behind them is Moses with the tablets of the law and Saint Paul, who stands holding a closed book and sword. Above them, Christ is addressing Aquinas, saying: 'Thomas, you have written well about me'. Gozzoli (1421–97) has carefully structured this painting so that the saint is depicted as preeminent among philosophers and theologians.

Moderate Enlightenment
Imran Qureshi
2006, opaque watercolour and gold leaf on wasli paper
18.5 × 14.5 cm (7 ¼ × 5 ¾ in)
Private collection

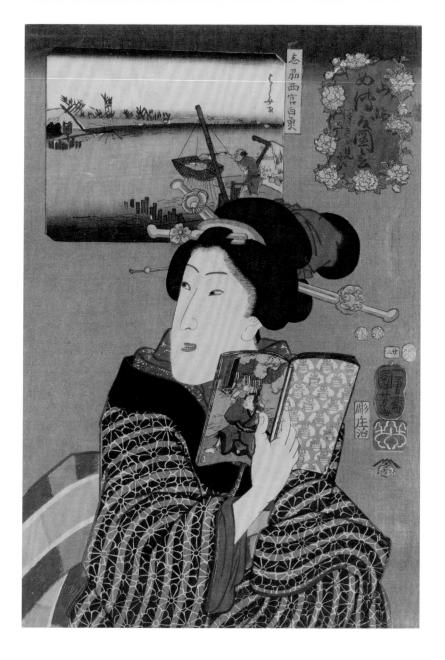

**Feeling Like Reading the Next Volume
from the series 'Landscapes and Beauties'**
Utagawa Kuniyoshi
before 1861 (Edo period), coloured print, dimensions unknown
Tokyo National Museum

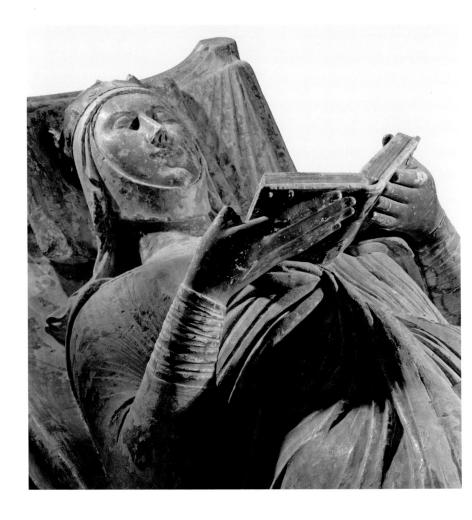

Tomb effigy of Eleanor of Aquitaine
Artist unknown
1204–10 (detail), polychromatic tuffeau limestone
overall: 69.4 × 235.3 × 75.1 cm (27 ⅜ × 92 ⅝ × 29 ½ in)
Fontevraud Abbey, Anjou, France

Instead of showing the deceased lying in state, this remarkable and unorthodox tomb effigy or *gisant* depicts Eleanor of Aquitaine as if she were alive, reading a book. As Queen Consort of both France (to Louis VII) and England (to Henry II), she was one of the most powerful women of twelfth-century Europe. The volume she is holding is most likely the Bible or a psalter (a book containing the Psalms), and while it was not uncommon for books to feature on effigies, to have one positioned so prominently was highly unusual. Indeed, two nearby *gisants* in Fontevraud Abbey, those of her son Richard the Lionheart and husband Henry II, feature no books at all. This suggests that literature was important to Eleanor. That she is shown actively reading is a sign of her great culture and learning at a time when female literacy and education was rare. It is believed that she was responsible for commissioning a number of books on the history of Britain. For modern writers Eleanor is an intriguing character and she has appeared in several works of fiction, most notably historical novels by Elizabeth Chadwick, Sharon Kay Penman and Jean Plaidy.

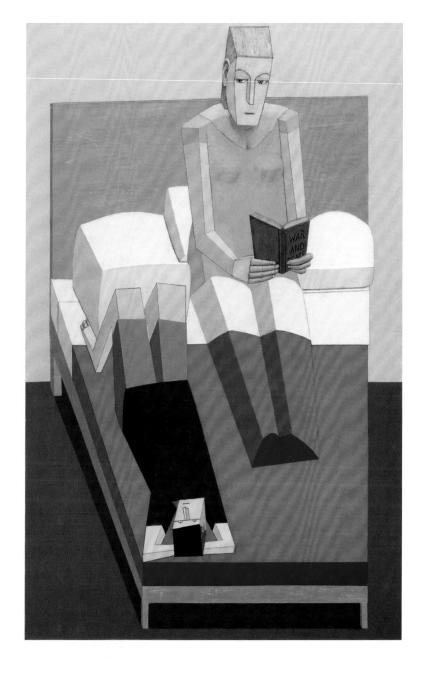

Reading in Bed
Mernet Larsen
2015, oil on canvas
152 × 97.2 cm (60 × 38 ¼ in)

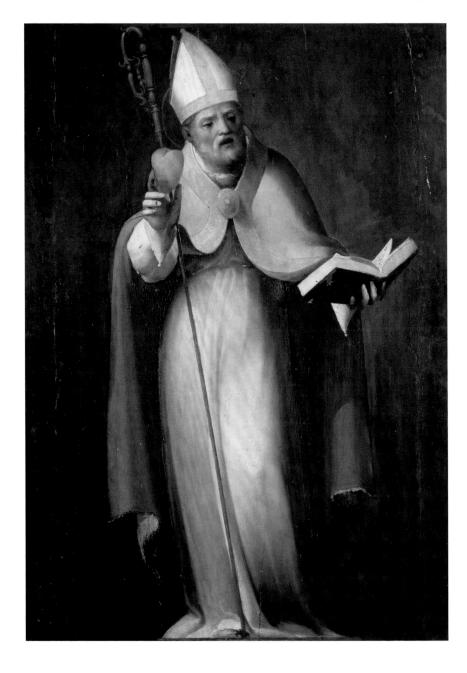

Saint Ignatius of Antioch
Domenico Beccafumi
before 1551, oil on wood, 101 × 73 cm (39 ¾ × 28 ¾ in)
Collezione Chigi-Saracini, Siena, Italy

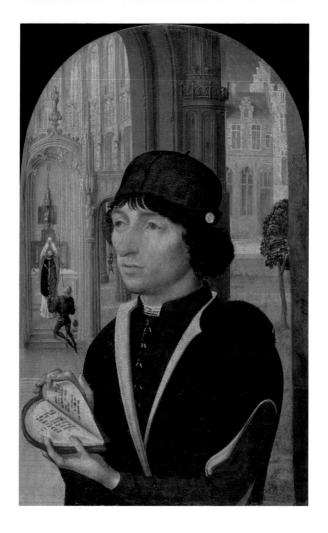

Young Man Holding a Book
Master of the View of Sainte Gudule
c.1480, oil on wood, 21 × 13 cm (8 ¼ × 5 ⅛ in)
The Metropolitan Museum of Art, New York

A contemplative young man holding a heart-shaped book stands at the door of a church. Behind him, a Mass is taking place, the apex of Catholic worship. The human heart has been understood as the traditional repository of human emotion since ancient times: Egyptian wisdom literature defines the heart as the seat of moral conscience, and the Bible equates it with a person's innermost being. As books became more common during the Middle Ages so too did the metaphor of the book of the heart, a place where the hidden or private self is recorded. Though the manuscript book in this painting is probably an artistic invention, heart-shaped codices containing poems and prayers did exist. In this painting the object may allude to the symbolism of the Mass in the background. The scene specifically shows the Elevation of the Host, a part of the ritual that echoes priest's call to worshippers to 'Lift up your Hearts!'. The artist has deliberately aligned the bread in the priest's hand with the man's book by placing them on the same vertical axis. This suggests a link between the Host as the body of Christ and the book of the heart, in which the man's deepest devotions to his Lord are written.

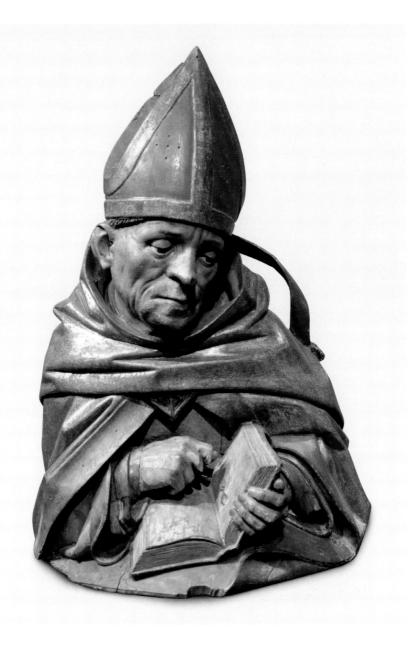

**Bust of a Church Father
(probably Saint Ambrose of Milan)
Hans Bilger**
1489–96, painted lime wood, height: c.60 cm (23 ⅝ in)
Liebieghaus, Frankfurt am Main, Germany

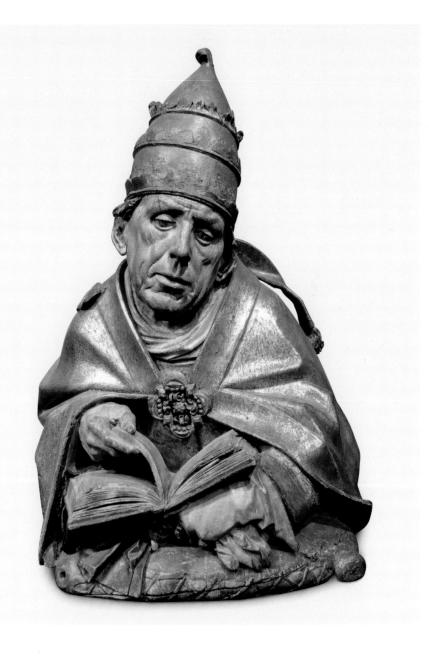

**Bust of a Church Father
(Saint Gregory the Great)**
Hans Bilger
1489–96, painted lime wood, height: c.60 cm (23 ⅝ in)
Liebieghaus, Frankfurt am Main, Germany

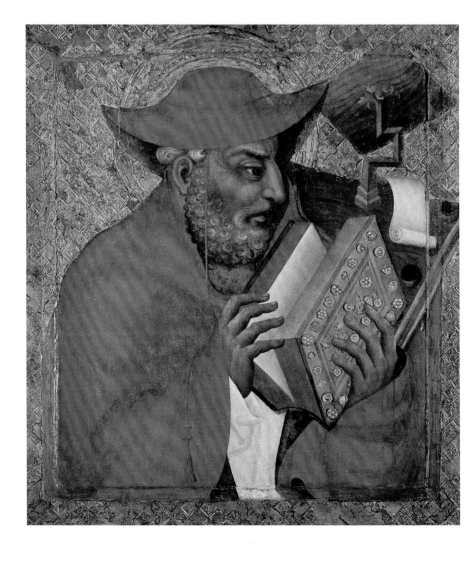

Saint Jerome
Master Theodoric
1360–65, tempera on wood, 113 × 105 cm (44 ½ × 41 ⅜ in)
Národní Galerie/Karlštejn Castle, Prague

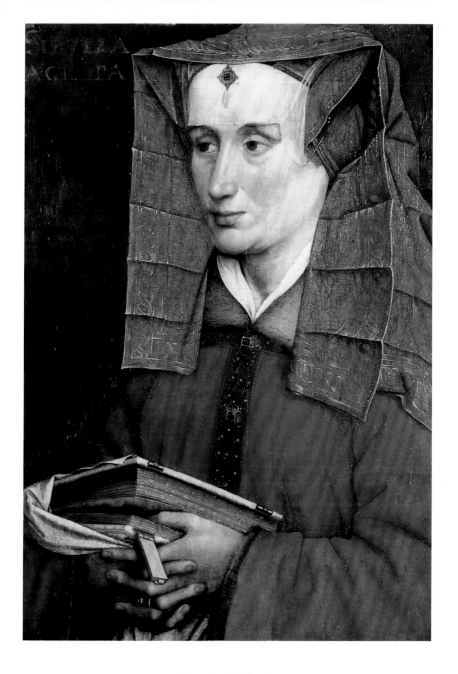

Portrait of a Lady
Jacques Daret
c.1430–40, oil on panel, 49.3 × 35.6 cm (19 ½ × 14 in)
Dumbarton Oaks, Washington DC

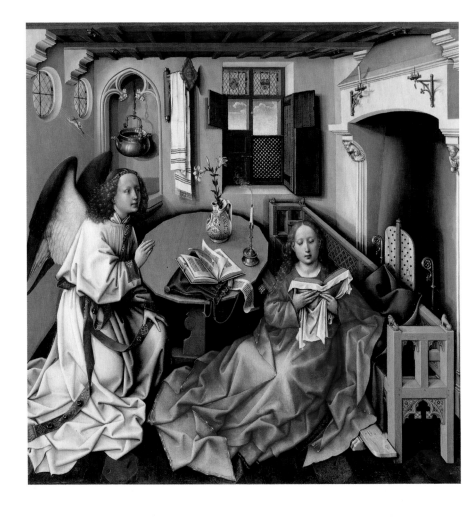

Central panel from the Annunciation Triptych
Mérode Altarpiece
Workshop of Robert Campin
c. 1427–32, oil on oak, 64.1 × 63.2 cm (25¼ × 24⅞ in)
The Cloisters/The Metropolitan Museum of Art, New York

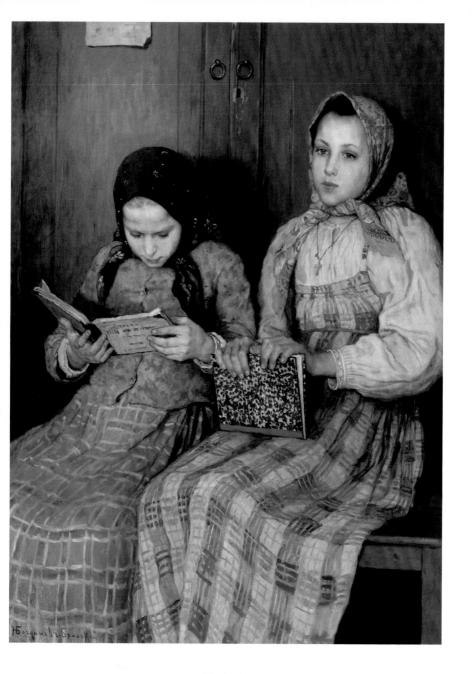

Students
Nikolai Bogdanov-Belsky
1901, oil on canvas, 167 × 138 cm (65 ¾ × 55 ⅜ in)
Saratov State Art Museum, Russia

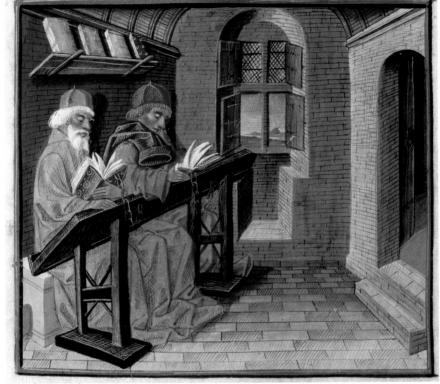

Two monks reading in a library
from 'Le Livre de Bonnes Moeurs' by Jacques Legrand
Master of Luçon
1400–10, illuminated manuscript, dimensions unknown
Bibliothèque nationale de France, Paris

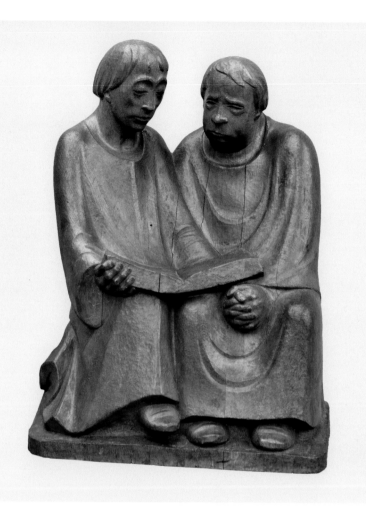

Reading Monks III
Ernst Barlach
1932, oak, 84 × 60 cm (33 × 23 ⅝ in)
Alte Nationalgalerie, Berlin

Two seated male figures are quietly contemplating an open book that rests on their knees. Apart from singing from shared songbooks, depictions of medieval monks reading together are unusual and reading is typically shown as an individual pursuit for personal study or devotion. But, despite its medieval appearance, this carved wooden sculpture actually dates from the twentieth century. Barlach (1870–1938), a committed pacifist, created it in interwar Germany against the backdrop of the Nazi Party's rise to power. His spiritually infused works often employ imagery and motifs that relate to the history of Christianity. While the book in this sculpture

might be the Bible, its identity has been left deliberately ambiguous. Here the image of shared reading speaks more broadly of community empowerment. The Nazis, who actively sought to reduce or control the influence of Christianity on German society, were opposed to the kind of spirituality expressed in Barlach's sculptures. Artworks such as this challenge the fascistic ideology that Hitler conveyed in his autobiographical book *Mein Kampf* (1925), a book that came to be as ubiquitous as the Bible in people's homes. About 400 of Barlach's works, including this one, were seized by the Nazis in 1937; criticized as 'un-German', they were labelled 'degenerate art'.

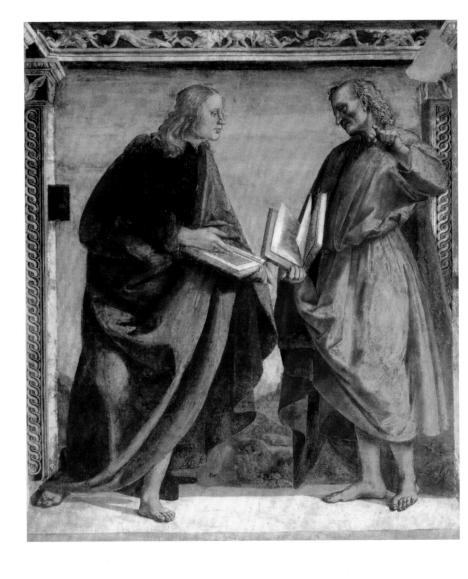

Pair of Apostles in Dispute
Luca Signorelli
c.1483, fresco, 238 × 200 cm (93 ¾ × 78 ¾ in)
Sacristy of Saint John
Basilica of Santa Casa, Loreto, Italy

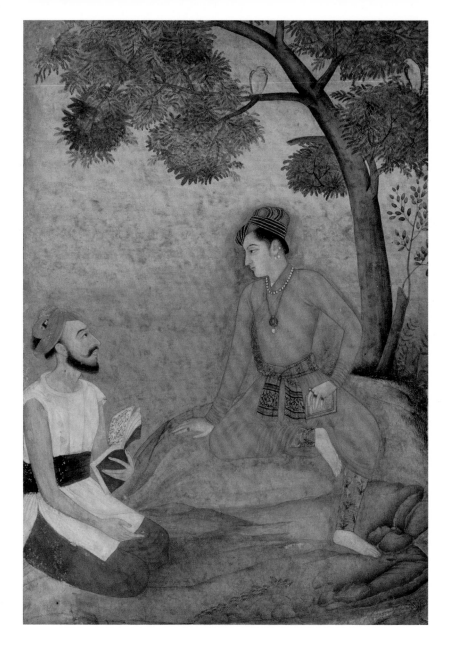

**A prince in discussion with a religious man holding a book
from 'Small Clive Album'**
Artist unknown (Mughal School)
18th century, opaque watercolour on paper, 19.6 × 12.5 cm (7 ¾ × 5 in)
Victoria & Albert Museum, London

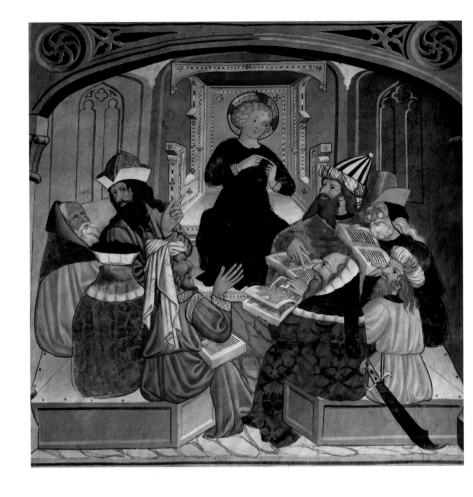

Jesus among the Doctors, from the 'Life of Christ'
Artist unknown
15th century, fresco, c.124 × 126 cm (48 ⅞ × 49 ⅝ in)
Chapelle Saint-Sébastien, Lanslevillard, Savoy, France

Seated in a large, throne-like chair, the twelve-year-old Jesus is engaged in a heated discussion with Jewish religious teachers – the Doctors. Amazed at the adolescent's erudition, the men search the scriptures to evaluate his teaching. One points to a page while an older figure peers closely at his book; another raises his hand in disputation, while others listen keenly. Christ himself does not hold a book, indicating that he knows the Scriptures by heart. The scene is based on an episode in the Gospel of Luke (2:41–52), in which Jesus accompanies Mary and Joseph on a pilgrimage to Jerusalem: when they return to Nazareth the boy stays behind, unbeknown to his parents. Three days later they find him in the Temple and are as astonished as the teachers. When confronted by Mary, Jesus replies: 'Why were you looking for me? Did you not know that I must be in my Father's house?' The event is frequently depicted in art and was commonly included in cycles of the Life of Christ, as in this example from a tiny rural chapel. The large books held by the teachers became a prominent feature of late medieval portrayals, reflecting the popularity of the codex format.

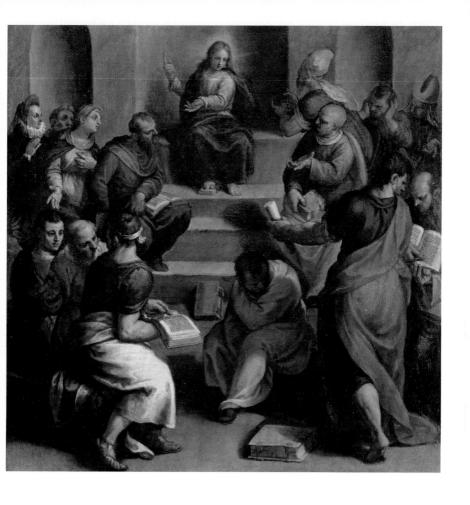

Christ among the Doctors
Palma Giovane
before 1628, oil on canvas
62 × 63 cm (24 ⅜ × 24 ⅞ in)
Musée Magnin, Dijon, France

'Gutenberg made
everyone a reader.'

Marshall McLuhan (1911–80)

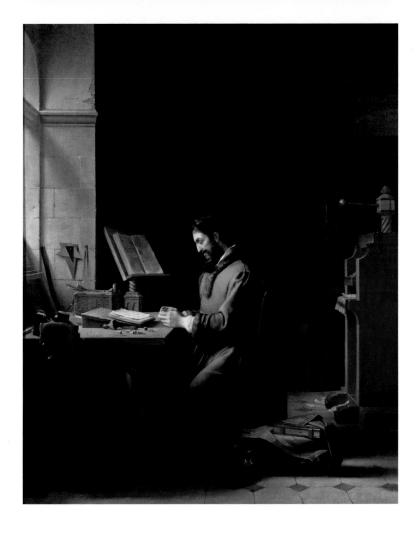

Gutenberg, Inventor of the Printing Press
Jean-Antoine Laurent
1831, oil on canvas, 98 × 79 cm (38 ⅝ × 31 ⅛ in)
Musée de Grenoble, France

In this painting Laurent (1763–1832) depicts Johannes Gutenberg sitting in his workshop, deep in contemplation. Books and bookbinding paraphernalia lie all around him. In his hands he holds the small blocks of moveable type with which he revolutionized the making of books in the West. Gutenberg's introduction of mechanical printing to Europe is considered to be the most important technological advance of the second millennium. His pioneering printing press provided the foundation for the modern era of mass communication and played a significant role in the developments of the Renaissance, the Protestant Reformation and the Enlightenment. Before the age of the printing press, professional scribes were employed to copy books by hand. After Gutenberg's invention, books became more accessible and affordable, allowing information and ideas to be disseminated far more rapidly. Political and religious powers began to lose their tight grip on society, while the increase in literacy brought education to the masses. Gutenberg's major work was his Latin Bible of 1455. Printed with two columns of forty-two lines a page, it was renowned for its technical quality and high aesthetic standards. Within a few years printing presses could be found in cities across Europe. Book production had changed forever.

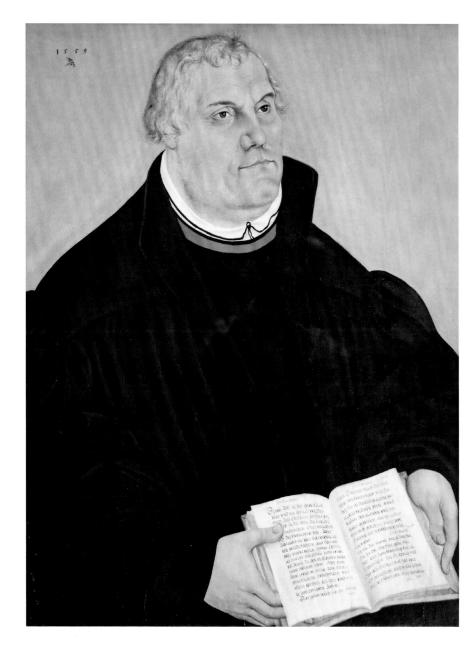

Portrait of Martin Luther
Lucas Cranach the Younger
1559, oil on panel, 46 × 32 cm (18 ⅛ × 12 ⅝ in)
Muzeum Narodowe, Kraków, Poland

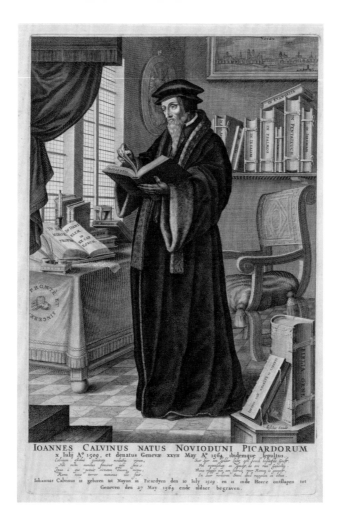

IOANNES CALVINUS NATUS NOVIODUNI PICARDORUM
x Iulÿ Aº 1509, et denatus Genevæ xxvii May Aº 1564, ibidemque sepultus.

Iohannes Calvinus is geboren tot Noyon in Picardyen den 10 Iuly 1509 en is inde Heere ontslapen tot
Geneven den 27 May 1564 ende aldaer begraven.

Portrait of John Calvin
François Stuerhelt
c.1602–52, engraving on paper, 32 × 20.9 cm (12 ⅝ × 8 ¼ in)
Rijksmuseum, Amsterdam

The French theologian John Calvin stands in his study surrounded by books. Alongside Martin Luther and Huldrych Zwingli, Calvin is considered to be the most significant figure of the Protestant Reformation. In this engraving Stuerhelt (active 1646–52) shows the reformer reading his *Institutes of the Christian Religion* (1536), among the most influential theological books ever published. It is a systematic defence of his faith that was instrumental in the development both of a school of Christian theology known as Calvinism, which teaches the absolute sovereignty of God in the salvation of believers, and of the Reformed confessional branch of Protestantism. Calvin was a prolific writer and

Stuerhelt includes a bookshelf laden with examples of his biblical commentaries. In the foreground is a copy of the Geneva Bible (1560), one of the most historically significant English translations of the Christian scriptures. Calvin played a major role in the development of this edition, which was the first mechanically printed, mass-produced Bible to be made directly available to the general public. It was the primary Bible of English Protestantism during the sixteenth century and was the scriptural source used by William Shakespeare, John Donne and John Bunyan, as well as the Pilgrim Fathers who sailed to America on the *Mayflower* in the seventeenth century.

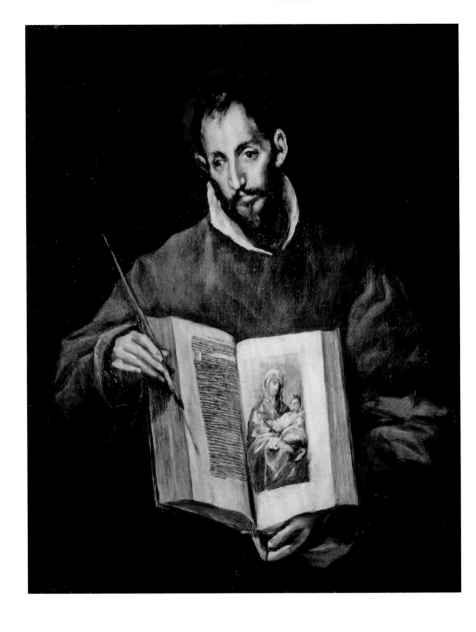

Saint Luke
El Greco
1605–10, oil on canvas, 98 × 72 cm (38 ⅝ × 28 ⅜ in)
Toledo Cathedral, Spain

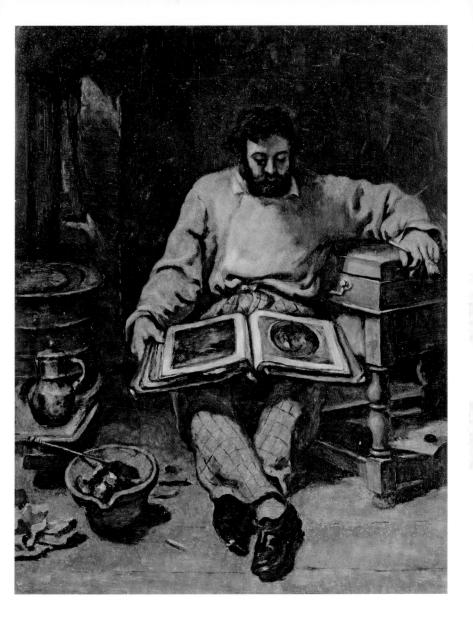

Marc Trapadoux Examining a Book of Prints
Gustave Courbet
1848, oil on canvas, 32 × 41 cm (12 ⅝ × 16 ⅛ in)
Musée d'art moderne, Troyes, France

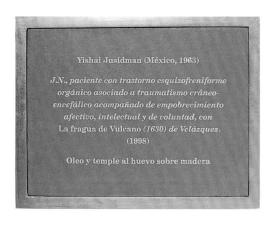

J.N., patient with organic schizophrenic disorder associated to cranial-encephalic trauma accompanied by hypoboulia and cognitiva-affective impoverishment, with 'The Forge of Vulcan' (1630) by Velázquez, from the series 'en/treat/ment'
Yishai Jusidman
1998, oil and egg tempera on wood, 91.5 × 51 cm (36 × 20 in)

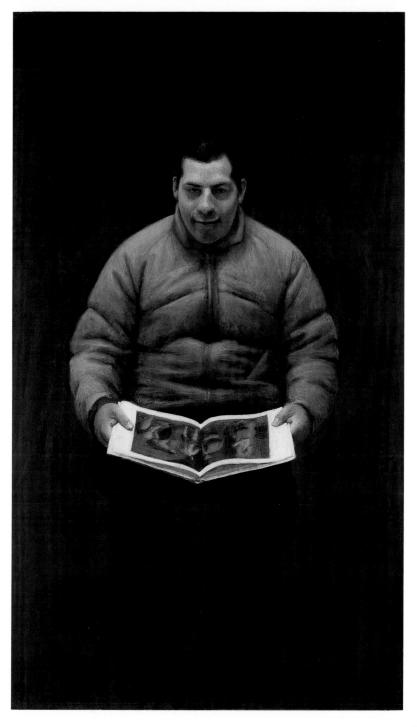

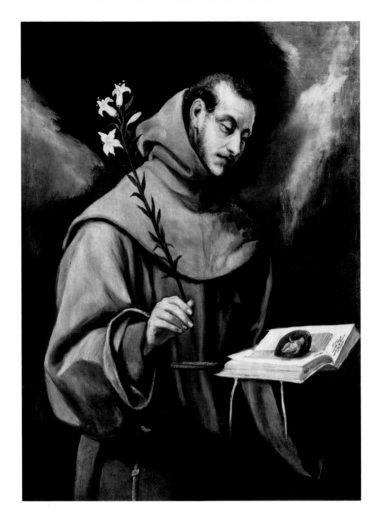

Saint Anthony of Padua
El Greco
c.1580, oil on canvas, 104 × 79 cm (40 ⅞ × 31 ⅛ in)
Museo Nacional del Prado, Madrid

A tiny baby lying on the pages of an open Bible has transfixed the gaze of Saint Anthony. According to legend, the saint's vision of the infant Christ occurred as he was preaching on the mystery of the Incarnation, the doctrine that God became human in the person of Jesus. His words were interrupted when suddenly the child miraculously appeared on the book in his hand. Saint Anthony was a Portuguese priest and friar of the Franciscan Order. He was known for his powerful preaching and theological expertise. His devotion to the poor and the sick ensured that he became one of the most quickly canonized saints in the history of the Catholic Church. In art he is often depicted with a book, which refers to his renowned scriptural knowledge, while the motif of white lilies represents his purity. Many paintings show him with the young Christ child, either held in his arm or standing on his book. Here, however, the Saviour is depicted as a foetus, ostensibly still inside the amniotic sac. It is believed that this was a later addition to the canvas and not originally painted by El Greco (1541–1614).

Glance of a Wounded Painting
Enzo Cucchi
1983, oil on canvas, 250 × 340.5 cm (98 ⅜ × 134 in)
Musée national d'art moderne, Centre Georges Pompidou, Paris

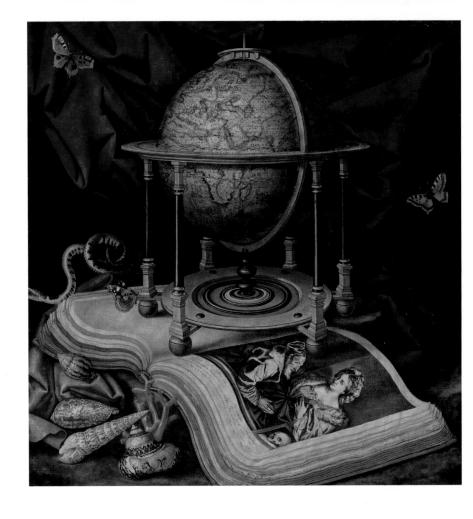

**Vanitas Still Life with a Terrestrial Globe,
a Book, Shells, a Snake and Butterflies**
Carstian Luyckx
c.1645–58, oil on canvas, 98.8 × 96 cm (38 ⅞ × 37 ¾ in)
Private collection

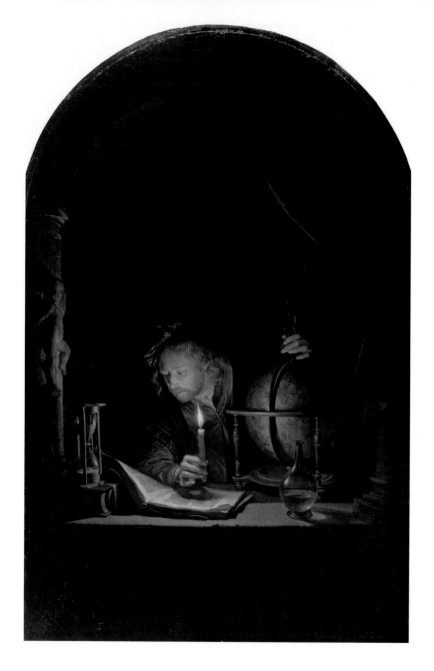

Astronomer by Candlelight
Gerard Dou
1655–59, oil on panel, 32 × 21.2 cm (12 ⅝ × 8 ⅜ in)
J. Paul Getty Museum, Los Angeles

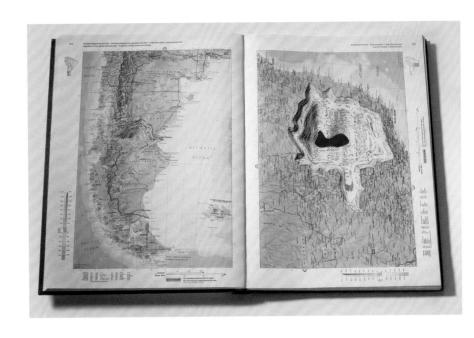

Atlas Landscape Rand McNally
The New International Atlas
Maya Lin
2006, recycled atlas (published 1981)
open: 38.1 × 59.1 × 2.9 cm (15 × 23¼ × 1⅛ in)
closed: 38.1 × 28.9 × 4.4 cm (15 × 11⅜ × 1¾ in)

An old atlas lies open at pages showing Argentina, Chile and Brazil. But the territories of these South American countries have been carved into, forming large, cratered voids. The sunken areas extend down through the atlas, revealing the pages underneath like layers of sedimentary rock. This altered book belongs to a series of similar works in which Lin (b.1959), using a craft knife, removes significant areas of geographical detail to create strange new topographies of her own design. Atlases are generally thought to be authoritative representations of the world in which we live. Using cartographic methods they take complex spatial information and present it in a clear and legible form. Lin, however, maintains that maps are not neutral but inherently political, and that the way in which they present the world inevitably influences one's perception of it. In an age of rampant globalization, borders and boundaries are becoming more malleable than ever. Her interventions deliberately challenge received ideas about territory and geographical separation, proposing a more fluid notion of place. But whether or not this is a positive development is left for viewers to decide.

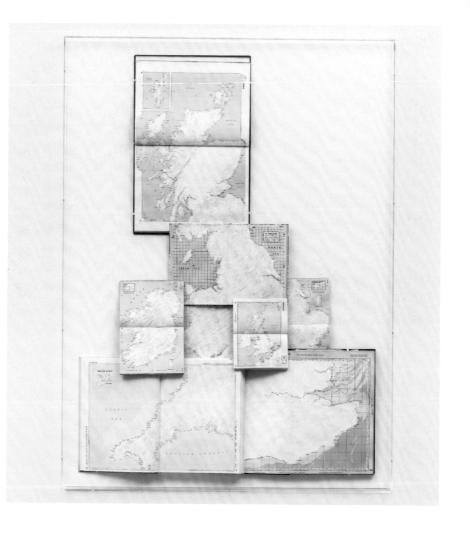

Only Blue (British Isles)
Tania Kovats
2014, eight altered atlases, acrylic box
150 × 110 × 10 cm (59 ⅛ × 43 ⅜ × 3 ⅞ in)

Like Maya Lin, Kovats (b.1966) also uses atlases in her work, but in a very different way. Instead of cutting, she defaces these now rather obsolete books with white paint, obliterating the landmasses and leaving just the blue of their surroundings. In this work, eight altered atlases have been stuck together to show the entirety of the British Isles: Great Britain, Ireland and several thousand smaller islands. In each open book a snow-like blanket hides the topography, along with the names of all cities, towns and other terrestrial features. The artist's erasure of the land draws attention to the bodies of water surrounding it, proposing a different way of looking and thinking about this part of Europe. As a maritime nation, Britain and Ireland have been significantly shaped by their relationship to the sea, but whereas these countries bear the traces of millenia of human activity, the waters around them show little obvious change. Yet the seas have physically and culturally shaped the British Isles through all time and will continue to do so far into the future. It is also a stark reminder that, like so many of the factual books in our world, any atlas may sooner or later be superseded by other technologies as well as by the changing realities of the places they represent.

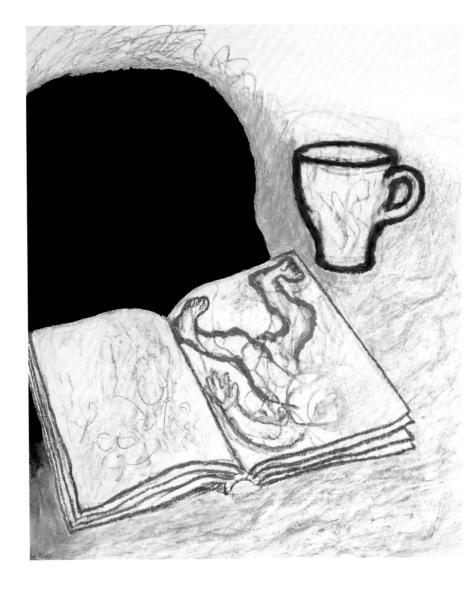

Open Book and Empty Cup
Ken Kiff
1999, oil pastel and acrylic on paper
84 × 72 cm (33 × 28 ⅜ in)
Private collection

Cup of Tea
André Derain
1935, oil on canvas
92 × 74 cm (36 ¼ × 29 ⅛ in)
Musée national d'art moderne, Centre Georges Pompidou, Paris

Many Books
Josephine Halvorson
2009, oil on linen
31.1 × 48.3 cm (15 × 19 in)
Private collection

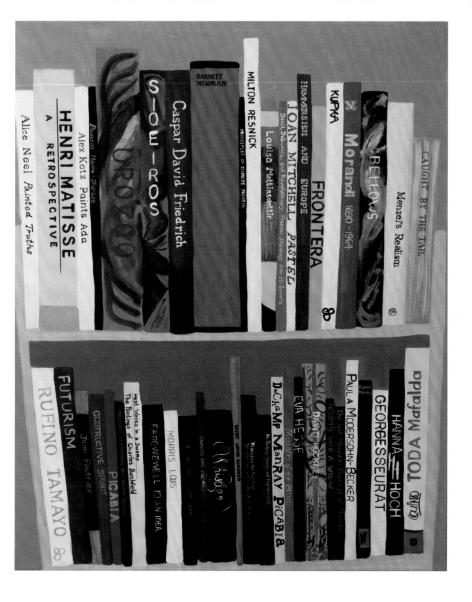

Reading List
Aliza Nisenbaum
2013, oil on linen
76.2 × 61 cm (30 × 24 in)
Private collection

Osbert *of* Aldgate — And the Troubadour — Elizabeth M. Stewart — PETTER DUFF & Co.

TOWER HILL. *An Historical Romance* — WILLIAM HARRISON AINSWORTH — BERNHARD TAUCHNITZ

THE NECESSARY MONUMENT — *ITS FUTURE IN THE CIVILIZED CITY* — THEO CROSBY — NYGS

CHRONICLES OF CANNON STREET *A FEW RECORDS OF AN OLD FIRM* — JOSEPH TRAVERS & SONS

THE MANSION HOUSE — *Or No Preaching in the Open Air Throughout the City of London* — GEORGE CHARLES SMITH — WAKEFIELD

BLACKFRIARS THE MONKS OF OLD — *A ROMANTIC CHRONICLE* — Volume — WALTER STEPHENS

THE TEMPLE — SACRED POEMS AND PRIVATE EJACULATIONS — HERBERT & HARVEY — PICKERING

EMBANKMENT DESIGN AND CONSTRUCTION IN COLD REGIONS • L. G. JOHNSON — TECHNICAL COUNCIL ON COLD REGIONS ENGINEERING

WESTMINSTER: Palace and Parliament — Patrick Cormack — F. WARNE

ST. JAMES'S PARK — A COMEDY BY "P.Q." — *John Cooper*

VICTORIA — The Biography of a Pigeon — ALICE RENTON — RANDOM HOUSE

THE SLOANE SQUARE SCANDAL — ANNIE THOMAS — GENERAL BOOKS

Madame M. Conway

Londinensi subterraneis: Circulus linea
Phil Shaw
2012, archival print
34 × 97 cm (13 ⅜ × 31 ⅛ in)

What do *Paddington Meets the Queen* by Michael Bond, *The Baker Street Dozen* by Sir Arthur Conan Doyle and *The King's Cross* by Angus Dun have in common? In the hands of Shaw (b.1950), they are reimagined as destinations on the London Underground. At first glance, this intriguing print appears simply to be a row of shelved books. A closer look reveals the name of a Tube station somewhere in each title. All of the stops from Aldgate to Liverpool Street via Victoria are represented, the yellow covers alluding to the colour of the subterranean Circle Line as it appears on the schematic Underground map. Shaw is known as a digital manipulator and so it is natural to question the veracity of his books.

However, whereas others of his works involve invented titles, all of these are genuine, appearing in the British Library catalogue. Whether or not they have all been published with mustard-coloured jackets is less certain. Shaw has produced an extensive series of these bookshelf prints, with several inspired by the London Underground and others that relate to the New York Subway. In 2013 he was commissioned to make a bespoke print for the 39th G8 Summit, for which he created a row of books that represented a quote by the eighteenth-century economist and moral philosopher Adam Smith: 'What can be added to the happiness of a man who is in health, out of debt and has a clear conscience?'

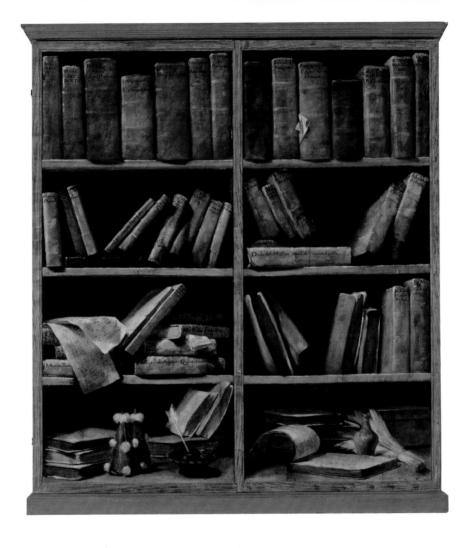

Bookshelves of Musical Books
Giuseppe Maria Crespi
1720–30, oil on canvas
two panels, each 165.5 × 78 cm (65 ¼ × 30 ¾ in)
Museo internazionale e biblioteca della musica, Bologna, Italy

No. 7 Art Books, Verona
from the series 'Hiding in Italy'
Liu Bolin
2012, colour photograph
112.5 × 150 cm (44 ⅓ × 59 in)

Voyager
Sean Landers
2012, oil on linen
182.9 × 269.2 cm (72 × 106 in)
Private collection

A Vanitas Still Life with Skull and Hourglass
Adriaen Coorte
1686, oil on canvas
50.1 × 41.4 cm (19 ¾ × 16 ¼ in)
Private collection

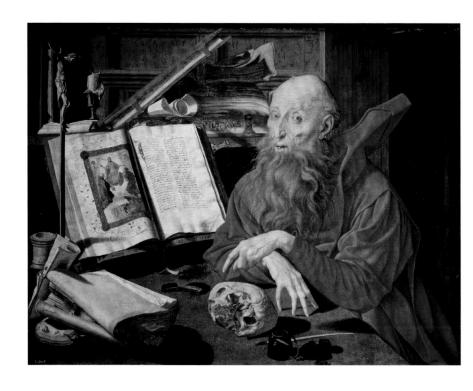

Saint Jerome
Marinus van Reymerswaele
1541, oil on panel, 80 × 108 cm (31 ½ × 42 ½ in)
Museo Nacional del Prado, Madrid

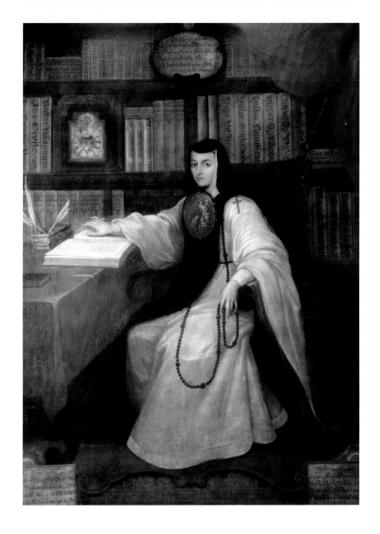

Portrait of Sor Juana Inés de la Cruz
Miguel Cabrera
c.1750, oil on canvas, dimensions unknown
Museo Nacional de Historia, Chapultepec Castle, Mexico City

In this posthumous portrait, the revered Mexican nun and polymath Sor Juana Inés de la Cruz sits at a desk in her library. Looking directly at the viewer with an assertive gaze, she holds a rosary in one hand while the other turns the pages of an open book. Among the volumes that Cabrera (1695-1768) has included in this scene are treatises on philosophy, theology, natural science and history, which, along with the desk, quills and inkwell, convey Sor Juana's status as a formidable scholar. In 1667 she became a nun in order to pursue her literary interests. During her time in the Hieronymite order (named after Saint Jerome), she wrote poetry, plays, and social manifestos. She also corresponded with other intellectuals in Mexico and abroad. After receiving criticism as a female writer, she became embroiled in an ecclesiastical dispute. She responded with her most famous work, *The Answer* (1691), in which she defended her rights as a woman to pursue a life of study, thought and creativity. Unmoved, the Catholic Church forced her to abandon her scholarship, her musical and scientific instruments and her collection of over four thousand volumes. She renounced it all in a letter signed in her own blood and spent the final year of her life caring for the infirm.

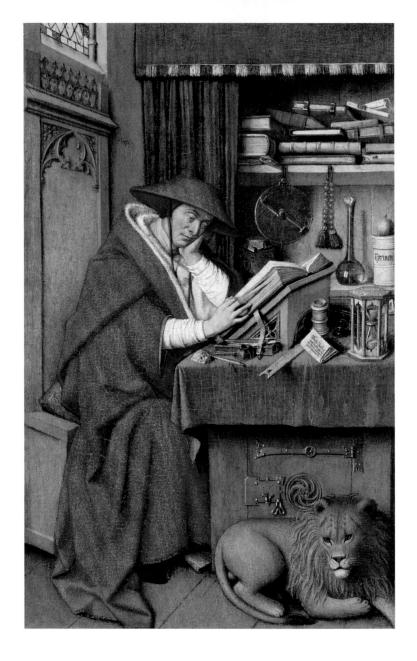

Saint Jerome in His Study
Jan van Eyck
c.1435, oil on linen on oak panel
20.6 × 13.3 cm (8 ⅛ × 5 ¼ in)
Detroit Institute of Arts, Michigan

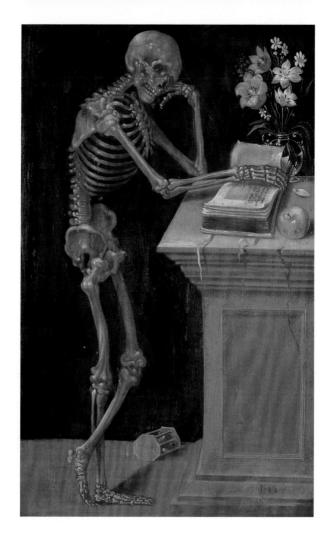

Vanitas
Hans Holbein the Younger
1543, oil on panel, dimensions unknown, private collection

A weary-looking skeleton rests on a tomb-like plinth while contemplating an open book. Adjacent to the bony figure is a vase of flowers, a plump apple and, on the floor, an overturned hourglass. This painting is an early example of the *vanitas* genre, in which each element reminds the viewer of their mortality and, more explicitly, the meaninglessness, or vanity, of worldly goods and pleasures. The book became a common symbol of this in seventeenth-century still lifes, but when Holbein (1497–1543) conceived this work it was less common. The composition is based on an image published in Andreas Vesalius's famous anatomy series, *De humani corporis fabrica* (1543), which shows a skeleton in an identical pose except that his hand rests upon a skull. By exchanging the skull for a book, Holbein expands Vesalius's design: the skeleton contemplating death now considers the transience of knowledge and human learning. While the book's identity is unknown, Holbein's painting evokes the words of the author of Ecclesiastes, the book of the Bible from which the *vanitas* genre derives its name: 'vanity of vanities; all is vanity ... of making many books there is no end; and much study is a weariness of the flesh'.

'Books are the quietest
and most constant
of friends; they are
the most accessible and
wisest of counsellors,
and the most
patient of teachers.'

Charles William Eliot (1834–1926)

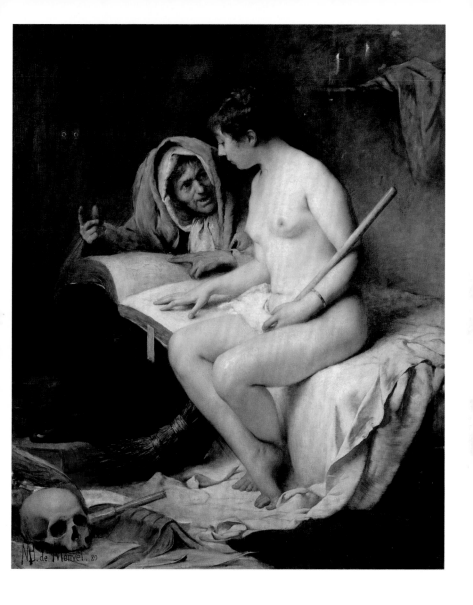

The Lesson Before the Sabbath
Maurice Boutet de Monvel
c.1880, oil on canvas
165 × 132 cm (65 × 52 in)
Chateau-Musée, Nemours, France

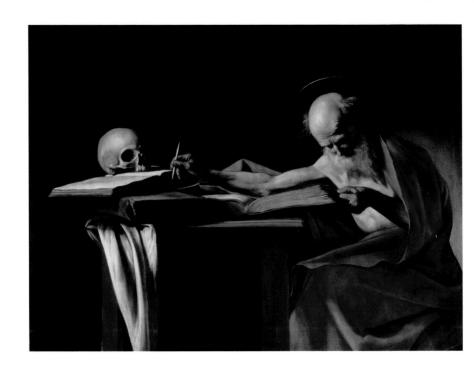

Saint Jerome
Caravaggio
1606, oil on canvas
116 × 153 cm (45 ⅝ × 60 ¼ in)
Galleria Borghese, Rome

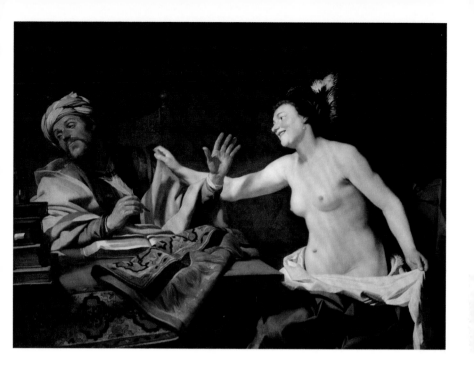

The Steadfast Philosopher
Gerrit van Honthorst

1623, oil on canvas, 151.5 × 207.5 cm (59 ⅝ × 81 ⅝ in)
Hohenbuchau Collection, Germany, on long-term
loan to the Princely Collections of Liechtenstein

An academic working at a book-strewn desk resists the advances of a semi-naked woman. Having let her dress slip down, the smiling seductress grabs hold of his shoulder, encouraging him to join her. The scholar, who raises his hand in refusal, turns his gaze away from her body, fixing his eyes on the stack of tomes; his dedication to learning demands that he resist her temptation. The exaggerated gestures of the figures lend this painting an air of humour and theatricality. But the meaning is not at all clear. What, for instance, is the relationship of the woman to the man? Is this his wife or a temptress? And if the latter, how did she find her way into his personal study? Van Honthorst (1592–1656) provides no answers to these questions, presenting the viewer with a visual conundrum. One interpretation could be that the scene is an exhortation to edify oneself by choosing the pursuits of the mind over the lusts of the flesh. Conversely, it could be seen as poking fun at the scholar, gently mocking his rigid attitude to academic study. Whatever the meaning, it seems that books have, for the moment at least, won his affections.

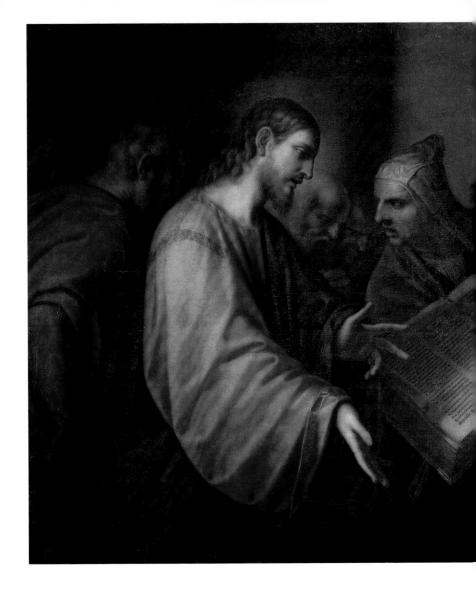

The Adulteress before Christ
Padovanino
1620, oil on canvas, 138 × 234 cm (54 ⅜ × 92 ⅛ in)
Kunsthistorisches Museum, Vienna

A young woman with a downcast face stands before Jesus while he debates the contents of a large book with a teacher who is seeking to discredit him. Bringing to him a woman caught in adultery, the religious leaders point out that the Law of Moses demands the penalty of being stoned to death, thus testing Jesus' reputation as a 'friend of sinners' and whether he will advocate breaking the Law by sparing her life. His response is to challenge the leaders over their own guilt, saying: 'He that is without sin among you, let him first cast a stone at her' (John 8:7).

The men skulk away and Jesus, showing compassion, forgives the woman. The painting depicts the irony of debating God's words with the one presented in John's theology as the very Word incarnate, and this is underscored by the enormous size of the Bible that Padovanino (1588–1649) depicts here. Such a book is deliberately anachronistic, not being in use until many centuries after Jesus' ministry; the message of the story is thus made contemporary, with viewers encouraged to search their own hearts before condemning the actions of others.

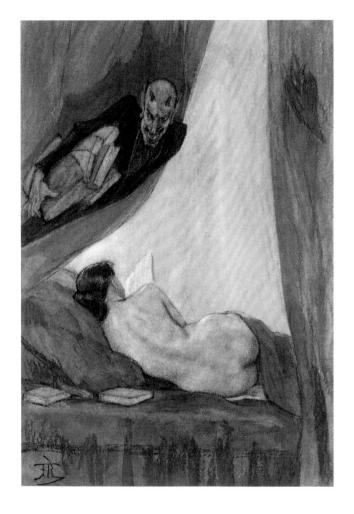

The Librarian, from the series 'A Hundred Light, Unpretentious Sketches to Amuse Respectable People'
Félicien Rops
1878, watercolour, 22 × 14.5 cm (8 ⅝ × 5 ¾ in)
Private collection

A nude woman with her back to the viewer is curled up in bed, absorbed in a salacious novel. Hovering above her head, partially concealed by a curtain, is a demonic librarian delivering an assortment of questionable books. In this watercolour, Rops (1833–98) plays on the idea popular in the eighteenth and nineteenth centuries that fiction could be morally dangerous to women. The desire to read for pleasure rather than for edification was frowned upon and there was a 'moral panic' that doing so could corrupt female readers in particular. These fears were heightened with the expansion of book production in the 1860s as the introduction of wood pulp increased accessibility to cheap, mass-produced novels. Rops was known for his political and social satires. This illustration belongs to a series of 114 drawings aimed at 'respectable people' that was commissioned by the Parisian bibliophile and collector Jules Noilly. That the woman is secretly reading erotic literature would have been clear to Rops's 'respectable' viewers. But the illustration is not a caution; rather, it is intended to expose the hypocrisy of those who pour scorn on such behaviour while indulging themselves in the same furtive activity.

The Devil Shows Saint Augustine the Book of Vices
from the Church Fathers Altarpiece
Michael Pacher
c.1480, oil on pine, 103 × 91 cm (40 ½ × 35 ⅞ in)
Alte Pinakothek, Munich

A grotesque creature with green skin, cloven hooves and leathery, webbed wings holds open a large, leather-bound book. The horned beast is none other than the Devil himself, confronting Saint Augustine, who is depicted in bishop's vestments, with a sumptuous red cope, mitre and crosier. Pacher (c.1435–98) painted this panel for the altarpiece of the Augustinian Abbey of Neustift in Brixen (now in Italy and also known as Novacella in Bressanone). It illustrates an apocryphal tale in which the saint, having spotted the Devil passing by with a book on his shoulder, asks to know its contents. Upon learning that it contained a record of people's sins, Augustine demanded to know what was written regarding his own transgressions, and was shown a page that recorded only his failure to recite Compline, the final prayer of the monastic day. Immediately, the saint visited the nearest church and, after completing his prayers, returned to the Evil One and demanded to see the page again. Upon turning to it, the Devil found it to be blank and realising he had been tricked, vanished in a fit of rage. Pacher's painting reminded the faithful that, through the redemptive work of Christ, their sins could also be blotted out and no longer held against them.

Extracting the Stone of Madness
Hieronymus Bosch
1501–05, oil on oak panel, 48.5 × 34.5 cm (19 ⅛ × 13 ⅝ in)
Museo Nacional del Prado, Madrid

A nun with a book balanced on her head watches impassively as open-air surgery is performed on an elderly peasant. Wielding a scalpel and wearing a strange, upturned funnel, the purported surgeon attempts to remove the cause of the patient's madness, which, curiously, appears to be a tulip rather than the titular stone. The fabled operation was a well-known theme in the sixteenth century, being understood to leave the sufferer even worse off. An inscription on the painting's decorative surround reads: 'Master, cut away the stone; my name is Lubbert Das'. In Dutch literature the name Lubbert was often given to characters displaying stupidity. The Dutch word for tulip ('tulp') also carries connotations of folly, and so it is likely that Bosch (c.1450–1516) intended this mysterious painting as a wry comment on human foolishness. The woman can therefore be seen as a 'book fool', a figure of ridicule who despite valuing books is ignorant of their contents. The inclusion of this character refers to the contemporary trend of collecting books primarily as physical objects. Bosch suggests that she has as much chance of imbibing wisdom from the volume on her head as the peasant has of being healed by the quack.

Crown
Wen Wu
2016, oil on canvas
30.5 × 25.5 cm (12 × 10 in)
Private collection

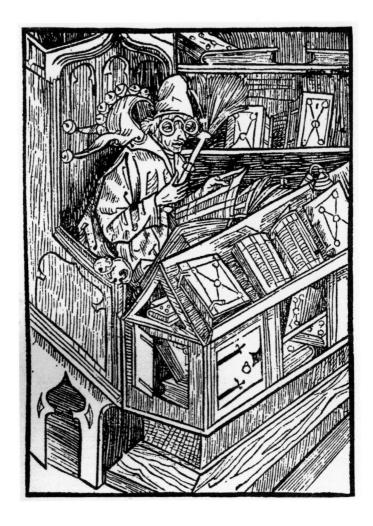

The Book Fool
from 'The Ship of Fools' by Sebastian Brant
Albrecht Dürer (attributed)
1494, woodcut, c.11 × 8 cm (4 ⅜ × 3 ⅛ in)

A man dressed in a jester's outfit and nightcap is seated at a lectern surrounded by weighty tomes. Though he wears thick reading glasses he is more concerned with shooing away flies with a feather duster than in reading what is before him. This woodcut, attributed to a young Dürer (1471–1528), depicts *Der Büchernarr* ('The Book Fool'), who despite collecting many volumes never actually reads any of them. The print was published in Sebastian Brant's 1494 satire *Das Narrenschiff* ('The Ship of Fools'), one of the most important works of fifteenth-century German literature. The book introduces readers to 109 fools, each with different shortcomings, who embark on a sea voyage. Brant intended the satirical tale to cultivate wisdom and reason in his readers. Proving incredibly popular, the book appeared in many editions and was translated into several languages. The image of the ridiculous scholar, the first fool to board the ship, became well known all over Europe. That book collecting had become the subject of satire so soon after Gutenberg's invention of the printing press reflects the remarkable growth of the market and the extent to which book culture had permeated the Continent in Brant's day.

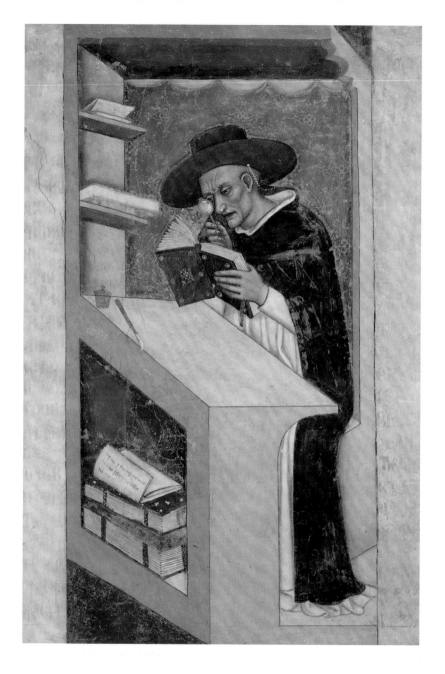

Cardinal Nicolas de Fréauville, from the series 'Forty Dominicans'
Tommaso da Modena
1352, fresco, c.100 × 65 cm (33 ⅜ × 25 ½ in)
Monastery of San Nicolò, Treviso, Italy

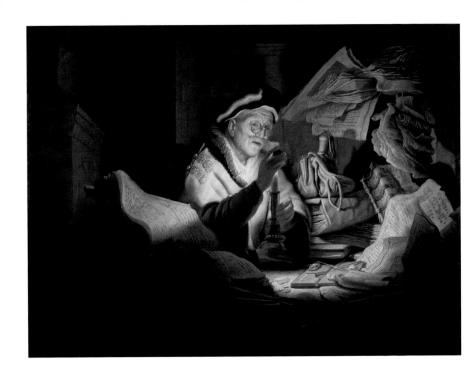

The Money Changer
(Parable of the Rich Man)
Rembrandt van Rijn
1627, oil on panel, 31.9 × 42.5 cm (12 ½ × 16 ¾ in)
Gemäldegalerie, Staatliche Museen zu Berlin

A richly dressed old man is sitting amid piles of books and papers, examining a gold coin by candlelight. The volumes around him are ledger bindings containing accounts and records. Such items appear in paintings of money changers and tax collectors from the sixteenth century. Unlike rigid hardback books, these leather- or parchment-covered tomes have very little structure and are prone to deformation. Similar objects can be seen in Jan Lievens' *Still Life with Books* (p.220). The poor state of the bindings here and the chaotic nature of the room, suggest that there is only one thing this man truly cares about: money. Rembrandt (1606–69) makes this clear by illuminating the coins on the desk while the rest of the room fades into darkness. This is a neat contrast to other works by Rembrandt, such as his nativity paintings, where illumination is used to indicate the divine presence of the infant Christ. This painting is thought to illustrate Jesus' parable of the rich fool. Found in Luke's Gospel (chapter twelve), it warns against the folly of hoarding wealth and material possessions, none of which can be retained after death. It is suggested that artists depicted ledger bindings as a symbol of moral degeneracy. The flaccid books in this painting thus mirror the man's soul, which serves money rather than God.

The Money Changer and His Wife
Quentin Metsys
1514, oil on panel
70.5 × 67 cm (27 ¾ × 26 ⅜ in)
Musée du Louvre, Paris

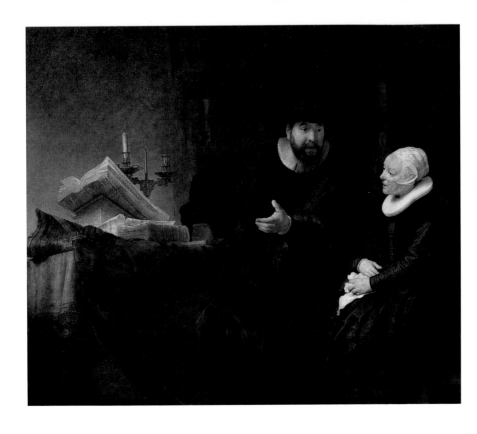

**Double Portrait of the Mennonite
Preacher Cornelis Claesz Anslo and
His Wife Aeltje Gerritsdr. Schouten**
Rembrandt van Rijn
1641, oil on canvas, 176 × 210 cm (69 ¼ × 82 ⅝ in)
Gemäldegalerie, Staatliche Museen zu Berlin

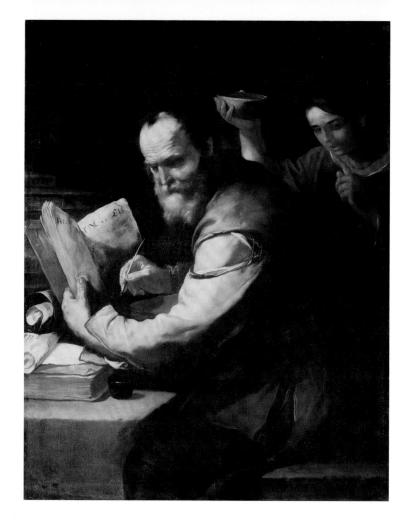

Xanthippe Pours Water into Socrates' Collar
Luca Giordano
1660s, oil on canvas, 132 × 105 cm (52 × 41 ⅜ in)
Collezione Molinari Pradelli, Marano di Castenaso, Italy

Deep in his studies, Socrates is writing at a desk filled with books. He does not notice Xanthippe, his wife, creeping up behind him with a bowl of water. With her finger to her lips she prepares to tip the liquid into the philosopher's collar, perhaps as an act of revenge. Xanthippe's reputation as a scolding wife derives from a section of Xenophon's *Symposium*, a Socratic dialogue dating from the late 360s BC, where she is described as a difficult companion. At a dinner party, Socrates, who prides himself on his knowledge and learning, is asked why he has not educated his wife. He replies by saying that he approaches her like an expert horseman: if he can learn to tame the fieriest of horses he can easily manage any other. Artists and writers have long exploited the squabbling couple's marital dynamic. This scene by Giordano (1634–1705) likely has its source in Jerome's treatise against Jovinianus, where it is claimed that Xanthippe emptied a chamber pot over her husband's head. In this account Socrates responds by saying that he knew her thundering would eventually be followed by rain. The painting is perhaps a caution against boasting of one's intellectual abilities.

The Forbidden Reading
Karel Ooms
1876, oil on canvas, 136 × 108 cm (53½ × 42½ in)
Musées royaux des Beaux-Arts de Belgique, Brussels

A man and a young woman look up in alarm, focusing their gaze towards something outside of the picture. Disturbed perhaps by a knock at their door, the father turns in his chair while his daughter rushes to close the book they have been studying. The painting is set in the sixteenth or seventeeth century, at a time when Protestants in the Low Countries were being persecuted for reading the Bible in the vernacular, a practice prohibited by the Roman Catholic Church as it sought to guard its authority over matters of doctrine. By studying the Scriptures secretly, this couple were breaking the law and, if caught, faced execution for their crime. The Belgian portraitist Ooms (1845–1900) produced this painting at a time when Protestants were still very much a minority, with parallels drawn between the contemporary situation and that of the persecutions of the Counter-Reformation. Ooms's painting proved to be a great encouragement, and many copies were made by other artists for display in Reformed churches. The image was also circulated widely through prints and displayed in many homes throughout the country.

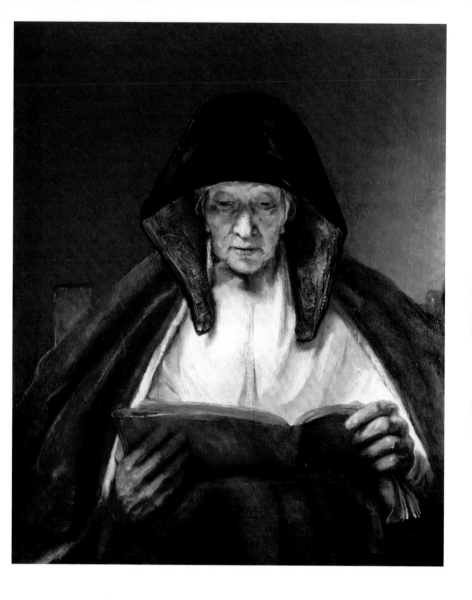

An Old Woman Reading
Rembrandt van Rijn
1655, oil on canvas
83 × 69.5 cm (32 ⅝ × 27 ⅜ in)
Buccleuch Collection, Drumlanrig Castle, Scotland

'Read the best books
first, or you may
not have a chance
to read them at all.'

Henry David Thoreau (1817–62)

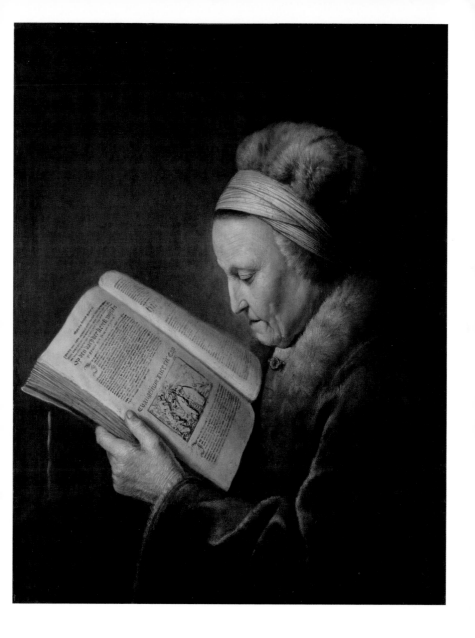

Old Woman Reading
Gerard Dou
c.1631–2, oil on panel
71.2 × 55.2 cm (28 × 21 ¾ in)
Rijksmuseum, Amsterdam

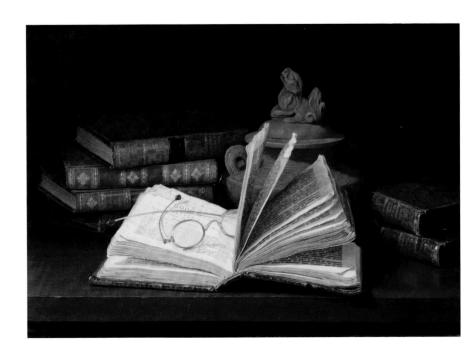

Some Interesting Volumes
Claude (Claudine) Raguet Hirst
1877, oil on canvas
25.5 × 36 cm (10 × 14 ⅓ in)
Private collection

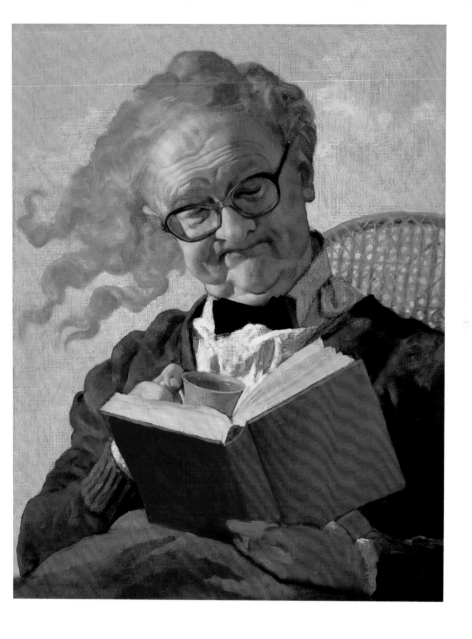

2070
John Currin
2005, oil on linen
91.4 × 71.1 cm (36 × 28 in)
Private collection

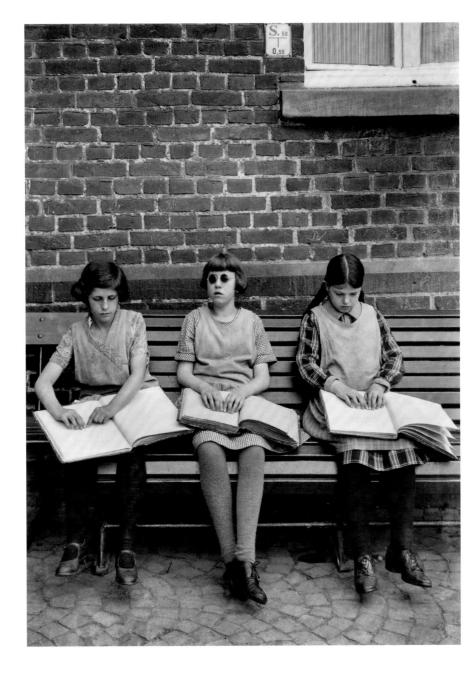

Blind Children
August Sander
1921–30, gelatin silver print on paper

'The dearest ones of time, the strongest friends of the soul - BOOKS.'

Emily Dickinson (1830–86)

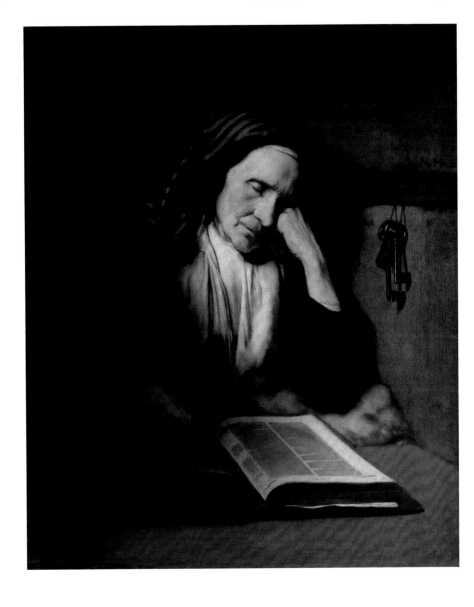

An Old Woman Dozing over a Book
Nicolaes Maes
c.1655, oil on canvas, 82.2 × 67 cm (32 ⅜ × 26 ⅜ in)
National Gallery of Art, Washington DC

The Uninteresting Lesson
Phillippe Jolyet
1905, oil on canvas, 67 × 56 cm (26 ⅜ × 22 in)
Musée des Ursulines, Mâcon, France

The Little Idler
Jean-Baptiste Greuze
1755, oil on canvas, 65 × 54.5 cm (25 ⅝ × 21 ½ in)
Musée Fabre de Montpellier, France

World of Dreams
Laura Theresa Alma-Tadema
1876, oil on canvas, 46 × 31 cm (18 ⅛ × 12 ¼ in)
Private collection

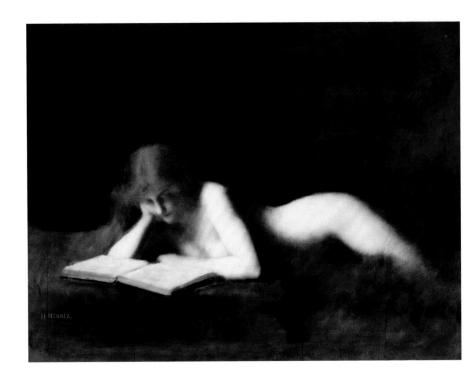

The Reader
Jean-Jacques Henner
1880–90, oil on canvas
94 × 123 cm (37 × 48 ⅜ in)
Musée d'Orsay, Paris

The Sleeping Student
Constantin Verhout
1663, oil on wood
38 × 31 cm (15 × 12¼ in)
Nationalmuseum, Stockholm

Text visible in image: 好好学习? Study well? 天天向上 Progress everyday?

Follow You
Wang Qingsong
2013, laser print
180 × 300 cm (70 ⅞ × 118 in)

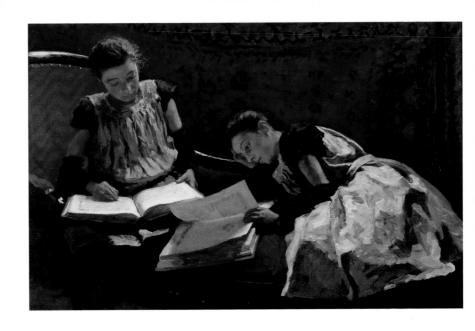

The Sisters
Willem Bastiaan Tholen
1893, oil on canvas
36.5 × 57 cm (114 ⅜ × 22 ½ in)
Museum Gouda, Netherlands

Kept In
Erskine Nicol
c.1871, oil on canvas
61 × 79.5 cm (24 × 31¼ in)
Private collection

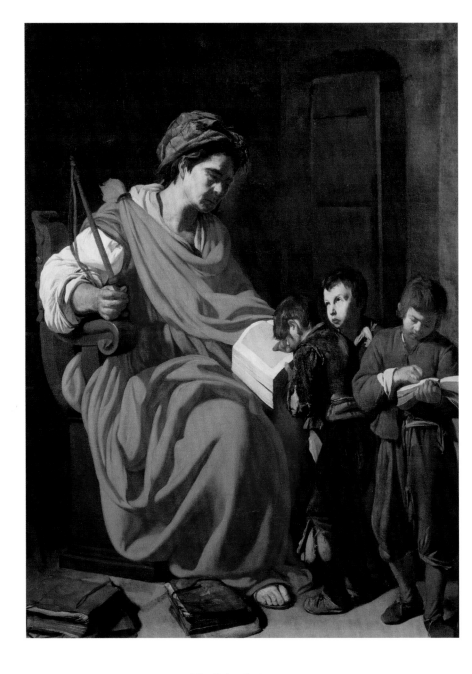

The Schoolmistress
Aniello Falcone
1620–30, oil on canvas, 100 × 75 cm (39 ⅜ × 29 ½ in)
Museo di Capodimonte, Naples

Saint Cassian
Amico Aspertini
early 16th century, panel, 34 × 38 cm (13 ⅜ × 15 in)
Pinacoteca di Brera, Milan

The Reading Lesson
Henriette Browne
mid-19th century, oil on canvas
27.5 × 22 cm (10 ⅞ × 8 ⅝ in)
Private collection

The School Teacher
Jan Steen
c.1668, oil on canvas
dimensions unknown
Private collection

The Reading
Fernand Léger
1924, oil on canvas
113.5 × 146 cm (44 ⅝ × 57 ½ in)
Musée national d'art moderne, Centre Georges Pompidou, Paris

Schoolchildren
Felice Casorati
1928, oil on board
169 × 151 cm (66 ½ × 59 ½ in)
Museo di Arte Moderna, Palermo, Italy

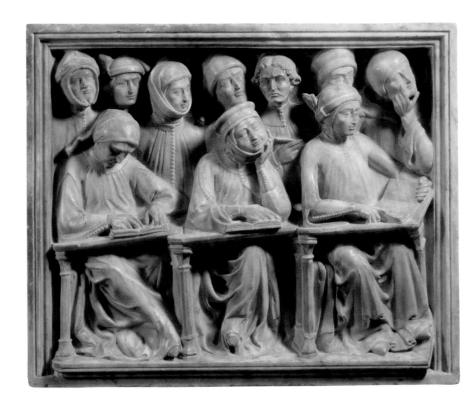

Students attending a lecture
from the Tomb of Giovanni da Legnano
Jacobello and Pierpaolo dalle Masegne
1383–6 (detail), marble, 63.3 × 76.5 cm (24 ⅞ × 30 ⅛ in)
Church of San Domenico, Bologna, Italy

**Interior of a Room with a Young Man
Seated at a Table**
Jan Davidsz. de Heem
1628, oil on panel, 60 × 82 cm (23 ⅝ × 32 ¼ in)
Ashmolean Museum, Oxford

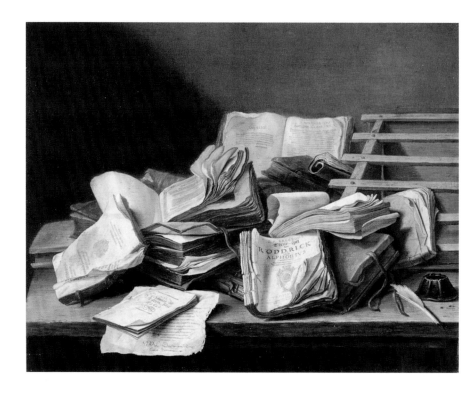

Still Life with Books
Jan Davidsz. de Heem
1628, oil on panel, 31.2 × 40.2 cm (12 ¼ × 15 ⅞ in)
Fondation Custodia/Collection Frits Lugt, Paris

Giotto in Cimabue's Studio
Jules-Claude Ziegler
c.1847, oil on canvas, 160 × 130 cm (63 × 51⅛ in)
Musée des Beaux-Arts de Bordeaux, France

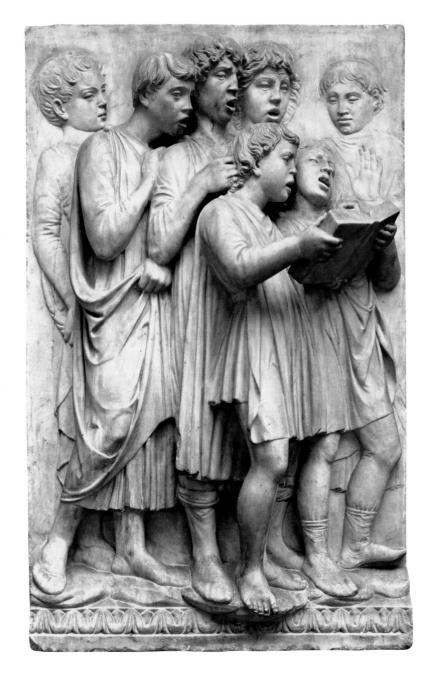

Choristers, panel from the Cantoria, Florence Cathedral
Luca della Robbia
1431–8, marble, Museo dell'Opera del Duomo, Florence

Three Young Women Making Music with a Jester
Master of the Female Half-Lengths
1500s, oil on oak panel, 63.7 × 89.5 cm (25 × 35 ¼ in)
Private collection

The Music Lesson
Charles West Cope
1876, oil on canvas, 74 × 64 cm (29 ⅛ × 25 ¼ in)
Private collection

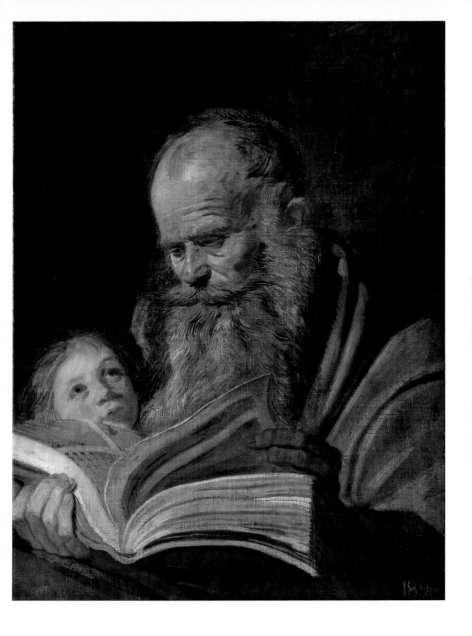

Saint Matthew
Frans Hals
c.1625, oil on canvas, 70 × 50 cm (27 ½ × 19 ⅝ in)
Odessa Museum of Western and Eastern Art, Ukraine

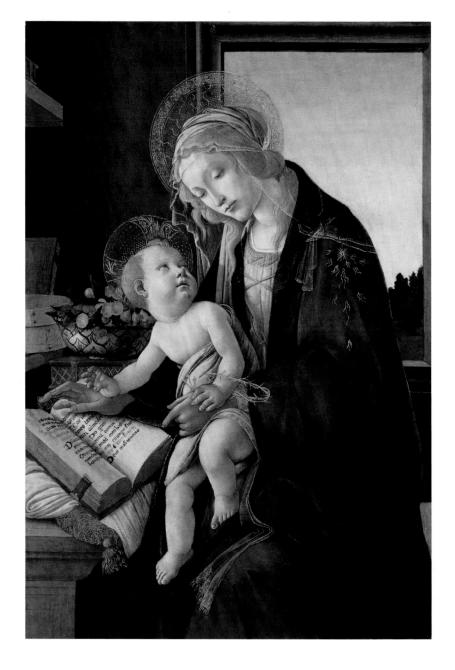

The Virgin and Child (Madonna of the Book)
Sandro Botticelli
1480–81, tempera on panel, 58 × 39.6 cm (22 ⅞ × 15 ⅝ in)
Museo Poldi Pezzoli, Milan

Mother and Child
Pieter Fransz. de Grebber
1622, oil on panel, 98.5 × 73.4 cm (38 ¾ × 28 ⅞ in)
Frans Hals Museum, Haarlem, Netherlands

**The Virgin and Child
(The Durán Virgin)**
Rogier van der Weyden
1435–8, oil on panel, 100 × 52 cm (39 ⅜ × 20 ½ in)
Museo Nacional del Prado, Madrid

**The Virgin and Child with a View of Venice
(The Tallard Madonna)**
Circle of Giorgione
between 1489 and 1511, oil on panel, 76.7 × 60.2 cm (30 ¼ × 23 ⅝ in)
Ashmolean Museum, Oxford

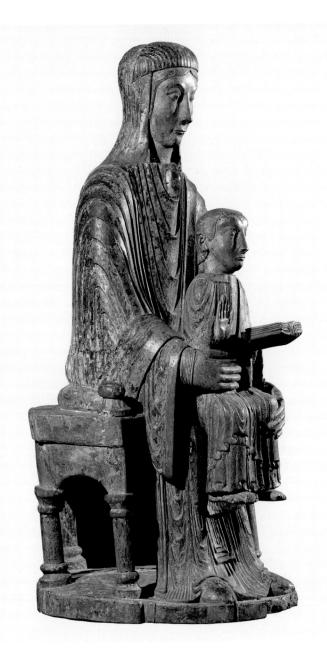

Our Lady of Vauclaire
Artist Unknown (French School)
12th century, polychrome wood with inlaid rock crystal
height: 73 cm (28 ¾ in), Église de Molompize, France

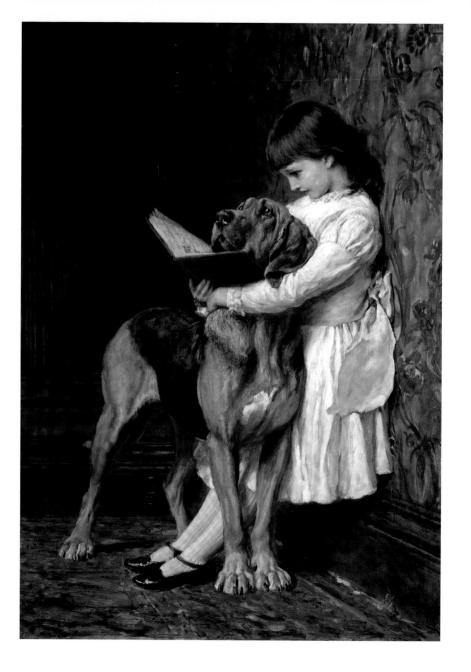

Compulsory Education
Briton Rivière
1887, oil on canvas, 79 × 53 cm (23½ × 20¾ in)
Private collection

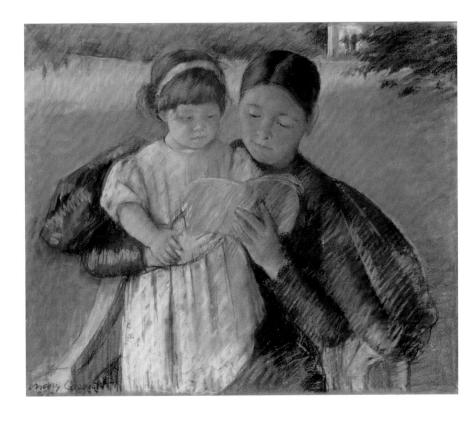

Nurse Reading to a Little Girl
Mary Cassatt
1895, pastel on wove paper, mounted on canvas
60 × 73 cm (23 ⅝ × 28 ¾ in)
The Metropolitan Museum of Art, New York

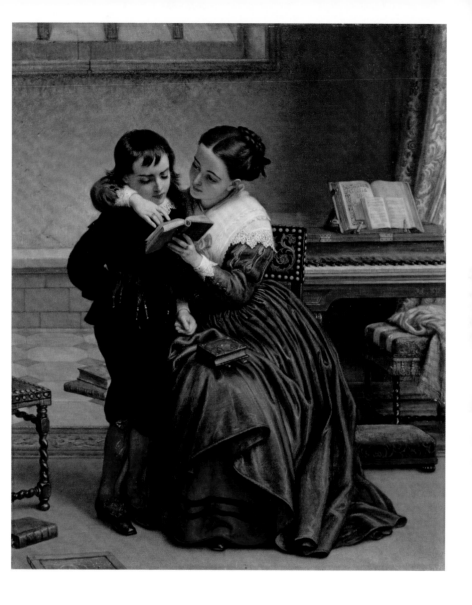

George Herbert and His Mother
Charles West Cope
1872, oil on canvas
74 × 61 cm (29 ⅛ × 24 in)
Gallery Oldham, UK

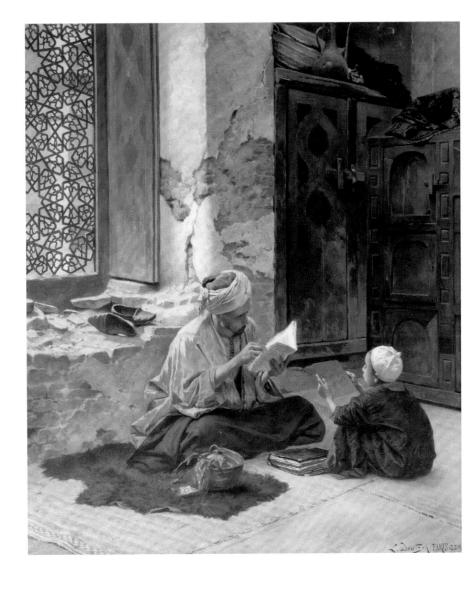

An Arab Schoolmaster
Ludwig Deutsch
1889, oil on panel
54.4 × 47.4 cm (27 ⅜ × 18 ⅝ in)
Touchstones Rochdale, UK

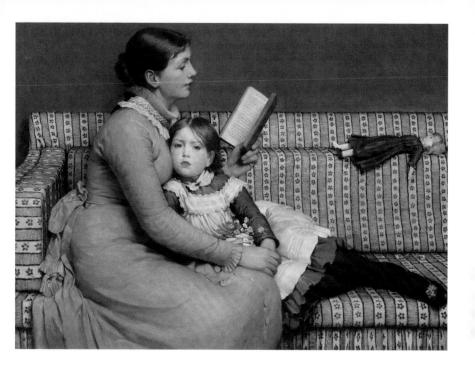

Alice in Wonderland
George Dunlop Leslie
c.1879, oil on canvas
81.4 × 111.8 cm (32 × 44 in)
Brighton and Hove Museums and Art Galleries, UK

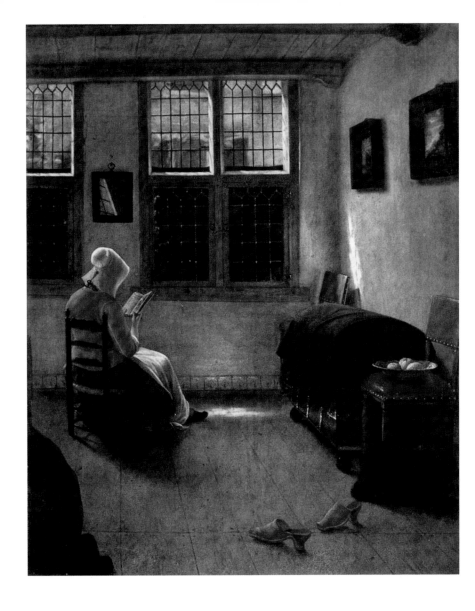

Reading Woman
Pieter Janssens (known as Elinga)
c.1665–70, oil on canvas
75.5 × 63.5 cm (29 ¾ × 25 in)
Alte Pinakothek, Munich

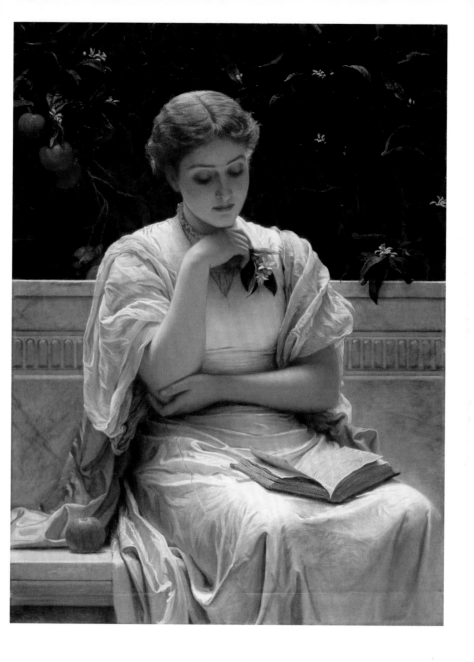

Girl Reading
Charles Edward Perugini
1878, oil on canvas
128.9 × 103.7 cm (50 ¾ × 40 ¾ in)
Manchester Art Gallery, UK

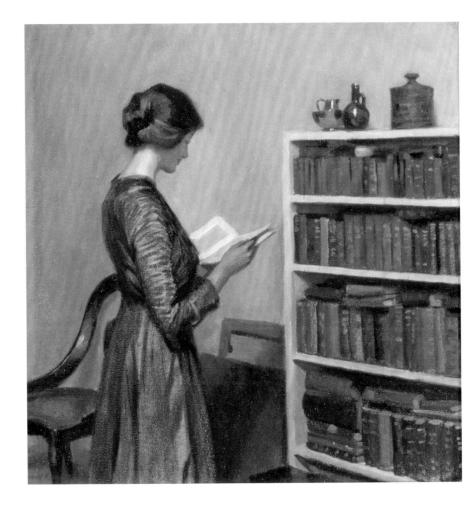

The Reader
Harold Knight
1910, oil on canvas
45 × 45 cm (17 ¾ × 17 ¾ in)
Brighton and Hove Museums and Art Galleries, UK

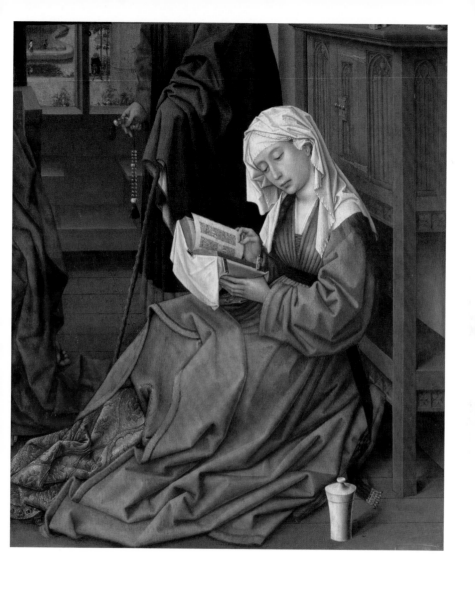

The Magdalene Reading
Rogier van der Weyden
before 1438, oil on mahogany
62.2 × 54.4 cm (24 ½ × 21 ⅜ in)
National Gallery, London

The Annunciation, manuscript leaf from a Book of Hours
Jean Bourdichon
c.1485–90, tempera and shell gold on parchment
9.6 × 6 cm (3 ¾ × 2 ⅜ in)
The Metropolitan Museum of Art, New York

The Reader
Federico Faruffini
c.1865, oil on canvas
59 × 40.5 cm (23 ¼ × 16 in)
Galleria d'Arte Moderna, Milan

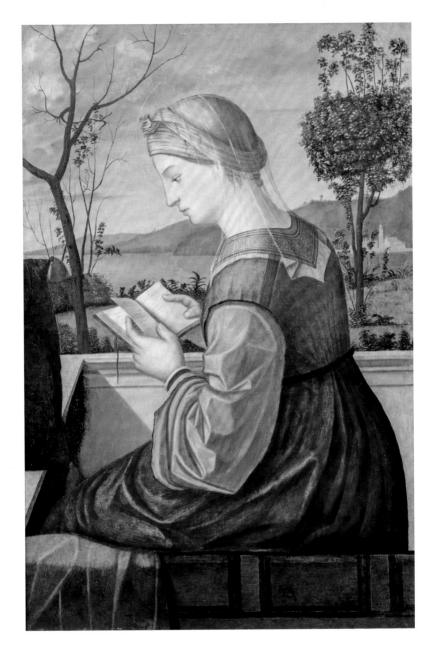

The Virgin Reading
Vittore Carpaccio
c.1505, oil on panel transferred to canvas
78 × 51 cm (30 ¾ × 20 ⅛ in)
National Gallery of Art, Washington DC

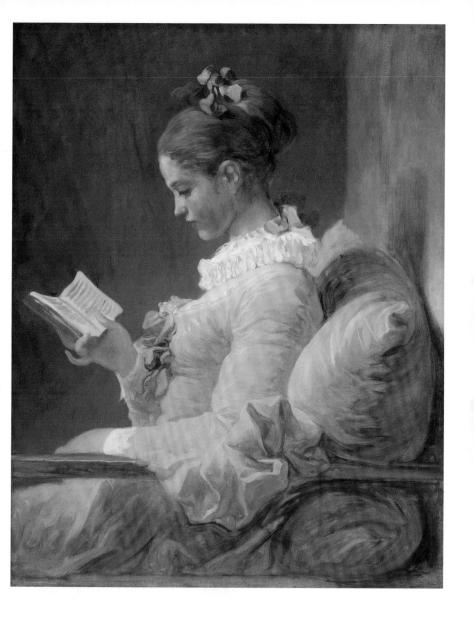

Young Girl Reading
Jean-Honoré Fragonard
c.1769, oil on canvas
81.1 × 64.8 cm (31 ⅞ × 25 ½ in)
National Gallery of Art, Washington DC

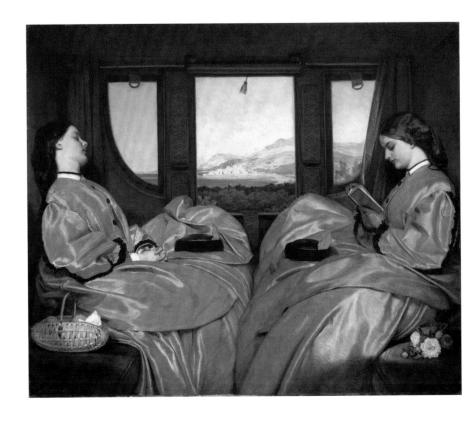

The Travelling Companions
Augustus Leopold Egg
1862, oil on canvas
65.3 × 78.7 cm (25 ¾ × 31 in)
Birmingham Museum and Art Gallery, UK

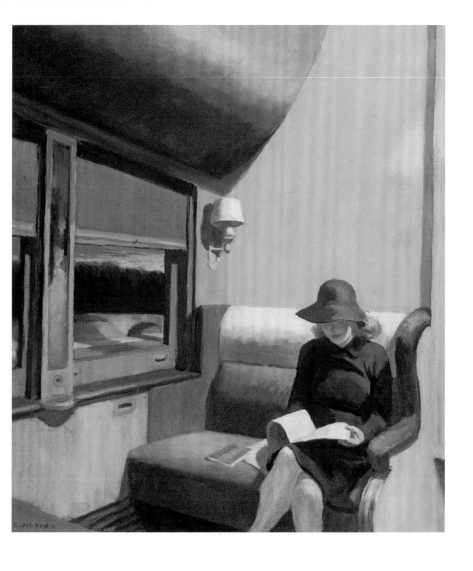

Compartment C, Car 293
Edward Hopper
1938, oil on canvas
50.8 × 45.7 cm (20 × 18 in)
Private collection

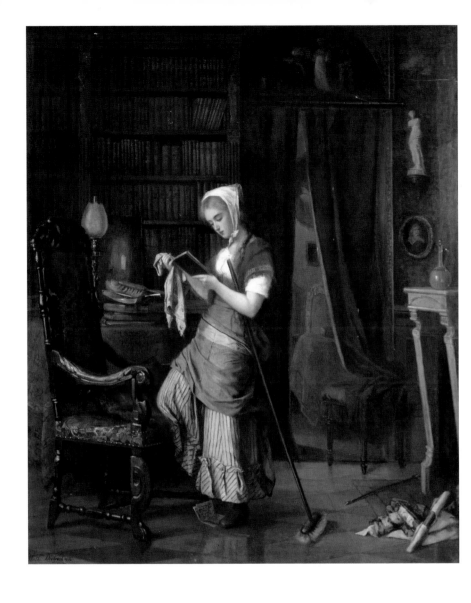

Farmhouse Interior
Johanne Mathilde Dietrichson
1875, oil on canvas, dimensions unknown
Private collection

Summer
Donald Moodie
c.1958, oil on canvas, 76.4 × 64.2 cm (30 × 25 ¼ in)
Royal Scottish Academy of Art and Architecture, Edinburgh

The New Novel
Winslow Homer
1877, watercolour on paper
24.1 × 52.1 cm (9 ½ × 20 ½ in)
Museum of Fine Arts, Springfield, Massachusetts

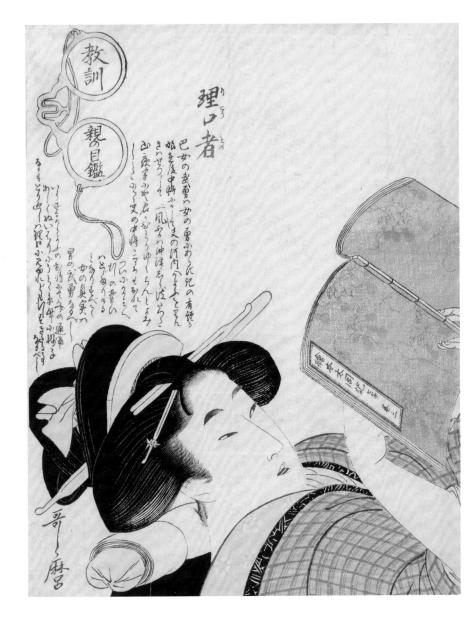

The Know-It-All
Kitagawa Utamaro
c.1802–3, woodcut print on paper
37 × 25 cm (14 ½ × 9 ⅞ in)
Museo de Bellas Artes de Bilbao, Spain

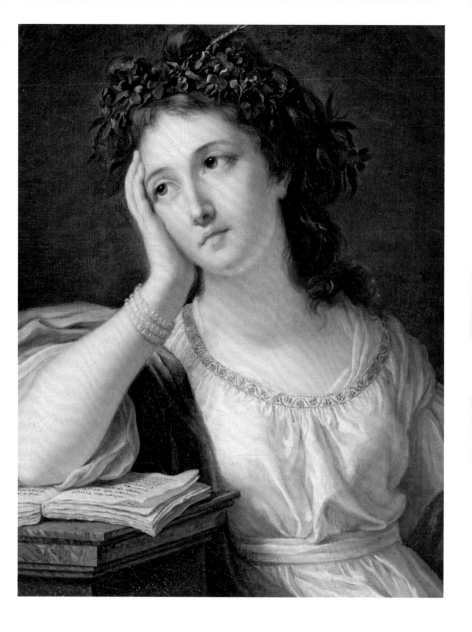

Young Woman Leaning on a Book
Anne Vallayer-Coster
1784, oil on canvas
dimensions unknown
Private collection

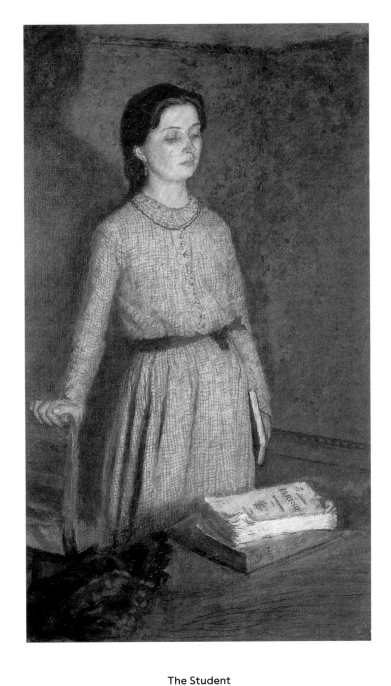

The Student
Gwen John
1903, oil on canvas , 56.1 × 33.1 cm (22 ⅛ × 13 in)
Manchester Art Gallery, UK

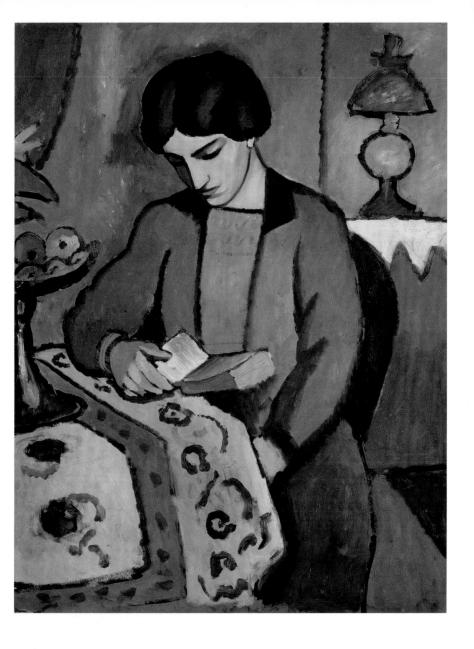

The Wife of the Artist (Elisabeth Macke)
August Macke
1912, oil on paper, 105 × 51 cm (41 ⅜ × 20 in)
Alte Nationalgalerie, Berlin

'Just the knowledge that a good book is awaiting one at the end of a long day makes that day happier.'

Kathleen Norris (b.1947)

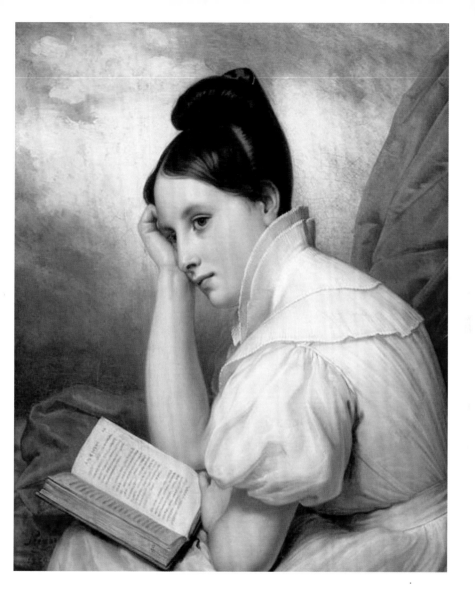

The Reader
Carl von Steuben
1829, oil on canvas
61.3 × 50.8 cm (24 ⅛ × 20 in)
Musée d'arts de Nantes, France

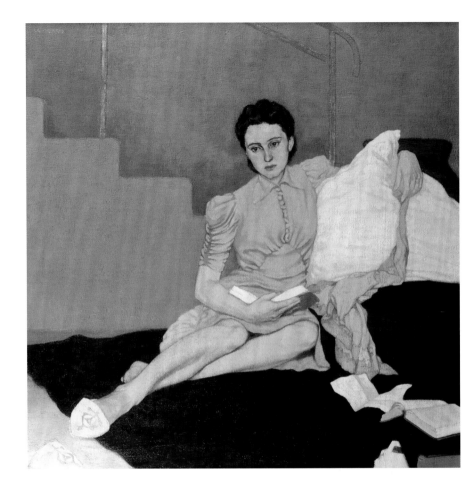

Girl in Grey
Louis le Brocquy
1939, oil on canvas, 93 × 93 cm (36 ⅝ × 36 ⅝ in)
Ferens Art Gallery, Hull, UK

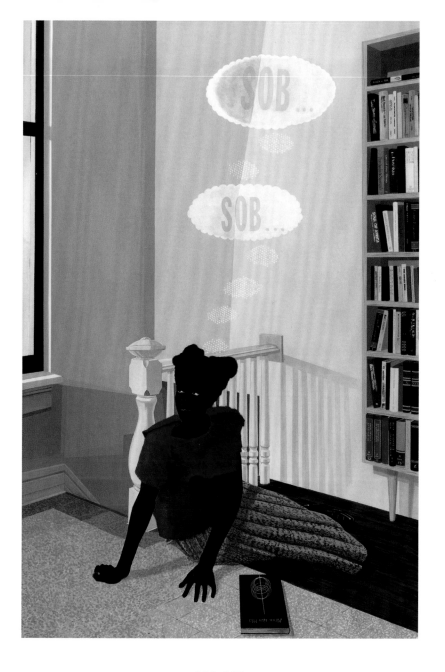

SOB, SOB
Kerry James Marshall
2003, acrylic on fibreglass, 274.3 × 182.9 cm (108 × 72 in)
Smithsonian American Art Museum, Washington DC

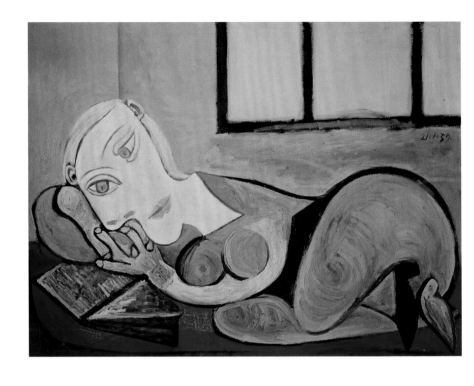

Reclining Woman Reading
Pablo Picasso
1939, oil on canvas
96.5 × 130 cm (38 × 51⅛ in)
Musée Picasso, Paris

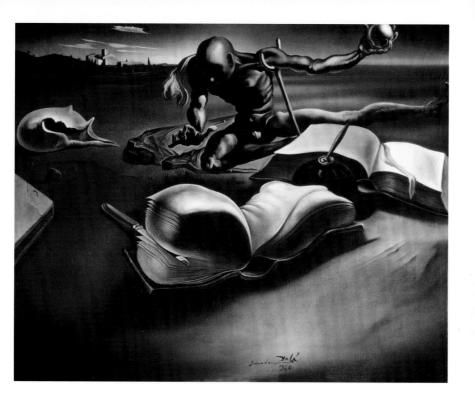

Book Transforming Itself into a Nude Woman
Salvador Dalí
1940, oil on canvas
41.3 × 51 cm (16 ¼ × 20 in)
Private collection

In this hallucinatory painting a large open book with a blue ribbon marker hovers over a sandy shore. In the foreground, another volume is metamorphosing into a reclining nude: its bulbous pages form the woman's buttocks, while the adjacent inkwell provides a head. Floating above the transmuting tome is an ominous figure, perhaps representing the artist; a knife suggests that his desire is to devour the emerging body. Dalí (1904–89) painted this surreal beach scene soon after the start of the Second World War. Some have compared it to the artist's earlier works inspired by the Spanish Civil War, but there is little here to suggest it was motivated by international affairs. In the year he painted it, Dalí left embattled Europe behind him for the United States, living between New York and Monterey, California, and embarked on an intense period of writing that resulted in his autobiography, *The Secret Life of Salvador Dalí* (1942). The empty book in this scene may allude to that project, while the metamorphosing volume might represent a metaphysical muse. Many monographs have been devoted to Dalí's work over the years, but until recently this painting eluded them all, hiding in a private collection from 1941 until 2004.

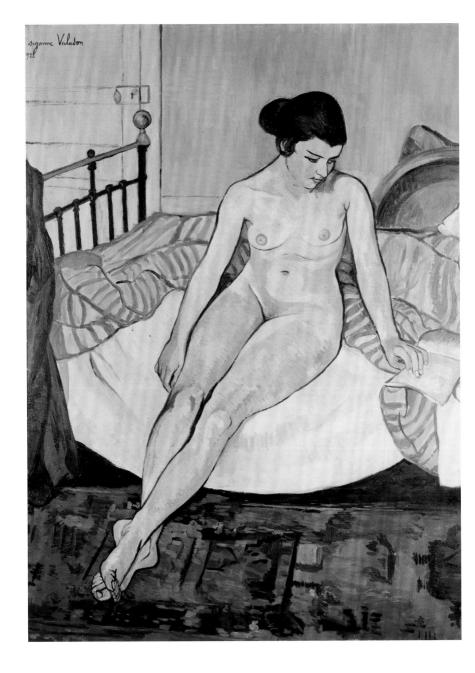

Nude with a Striped Blanket
Suzanne Valadon
1922, oil on canvas, 81 × 100 cm (31 ⅞ × 39 ⅜ in)
Musee d'Art Moderne de la Ville de Paris

'The ideal companion
in bed is a good book.'

Robertson Davies (1913–95)

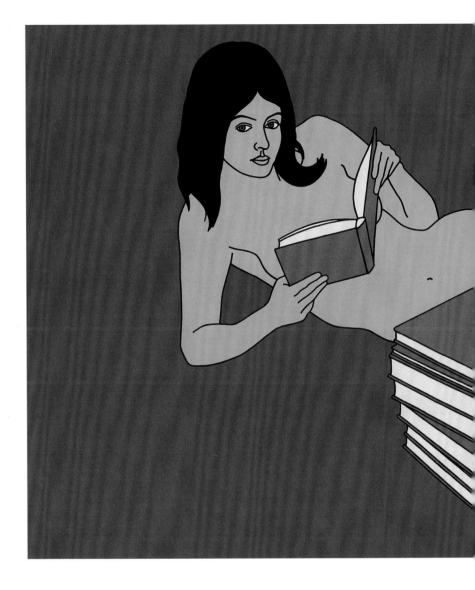

Nude with Books
Patrick Caulfield
1968, acrylic on canvas
152.4 × 274.4 cm (60 × 108 in)
Private collection

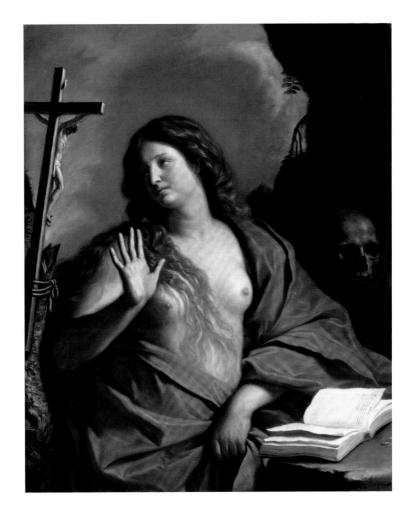

The Penitent Magdalene
Guercino (Giovanni Francesco Barbieri)
c.1648–55, oil on canvas
114 × 92.4 cm (44 ¾ × 36 ⅜ in)
Private collection

With her breasts exposed, Mary Magdalene turns her gaze away from the book she has been reading to focus on a crucifix by her side. Her hand is raised as if shunning the open volume, while behind her is a skull. In medieval tradition Mary Magdalene was a prostitute whom Jesus redeemed after casting seven demons out of her. Later, she supposedly retreated from the world, living an ascetic existence. Images of the saint were very popular during the Counter-Reformation, a period of Catholic resurgence that began in the 1540s in response to the Protestant Reformation. With this came a renewed emphasis on penitence and morality, and the symbolism of the Magdalene was widely used to encourage Catholics to renounce worldliness. The skull that Guercino (1591-1666) includes here as an emblem of mortality is common in depictions of the saint. The book is another recurring symbol, though its meaning is less clear. It perhaps alludes to knowledge, but the saint's forceful gesture suggests that this book is in fact a symbol of vanity. The painting can therefore be seen as an encouragement to forsake worldly wisdom as well as goods and, pleasures in order to pursue a life of devotion to Christ.

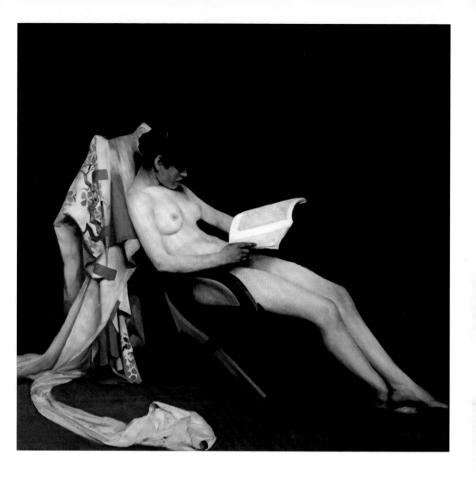

The Reading Girl
Théodore Roussel
1886–7, oil on canvas
152.4 × 161.3 cm (60 × 63 ½ in)
Tate, London

'Reading is to the mind what exercise is to the body.'

Sir Richard Steele (1672–1729)

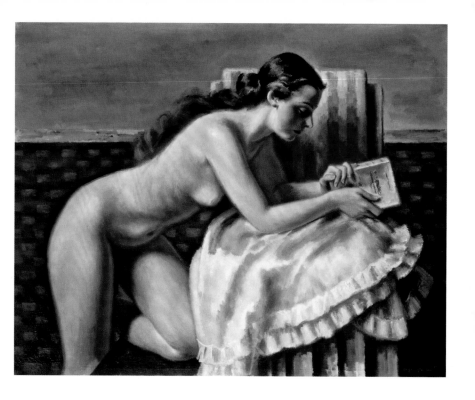

A Good Book
Eugene Speicher
20th century, oil on canvas
102 × 130 cm (40 × 51 in)
Private collection

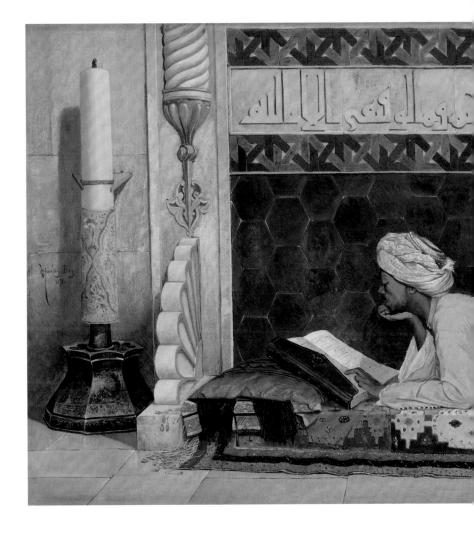

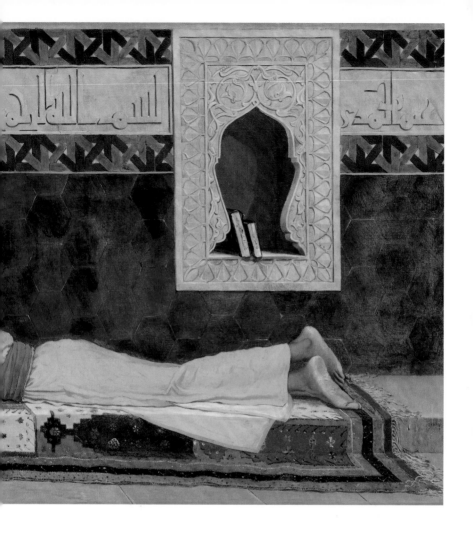

The Scholar
Osman Hamdi Bey
1878, oil on canvas
45.5 × 90 cm (18 × 35 ½ in)
Private collection

94 Degrees in the Shade
Lawrence Alma-Tadema
1876, oil on canvas laid on mahogany panel
35.3 × 21.6 cm (13 ⅞ × 8 ½ in)
Fitzwilliam Museum, Cambridge, UK

Outside Myself (Monument Valley)
Tracey Emin
1994, C-print, 65 × 81 cm (25 ⅝ × 31 ⅞ in)

Sitting in front of the spectacular sandstone landforms of Monument Valley, Emin (b.1963) reads from her memoir, *Exploration of the Soul* (1994). The photograph was taken during her trip to the United States in that same year, where she drove from San Francisco to New York giving readings from this autobiography. In it Emin recounts significant events in her early life, from the moment of conception to her experience of being raped at the age of thirteen. Emin describes the stream-of-consciousness text as a mental journey, a coming to terms with her childhood experiences of innocence, beauty and evil.

It opens with a celebration of the cycle of life and imagines the passionate encounter between her parents in which she and her twin brother Paul were conceived. Illustrated with pictures of Emin and her brother, *Exploration of the Soul* was originally published in an edition of just two hundred copies. Text from the first page is handwritten and appliquéd onto the back of the upholstered chair, which was inherited from the artist's grandmother. It is accompanied by other words and phrases personal to Emin, including the name of each place she visited during her American road trip.

Round Hill
Alex Katz
1977, oil on linen, 183 × 244 cm (72 × 96 in)
Los Angeles County Museum of Art

READING POSITION FOR SECOND DEGREE BURN
Stage I, Stage II. Book, skin, solar energy. Exposure time: 5 hours. Jones Beach. 1970

Reading Position for Second Degree Burn
Dennis Oppenheim
1970, colour photography and text
215.9 × 152.4 cm (85 × 60 in)

Taking a trip to New York's Jones Beach, Oppenheim (1938–2011) lay down on the sand with a copy of William Balck's *Tactics* (1914). But instead of reading it, he placed the large hardback book on his bare chest and lay in the blazing sun for five hours. Two colour photographs were taken to document this action; the first shows the long-haired artist with the book resting on his pale-skin; the second shows him in the same position, his skin now red and raw except for a large rectangle where the book had been. Initially associated with the Land Art movement, Oppenheim's earliest works were large-scale, using the natural landscape as a sculptural medium. This piece was one of the first in which he used his own body as material; his skin became a canvas for the sun to leave its mark. The book chosen by Oppenheim is on the strategy of warfare; it was originally written by a Prussian military officer and then translated into English by an American Army officer who fought in the Second World War and was never defeated. The artist's reading material suggests that with this work and others he was preparing to take on the art world from a series of new and innovative strategic positions.

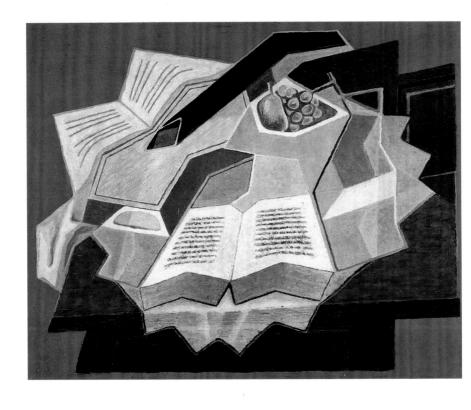

The Open Book
Juan Gris
1925, oil on canvas
73 × 92 cm (28 ¾ × 36 ¼ in)
Kunstmuseum Bern, Switzerland

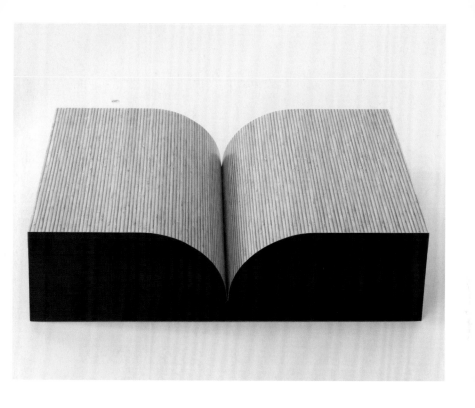

Book
Richard Artschwager
1987, multiple of wood and formica
overall: 13 × 51.1 × 30.7 cm (5 ⅛ × 20 ⅛ × 12 ⅛ in)

Prince Carlos of Viana
José Moreno Carbonero
1881, oil on canvas, 310 × 242 cm (122 × 95 ¼ in)
Museo Nacional del Prado, Madrid

An embittered Spanish prince is deep in thought amid the huge volumes of a medieval library. Sitting in a throne-like chair he stares into space, distracted from his studies. In the mid-fifteenth century, Carlos de Viana was heir to both the thrones of Aragon and Navarre in northern Spain. Yet his father King Juan II disowned him, favouring instead his brother, Fernando 'the Catholic'. Due to Carlos's growing popularity with the Catalonians, Fernando forced him to retreat from public life. Taking refuge at a convent in Naples, he spent most of his time reading and studying in its library, accompanied only by a greyhound. Carbonero (1860–1942) has carefully rendered the large leather bindings with their metal clasps as well as the scattered scrolls and dusty nooks of the imagined library. Indeed, he has approached the antiquarian books with as much care as the central figure. Carlos was a very learned prince, translating works by Aristotle into Aragonese as well as writing a history of the kings of Navarre. But here he seems fragile, detached from his ambitious literary pursuits. His vacant expression conveys the depths of his despair as he comes to terms with the loss of his birthright.

Portrait of Miguel de Unamuno
José Gutiérrez Solana
1936, oil on canvas, 141 × 116 cm (55 ½ × 45 ⅝ in)
Museo Nacional Centro de Arte Reina Sofía, Madrid

'How many a man has dated a new era in his life from the reading of a book!'

Henry David Thoreau (1817–62)

The Lord is My Shepherd
Eastman Johnson
1863, oil on wood, 42.3 × 33.2 cm (16 ⅝ × 13 ⅛ in)
Smithsonian American Art Museum, Washington DC

An African American man sitting on a stool at a kitchen hearth is reading from a Bible. Johnson (1824–1906) painted this scene during the American Civil War, shortly after President Lincoln's Emancipation Proclamation freed black slaves in the Confederate States. The painting's title is taken from Psalm 23, which begins with the well-known line, 'The Lord is my shepherd; I shall not want'. However, the Psalms appear towards the middle of the Bible, whereas the man is clearly reading from a passage near the beginning of the Scriptures, perhaps from Exodus, in which the ancient story of Moses leading the Israelites out of slavery in Egypt is recounted. This story of deliverance from captivity had a particular resonance for slaves, and the abolitionists who fought for an end to slavery often referenced it in their campaigns. But for Johnson and others, freedom meant more than physical emancipation. Abolitionists believed that former slaves must be educated to enable them to participate as citizens. Yet literacy among slaves was very low and even illegal in some parts of the South, and seeing a black man reading in the mid-nineteenth century would have surprised some white viewers. Johnson's message here is clear: for slaves to be truly liberated they should also be allowed to read.

Still Life with Bible
Vincent van Gogh
1885, oil on canvas
65.7 × 78.5 cm (25 ⅞ × 30 ⅛ in)
Van Gogh Museum, Amsterdam

A small yellow paperback sits next to a large leather-bound Bible. Van Gogh (1853–90) produced this poignant painting soon after his father's death, completing it in a single day. The Bible represents the worldview of his father, who was a minister in the Dutch Reformed Church. The yellow novel is *La Joie de vivre* (1884) by Émile Zola, whose writings Van Gogh greatly admired as a reflection of life as it really was. The snuffed-out candle may refer to death but also suggests the view that the Scriptures, sinking into the shadows, belong to a former time. In contrast, Zola's novel is bright, relevant and vital. While its title is legible, the biblical text, rendered as abstract blocks of colour, is not. Nevertheless, the artist shows that it is open to Isaiah 53, where the famous account of the 'suffering servant' appears, taken by Christians as an Old Testament foreshadowing of Jesus as 'a man of sorrows acquainted with grief'. Zola's title, *The Joy of Living*, is ironic, for there is no joy in his dark tale of suffering and misery. Together, the two radically different books speak of the artist's grief in the wake of his personal loss.

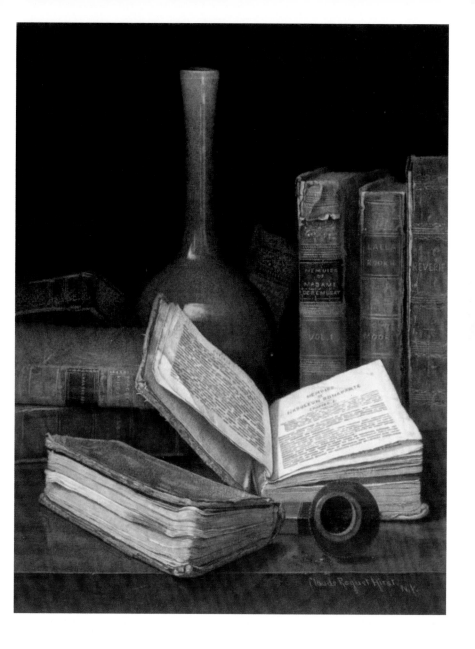

The Bookworm's Table
Claude (Claudine) Raguet Hirst
1890s, watercolour over graphite on cream paper
31.8 × 24.1 cm (12½ × 9½ in)
Brooklyn Museum, New York

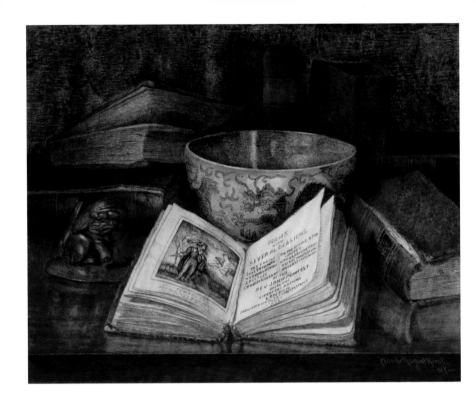

A Book of Poems
Claude (Claudine) Raguet Hirst
late 19th century, oil on canvas
dimensions unknown
Private collection

Open[ed] Books I–VIII
András Böröcz
2010, ink drawing on handmade paper on pine boards
from 30.5 × 10.2 × 1.9 cm to 45.8 × 15.3 × 1.9 cm
(12 × 4 × ¾ in to 18 × 6 × ¾ in)

'An empty book is like an infant's soul, in which anything may be written. It is capable of all things, but containeth nothing.'

Thomas Traherne (1637–74)

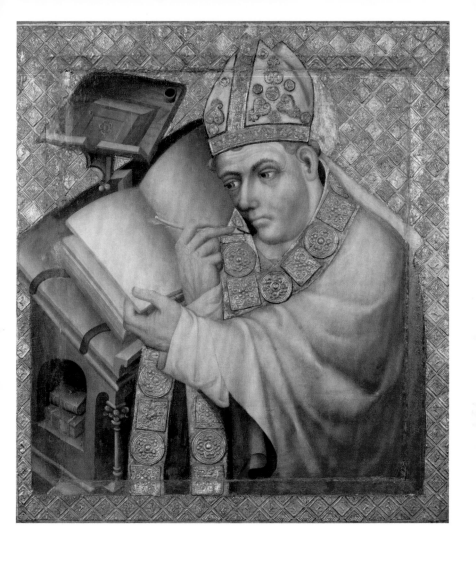

Writing Bishop
Master Theodoric
1360–65, tempera on wood
113 × 105 cm (44 ½ × 41 ⅜ in)
Národní Galerie, Prague

The Open Missal
Ludger tom Ring the Younger
c.1570, oil on oak panel, 66.7 × 66.7 cm (26 ¼ × 26 ¼ in)
Francis Lehman Loeb Art Center,
Vassar College, Poughkeepsie, NY

Untitled (book)
Michael Craig-Martin
2014, acrylic on aluminium
200 × 200 cm (78 ¾ × 78 ¾ in)

SĀDREAS

ET IN IESVM CHRISTV̄ FILV̄ EIVS VNICV̄. DOMINVM NOSTRV̄

Saint Andrew
Artus Wolfordt
early 17th century, oil on canvas
116 × 91.4 cm (45 ¾ × 36 in)
Private collection

Portrait of Emile Verhaeren
Théo van Rysselberghe
1915, oil on canvas
77.5 × 92 cm (30½ × 36¼ in)
Musée d'Orsay, Paris

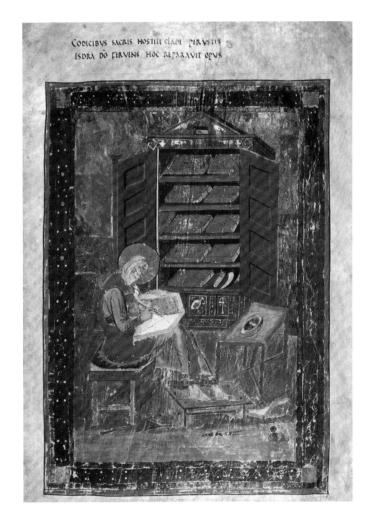

CODICIBVS SACRIS HOSTILI CLADE PERVSTIS
ESDRA DO FERVENS HOC REPARAVIT OPVS

Ezra the Scribe, from the Codex Amiatinus
Artist unknown
before 716, illuminated manuscript on vellum, 50.5 × 34 cm (19 ⅞ × 13 ⅜ in)
Biblioteca Medicea Laurenziana, Florence

The haloed figure of Ezra the Scribe is sitting on a bench, busily writing a manuscript. Beside him is an open book cupboard containing a Bible in nine volumes, each one lying on its side and clasped shut. This illustration, one of the earliest images of bound manuscripts in existence, appears as the frontispiece of the Codex Amiatinus, the oldest extant copy of Jerome's Latin Vulgate translation of the Bible. Ezra was an ancient Israelite scribe, priest and religious teacher who authored the biblical book that bears his name. In Jewish tradition he is connected with the collecting and editing of the canon of Scripture, making him an ideal subject for a Bible frontispiece. Although Ezra would have worked with scrolls, he is depicted here writing in a codex, the earliest form of book, which began to proliferate from the fourth century. The Codex Amiatinus is one of the most important copies of the Bible in the world. It was produced at Monkwearmouth, a renowned monastery and bookmaking centre in northeast England. Monks began working on the book in 692 AD and after its completion in the early eighth century it was gifted to the Pope.

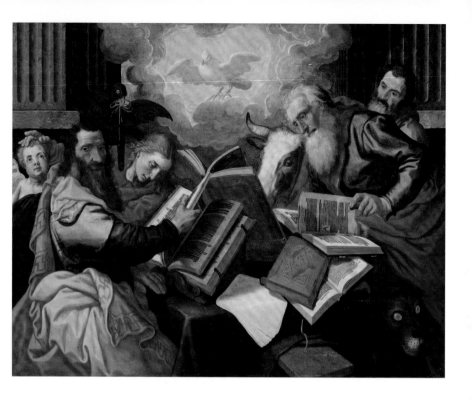

The Four Evangelists
Pieter Aertsen
1560–65, oil on oak, 113 × 143 cm (44 ½ × 56 ¼ in)
Kunsthistorisches Museum, Vienna

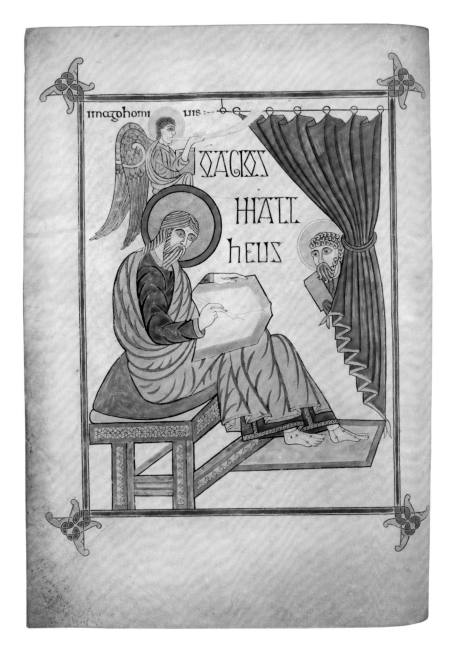

**Saint Matthew the Evangelist
from the Lindisfarne Gospels
Eadfrith of Lindisfarne (attributed)**
c.700, illuminated manuscript on parchment
36.5 × 27.5 cm (14 ⅜ × 10 ⅞ in), British Library, London

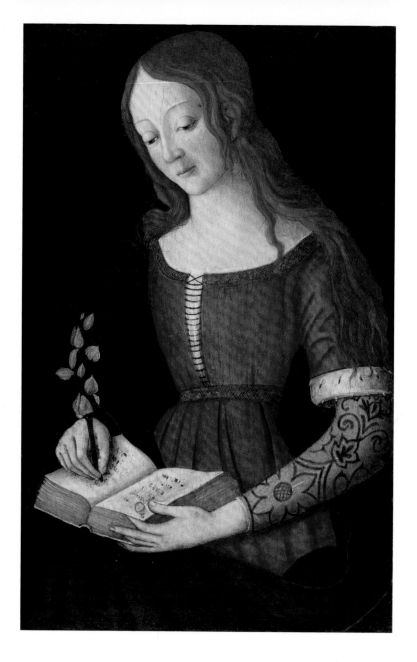

A Young Lady Writing in a Hymnal
Giacomo Pacchiarotto
after 1500, oil on panel
44.5 × 28.5 cm (17½ × 11¼ in)
Private collection

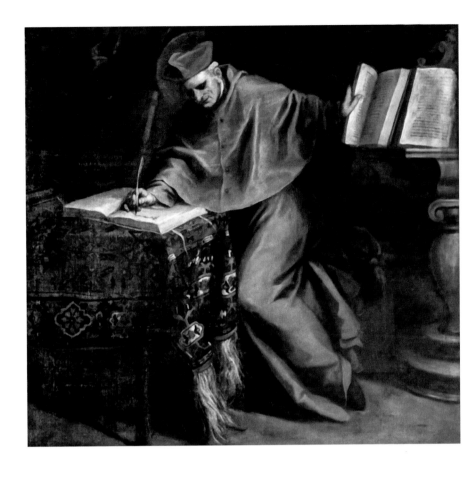

Saint Bonaventure in His Study
Palma Giovane
late 16th/early 17th century, oil on panel, dimensions unknown
San Francesco della Vigna, Venice

Martin Luther Translating the Bible at the Wartburg, plate XXIV from 'The Life of Luther in Forty-eight Historical Engravings'
Gustav König
c.1850, engraving, published by Nathaniel Cooke, London

This engraving shows the Church reformer Martin Luther at the castle of Wartburg in Thuringia, Germany. He works diligently on translating the New Testament from Greek into German, a task he completed in just eleven weeks. Four years earlier he had sparked the Protestant Reformation by publishing his Ninety-five Theses, a document in which he criticized the corruption of the Roman Catholic Church and the Papacy. After refusing to recant, he was excommunicated and declared an outlaw by the Holy Roman Emperor Charles V. For his own safety he was sequestered in the Wartburg by Frederick the Wise of Saxony, where he disguised himself with a beard and the name Junker Jörg

('Knight George'), hence the sword. First published in 1522, Luther's New Testament was portable and easy to read. Unlike previous German Bibles, it was a vernacular book for ordinary people, combining several dialects into a unified language and making a significant contribution to the development of modern German. To many, the reformer's rejection of papal authority and insistence on the supremacy of the Bible in doctrial matters made him a national hero; to others he was a dangerous heretic. König (1808–69) illustrated an immensely popular biography of Luther and his depiction of this revolutionary moment resonated with contemporary aspirations for a German nation.

Portrait of Charles Baudelaire
Gustave Courbet
1848, oil on canvas, 54 × 65 cm (21¼ × 25⅝ in)
Musée Fabre, Montpellier, France

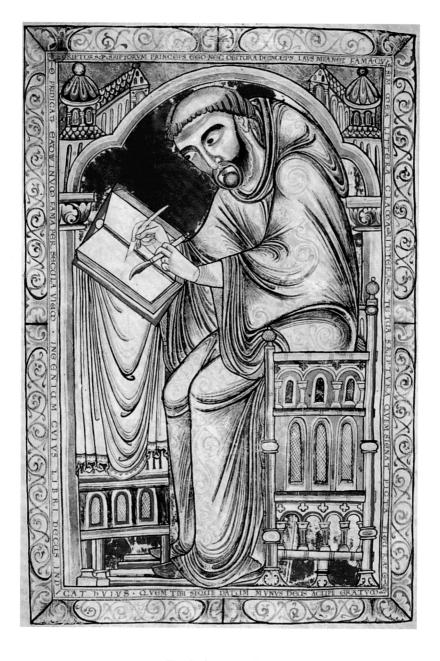

The Scribe Eadwine
from the Canterbury Psalter
Artist unknown
c.1150, pigment on vellum, 51.5 × 41.5 cm (20 ¼ × 16 ⅜ in)
Trinity College, Cambridge, UK

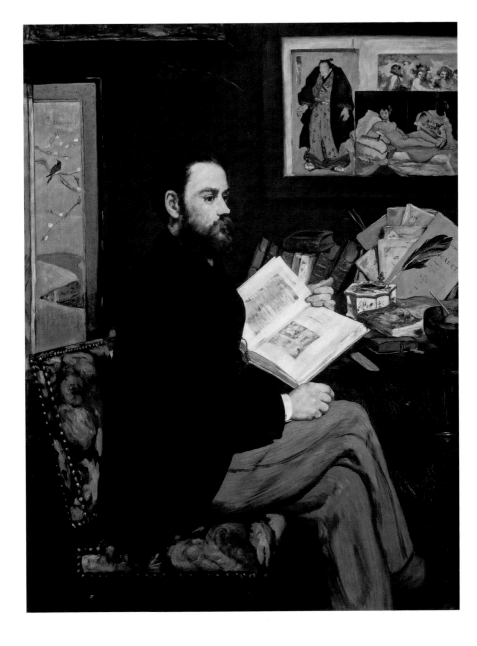

Émile Zola
Édouard Manet
1868, oil on canvas
146.5 × 114 cm (57 ¾ × 44 ⅞ in)
Musée d'Orsay, Paris

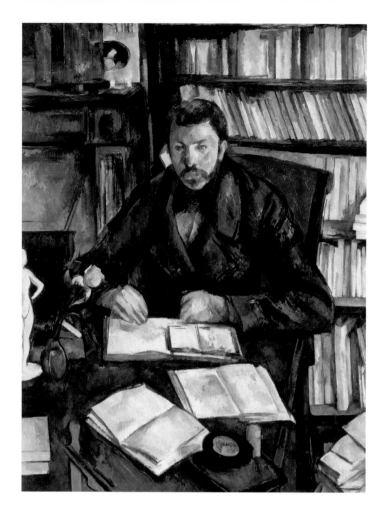

Gustave Geffroy
Paul Cézanne
1895–6, oil on canvas
117 × 89.5 cm (46 ⅛ × 35 ¼ in)
Musée d'Orsay, Paris

The French novelist and art critic Gustave Geffroy sits in his library, deep in thought. His desk is littered with open books and many more are crammed onto the shelves behind him. Some volumes are precariously balanced, while others overflow onto the floor below. Geffroy was an early historian of Impressionism and was among the first to write positively about Cézanne's (1839–1906) work. In a show of gratitude the artist offered to paint his portrait, and for a period of three months in 1895 the critic posed daily at his Paris home. But the results displeased Cézanne and he abruptly left Paris, leaving the painting unfinished. Some have speculated that relations between the two men grew sour. Evidence is scant, but it is intriguing that Cézanne spent most of his time painting the books, leaving the sitter's face and hands incomplete. Though the portrait was abandoned it became popular after the artist's death. Cubist painters in particular were interested in its geometry: the multiple angles of perspective and the relationships between the bookcase and the strewn books. The painting thus came to be viewed more as a study of Geffroy's library than of the critic himself.

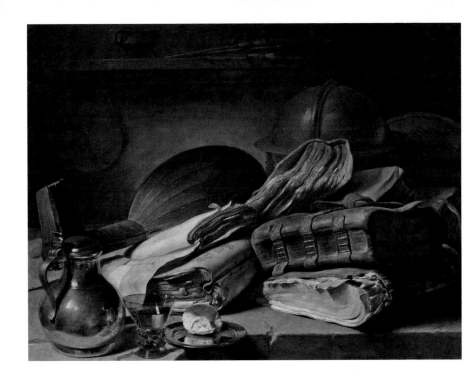

Still Life with Books
Jan Lievens
c.1627–8, oil on panel
91 × 120 cm (35 ⅞ × 47 ¼ in)
Rijksmuseum, Amsterdam

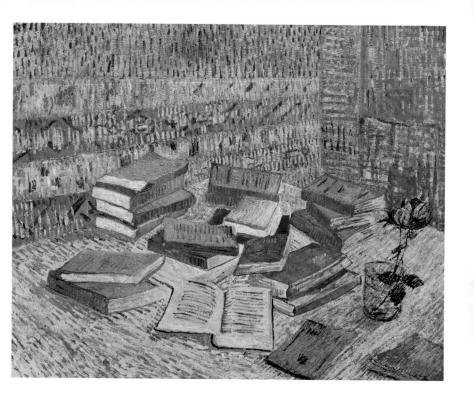

Still Life with French Novels and a Rose
Vincent van Gogh
1887, oil on canvas
73 × 93 cm (28 ¾ × 36 ⅝ in)
Private collection

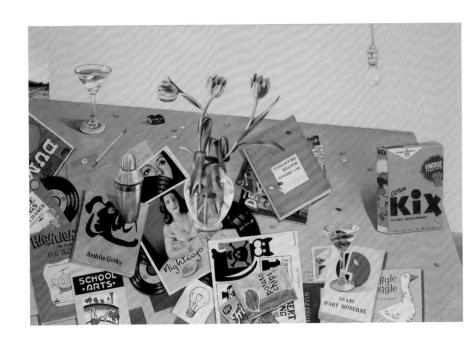

Cornered
Richard Baker
2010, oil on canvas
101.6 × 152.4 cm (40 × 60 in)
Private Collection

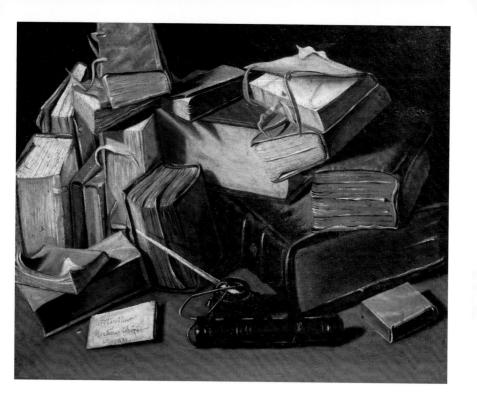

Still Life with Old Books
Charles Emmanuel Biset
late 17th century, oil on canvas
52 × 60.5 cm (20 ½ × 23 ¾ in)
Musée municipal de Bourg-en-Bresse, France

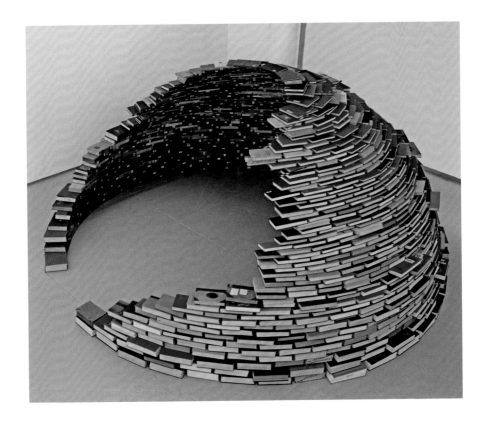

HOME
Miler Lagos
2011, stacked books, 180 × 400 (diam.) cm (70 ⅞ × 157 ½ in)
Installation view at Magnan Metz Gallery, New York

This incomplete igloo has been constructed entirely with books salvaged from a defunct US Navy base library. Using them like bricks, Lagos (b.1973) laid each one flat and carefully built up the dome-shaped structure layer by layer, with larger volumes placed at the base and slimmer ones at the top. With each book facing outwards, the sculpture's exterior appears as a yellowing paper shell, while its interior comprises a patchwork of variegated bindings. It is inside the structure that the spines of individual volumes can be read; among the many hundreds of books are foreign-language dictionaries, medical reference tomes, geographical studies and works of psychology. For Lagos, the igloo represents an ancient site of knowledge transfer. Traditionally, it is the place where the Inuit people of North America and Greenland have for centuries passed down wisdom from one generation to another. It is also a place of shelter, protection and community. Yet this self-supporting structure of paper and cardboard is fragile: none of the books used here have been stuck or secured, being held together solely by their own weight. In this way, Lagos points both to knowledge held in delicate balance but also to the systems of information and control in which it is contained.

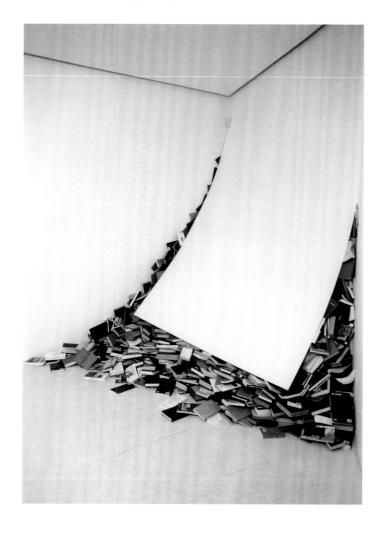

Contemporáneos
Alicia Martín
2000, book installation, dimensions variable
installation view at Galeria Oliva Arauna, Madrid

A mass of books has seemingly burst through the wall of a gallery, scattering literature in all directions. The flood presumably emanates from a neighbouring room so rammed with paperbacks and hardbacks that they can no longer be contained. The volumes have thus become an uncontrollable force, gushing into the room like a flow of liquid. Martín (b.1964) uses books as a sculptural material, regularly creating torrents of reading material that arc in and out of buildings like rushing water. But the Spanish artist's site-specific installations are not celebrations of literature; rather, they are cautionary lessons for a culture that has become saturated with information. Although she recognizes that books are an essential component of a healthy society, she also sees their potential as a destructive force. It is the superabundance of information, she warns, that can give rise to collapse. Edgar Allan Poe made a similar observation in 1836, writing: 'the enormous multiplication of books in every branch of knowledge, is one of the greatest evils of this age'. For Poe, it was the excess of information that made the pursuit of truth that much more difficult. It is perhaps even more the case in our own age.

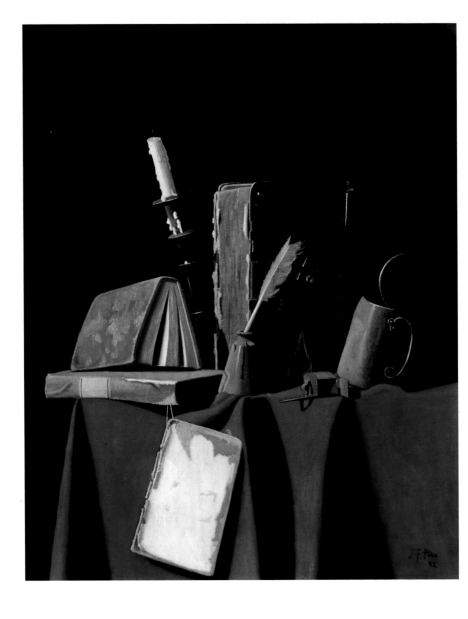

The Writer's Table: A Precarious Moment
John Frederick Peto
1892, oil on canvas, 69.9 × 56.5 cm (27½ × 22¼ in)
Private collection

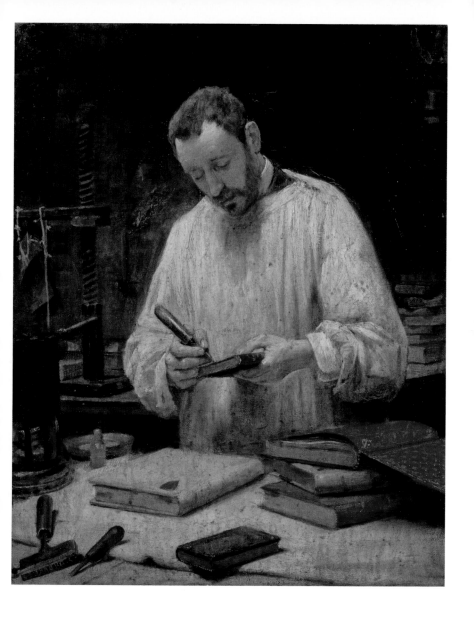

Dewattines the Bookbinder
Alphonse-Jules Debaene
19th century, oil on canvas, 40.5 × 32.6 cm (16 × 12 ⅞ in)
Palais des Beaux-Arts, Lille, France

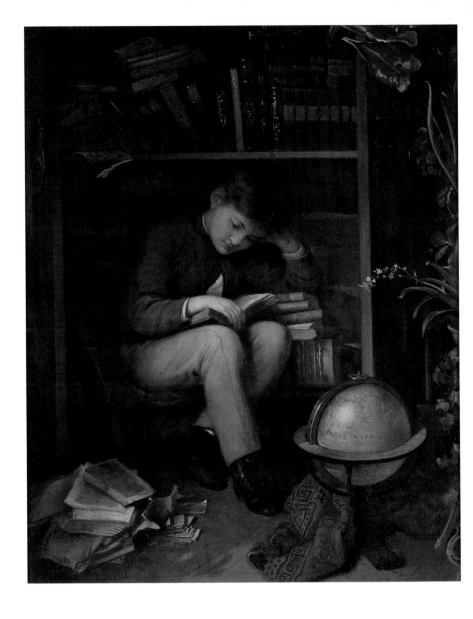

A Little Bookworm
Eduard Swoboda
19th century, oil on canvas laid on card
47 × 38.5 cm (18 ½ × 15 ⅛ in)
Private collection

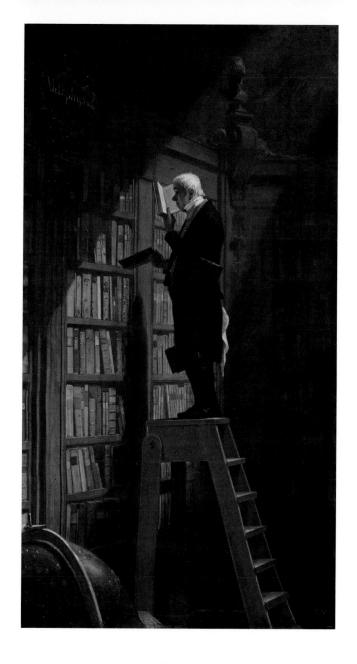

The Bookworm
Carl Spitzweg
c.1850, oil on canvas
49.5 × 27.7 cm (19 ½ × 10 ⅞ in)
Private collection

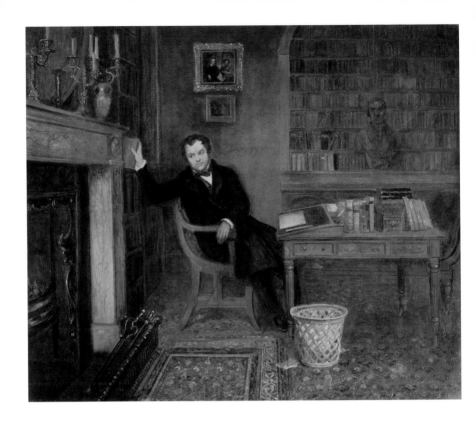

John Forster in His Library
Edward Matthew Ward
c.1850, oil on canvas
63.5 × 76.1 cm (25 × 30 in)
Victoria & Albert Museum, London

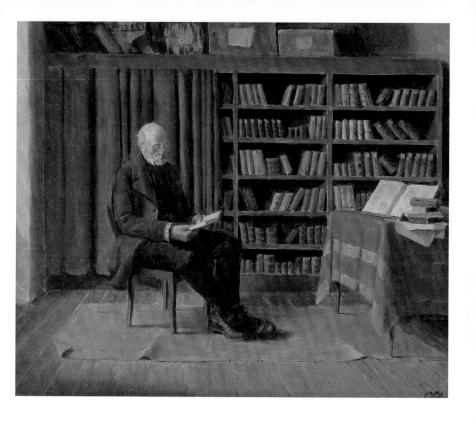

In the Library
Ludwig Valenta
early 20th century, oil on panel
23.5 × 29 cm (9 ¼ × 11 ⅜ in)
Private collection

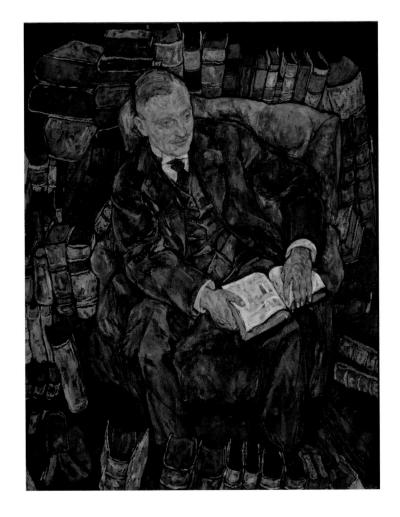

Dr Hugo Koller
Egon Schiele
1918, oil on canvas
140.3 × 110 cm (55 ¼ × 43 ¼ in)
Belvedere, Vienna

With not a single shelf in sight, Hugo Koller is pictured in his library seated amid a mountain of jumbled books. Antiquarian volumes of all sizes surround him, with some piled so high that they even overshadow his armchair. Indeed, the industrialist and art patron appears almost cocooned by his collection. Schiele (1890–1918), who painted this portrait shortly before his death from influenza, was clearly fascinated by the objects of Koller's obsession. The varied leather and vellum bindings and tinted fore-edges are rendered as a motley patchwork of colours and textures. Despite the abundance, Schiele showed only a fraction of the sitter's vast library, which reportedly comprised several thousand volumes. The chaos of Koller's collection suggests that the bibliophile took more pleasure from reading his books than their physical maintenance, a fact confirmed by Schiele's inclusion of the open volume on his lap. While its subject is not revealed, it could well be a treatise on medicine, mathematics or physics, all of which Koller had studied formally in relation to his doctoral work in the field of electrochemistry.

'Beware you be not
swallowed up on books!
An ounce of love
is worth a pound
of knowledge.'

John Wesley (1703–91)

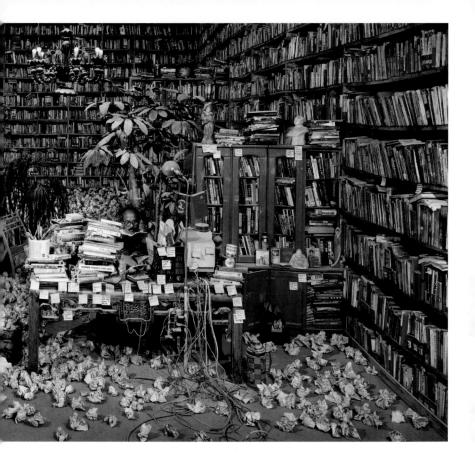

Follow Him
Wang Qingsong
2010, C-print
130 × 300 cm (51 ⅕ × 118 ⅛ in)

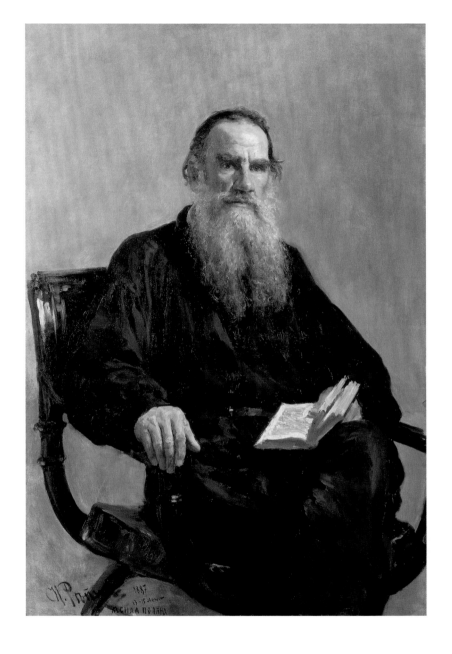

Portrait of Leo Tolstoy
Ilya Efimovich Repin
1881, oil on canvas
124 × 88 cm (48 ¾ × 34 ⅝ in)
Tretyakov Gallery, Moscow

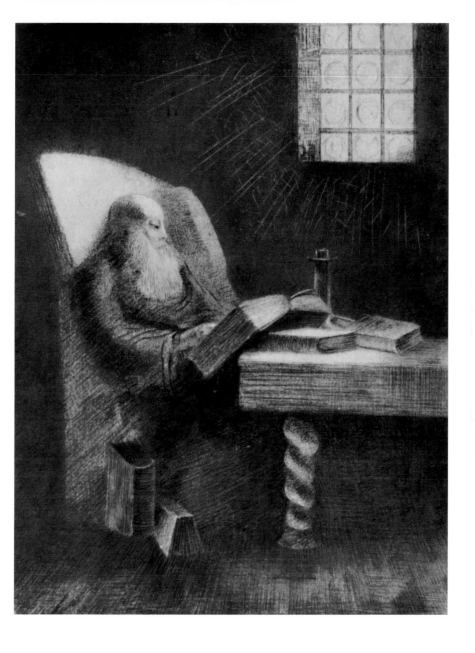

The Reader
Odilon Redon
1892, lithograph with chine appliqué
30.9 × 23.7 cm (12 × 9 in)
Museum of Modern Art, New York

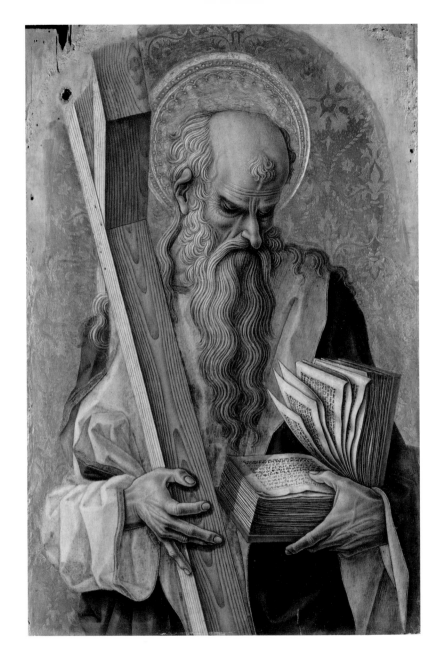

Saint Andrew
Carlo Crivelli
1476, tempera on poplar, 61 × 40 cm (24 × 15 ¾ in)
National Gallery, London

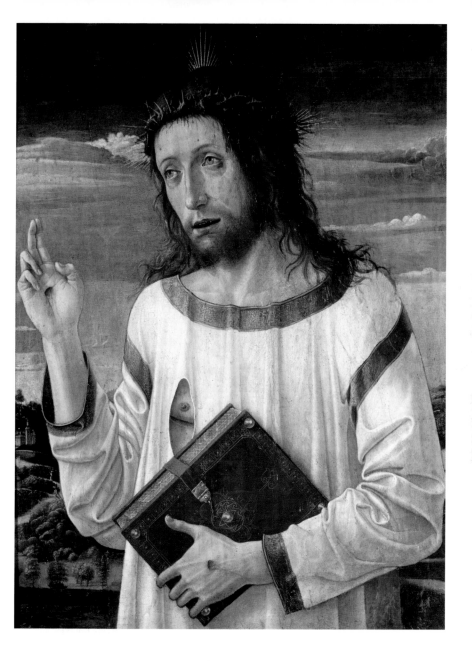

Christ Blessing
Giovanni Bellini
1459, tempera on wood
58 × 46 cm (22 ¾ × 18 ⅛ in)
Musée du Louvre, Paris

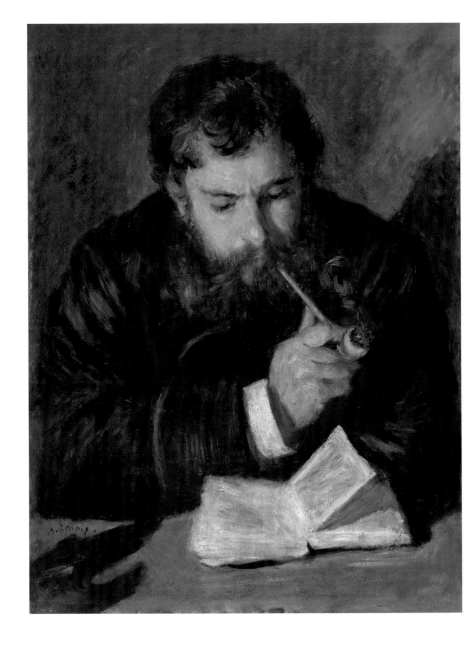

Claude Monet
Pierre-Auguste Renoir
1873–4, oil on canvas
65 × 50 cm (25 ⅝ × 19 ⅝ in)
National Gallery of Art, Washington DC

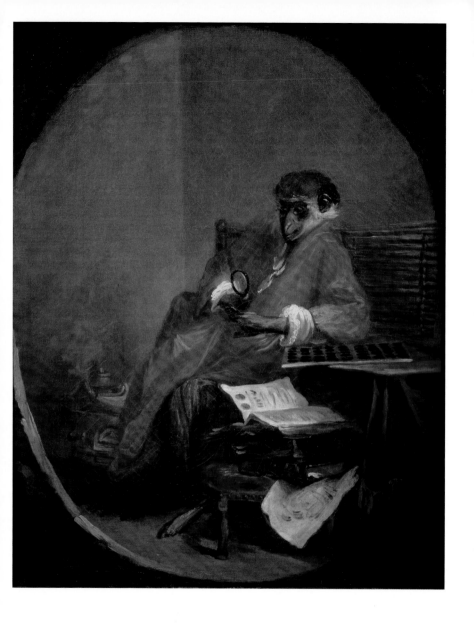

The Antiquarian Monkey
Jean-Siméon Chardin
c.1726, oil on canvas
81 × 64.5 cm (31 ⅞ × 25 ¼ in)
Musée du Louvre, Paris

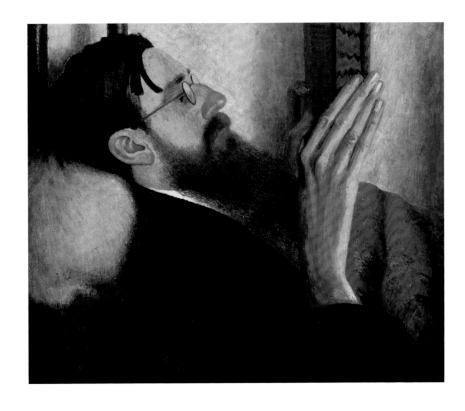

Lytton Strachey
Dora Carrington
1916, oil on panel
50.8 × 60.9 cm (20 × 24 in)
National Portrait Gallery, London

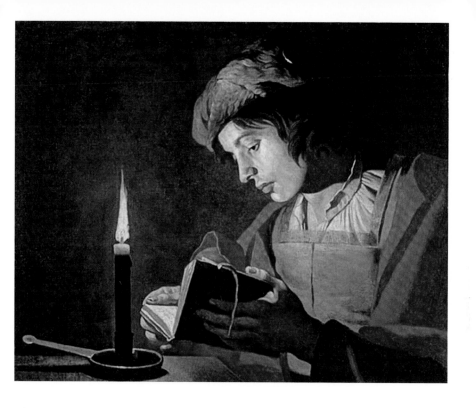

A Young Man Reading by Candlelight
Matthias Stom
c.1630, oil on canvas
58.5 × 73.5 cm (23 × 29 in)
Nationalmuseum, Stockholm

Reading by Lamplight
James Abbott McNeill Whistler
c.1859, etching
20.3 × 15.9 cm (8 × 6 ¼ in)
Los Angeles County Museum of Art

The Oil Lamp
Pierre Bonnard
1898–1900, oil on panel
55.3 × 51.8 cm (21 ¾ × 20 ⅜ in)
Fitzwilliam Museum, Cambridge, UK

Christian Reading His Book, from
'The Pilgrim's Progress' by John Bunyan
William Blake

c.1824, watercolour, dimensions unknown, Frick Collection, New York

A hunched figure straining under the weight of a heavy burden is studying an open book. This is Christian, the protagonist of John Bunyan's *The Pilgrim's Progress* (1678), one of the most widely read and influential books in English literature. Depicting the pilgrim with a despondent expression, Blake (1757–1827) shows him setting out on his epic journey from the City of Destruction to the Celestial City. The watercolour is one in a series of twenty-eight illustrating Bunyan's novel that the artist produced shortly before his death. The project was never completed, and the images were not used in an edition of the book until 1941. *The Pilgrim's Progress* was intended as a spiritual lesson, an allegory of the Christian life in which a searcher after truth journeys from earth to heaven guided by the words of a book. Although the book's identity is not explicitly revealed, it is assumed to be the Bible due to Christian's statement that it was 'made by Him that cannot lie' (i.e. God). The Bible was an immensely important source of creative inspiration for Blake, and the resemblance here of Christian to the artist himself as a young man suggests that he identified closely with Bunyan's pilgrim.

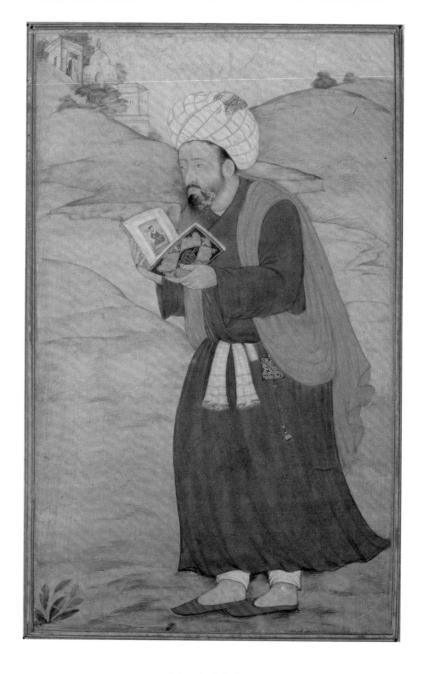

Islamic Scholar
Artist unknown (Mughal School)
late 17th century, 10.6 × 6.7 cm (4 ⅛ × 2 ⅝ in)
Museum für Islamische Kunst, Staatliche Museen, Berlin

Portrait of Jacques Nayral
Albert Gleizes
1911, oil on canvas, 161.9 × 114 cm (63 ¾ × 45 in)
Tate, London

Portrait of John Forste (Man with Glass Eye)
George Grosz
1926, oil on canvas, 104 × 73.7 cm (41 × 29 in)
Private collection

Portrait of Nakib Khan
Artist unknown (Mughal School)
early 17th century, tempera
31.4 × 20.5 cm (12 ⅜ × 8 in)
Collection of the Hermitage, St Petersburg, Russia

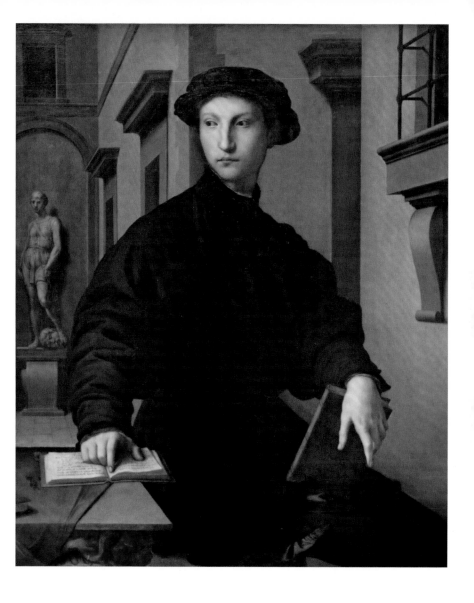

Portrait of Ugolino Martelli
Agnolo Bronzino
1536–7, oil on poplar wood
102 × 85 cm (40 ⅛ × 33 ½ in)
Gemäldegalerie, Staatliche Museen zu Berlin

'There are as many good writers as ever there were. The problem is that there are so few good readers.'

Gore Vidal (1925–2012)

The Subjugated Reader
René Magritte
1928, oil on canvas
92 × 73 cm (36 ¼ × 28 ¾ in)
Louvre Abu Dhabi

A WORD TO THE WISE.
HAVE A BOOK IN CASE YOU ARE BORED.

**A Word to the Wise – Have a Book in Case
You are Bored, from 'Life' Magazine**
Charles Dana Gibson
1900, halftone lithograph on heavy stock paper
28.9 × 43.5 cm (11 3/8 × 17 1/8 in)

Nude Reading
Roy Lichtenstein
1992, relief print on paper
77.8 × 92.2 cm (30 ½ × 36 ⅓ in)
Tate, London

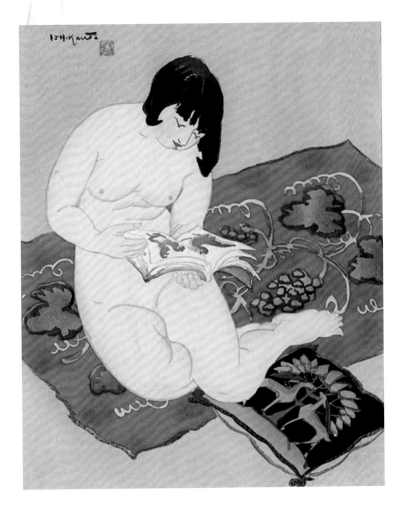

Reading ('Dokusho'), from the series
'Ten Types of Female Nudes' ('Rajo Jusshu')
Ishikawa Toraji
1934, colour woodblock, 48 × 37 cm (18 ⅞ × 14 ½ in)
National Gallery of Victoria, Melbourne

A naked woman relaxes on a rug, gazing at an illus-trated magazine. Her fashionable hairstyle, choice of reading matter and non-traditional furnishings identify her as a Japanese *moga* or modern girl, a young and independent female who enjoys Western fashion and tastes. Emerging in the 1920s, the *moga* defied tradi-tional cultural expectations by embracing the lifestyles and attitudes of European and American youth. Rising literacy among Japanese women during this period was reflected by an increase in women's magazines. Ishikawa (1875–1964) makes reference to the new lit-erature in this woodblock print, which belongs to his 'Ten Types of Female Nudes' series. Each print features a buxom young girl in the privacy of her own home. The tightly framed compositions generate an intimacy with the subjects, which adds to the prints' erotically charged atmosphere. The series was an attempt to update the traditional Japanese subject of *bijin-ga* (beautiful women) in the style of the *shin-hanga* (new prints) art movement that sought to fuse traditional Japanese art with modern Western influences such as Impressionism. However, the prints proved highly controversial and were immediately banned by the Japanese authorities.

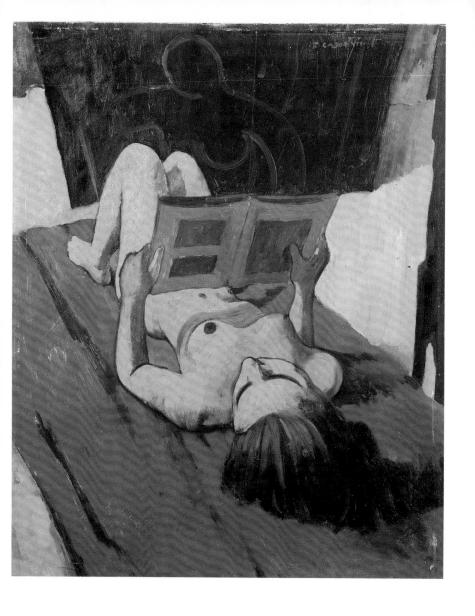

Reclining Nude Reading
Felice Casorati
c.1943, oil on panel, 50 × 40 cm (19 ⅝ × 15 ¾ in)
Private collection

'When I have a little money, I buy books; and if I have any left, I buy food and clothes.'

Erasmus of Rotterdam (1466–1536)

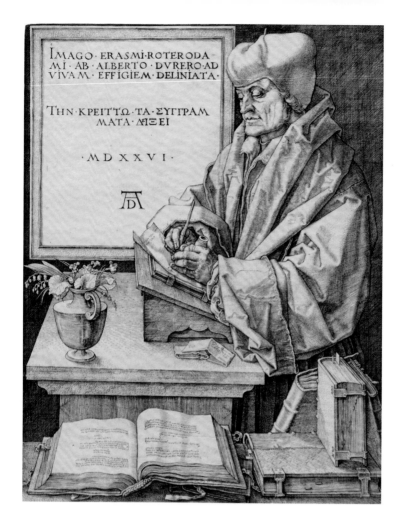

Erasmus of Rotterdam
Albrecht Dürer
1526, engraving on laid paper, 24.5 × 19 cm (9 ⅝ × 7 ½ in)
Victoria & Albert Museum, London

This elaborate half-length portrait shows the renowned humanist scholar and Catholic theologian Erasmus of Rotterdam (1466–1536) standing at a table writing a letter with a reed pen. On a shelf in the foreground are several books that indicate Erasmus's internationally celebrated intellect and literary interests. The open volume is probably the *Adagia* (1500), his annotated collection of Greek and Latin proverbs. However, his most influential publication was the *Novum Instrumentum omne*, the first printed New Testament in Greek (1516). Also known as the *Textus Receptus*, the translation provided the textual base for the vernacular New Testaments of the Protestant Reformation. Erasmus commissioned this engraving himself after meeting with Dürer (1471–1528) in the Netherlands in 1520 and 1521. Although the image is one of the best-known portraits of the scholar, it is apparently not a good likeness. Yet despite his own criticisms of the print, Erasmus allowed copies to circulate. The inscription in Latin and Greek, framed like a painting on the wall behind him, reads: 'This image of Erasmus of Rotterdam was drawn from life by Albrecht Dürer. His writings show a better portrait'. The engraving remains one of the richest depictions of scholarly sophistication in the history of art.

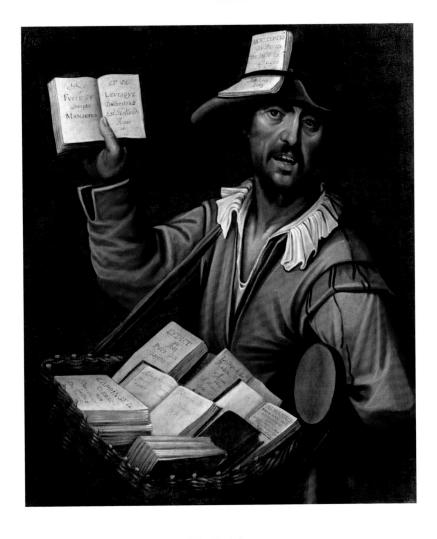

The Peddler
Artist unknown (French School)
17th century, oil on canvas, 72 × 85 cm (28 ⅜ × 33 ½ in)
Private collection

With a basket full of cheap books and printed pamphlets strapped around his body, this itinerant salesman holds aloft his latest wares. Book peddlers such as this were a common sight across rural Europe in the seventeenth century. Known as 'colporteurs', they are regarded as the most important distributors of popular printed material between 1600 and 1850. Travelling from village to village, they hawked their merchandise in market squares, taverns, open fields and, sometimes, door to door. New types of books were appearing on the market at a rapid rate during this period; chapbooks, broadsides, political and religious pamphlets, almanacs and songbooks were all distributed by colporteurs, playing a significant role in the growth of the book trade in non-urban areas. Entrepreneurial publishers in England and Holland relied heavily upon travelling peddlers to distribute their products among communities that could not easily access the established booksellers in towns and cities. Colporteurs also helped to spread revolutionary ideas. Consequently, they increasingly found themselves viewed with suspicion by those in authority and many attempts were made to regulate and at times suppress their activities.

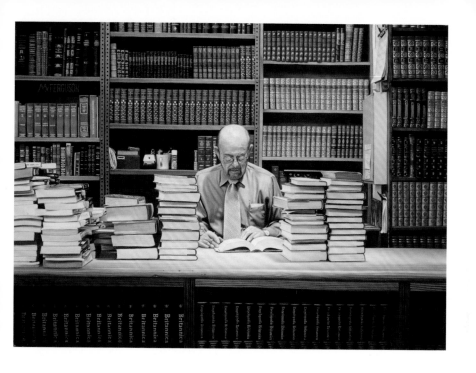

Strand Book Store
Max Ferguson
2010, oil on panel
40.6 × 55.9 cm (16 × 22 in)
Private collection

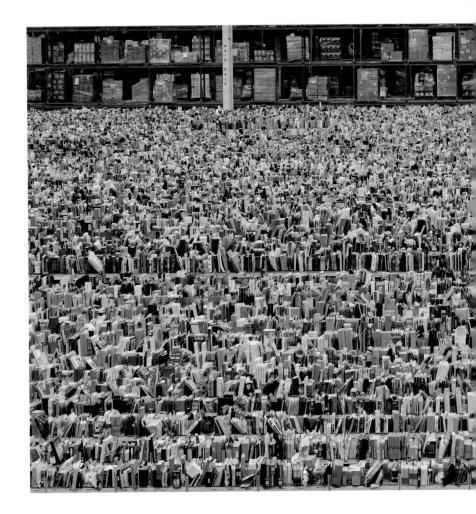

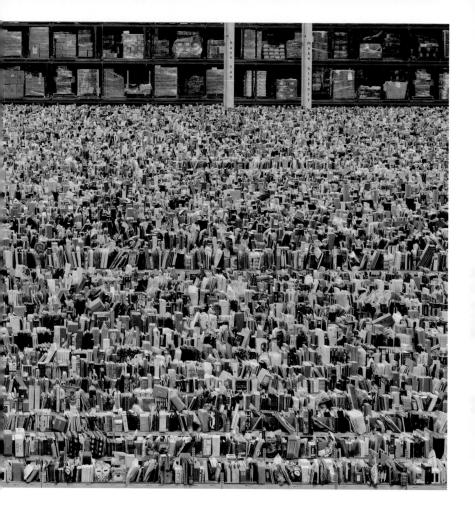

Amazon
Andreas Gursky
2016, C-print
207 × 407 × 6.2 cm
(81½ × 160¼ × 2½ in)

This vast ocean of consumer goods represents just a small percentage of stock at Amazon's million-square-foot warehouse in Phoenix, Arizona. Not only is the scene packed with books but also thousands upon thousands of other objects, such as soft toys, mugs, ink cartridges, boxing gloves and electrical items. Gursky (b.1955), who is known for his detailed, large-format photographs that document various aspects of the modern world, positioned his camera high up in the warehouse, overlooking the rows and rows of jam-packed shelves. Nothing here is orga-nized alphabetically, or even by product type; rather, the items are placed according to a computer algo-rithm based on consumer spending patterns. Order pickers rely on machines to locate products from the dizzying array, which is arranged so that items can be retrieved as quickly as possible. Books made Amazon what it is today, but the diversity of goods on show reflects the extent to which the behemoth retailer has diversified since beginning as one of the world's first online booksellers in 1995. Its aim then was to provide the widest selection of books on the Internet. Now, evidently, it wants to offer the greatest selection of goods on the planet.

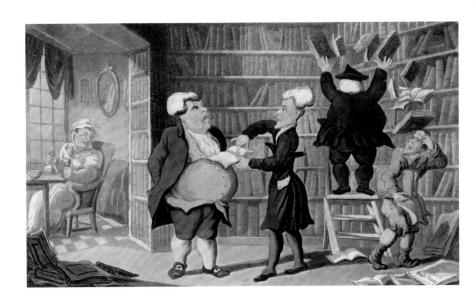

Dr Syntax and the Bookseller, from
'The Schoolmaster's Tour' by William Combe
Thomas Rowlandson
1812, aquatint on paper
11 × 19 cm (4 ⅜ × 7 ½ in)

Dr Syntax, the fictional schoolmaster, is arguing with a disinterested bookseller who refuses to publish his travel journal. Gesturing to the book, which rests comically on the man's bulging stomach, Syntax tries to convince him of its potential. Behind them, a portly gentleman on a stepladder sends books flying onto a young man's head while the dealer's wife watches on disapprovingly. This illustration by Rowlandson (1756–1827) was the first of many he produced for *The Poetical Magazine* during the early nineteenth century. Published under the title 'The Schoolmaster's Tour', they were accompanied by the comic verse of William Combe. So popular was the series that in 1812 it was compiled as a book. The idea was to parody the phenomenon of 'picturesque tourism' promoted by the illustrated travel books of William Gilpin. Inspired by his ideas, travellers journeyed through Britain's landscapes in search of 'the picturesque'. Attempting to emulate Gilpin's success, imitators flooded the market with second-rate copies. The reluctance of this bookseller to publish Syntax's guide reflects the oversaturation of the market at this time. In creating Dr Syntax, Rowlandson was not mocking tourists but rather deriding those who exploited the latest trends in publishing.

Days since the Last Episode: 366
Sebastián Gordín
2011 (detail), wood, veneer, glass, bronze and LEDs lights
53 × 159 × 151 cm (20 ⅞ × 62 ½ × 59 ½ in)
Colección Gabriel Vázquez, Buenos Aires

A great calamity has hit this library; its shelves are toppling like dominoes, sending volumes tumbling to the floor. Presented in a glass display case, the miniature scene is frozen like a film still. Books are suspended in mid-air and the floor appears to be collapsing. Viewers are cast simultaneously as voyeurs and detectives and left to speculate as to what mysterious event lies behind this Lilliputian disaster. Gordín (b.1969) is well known for his small-scale wooden sculptures depicting moments of intense drama and imminent threat. But with their elusive context, experiencing his works is like stumbling into a story halfway through. The artist has made several pieces on the theme of books, echoing his roots in Buenos Aires, a city with more bookshops per inhabitant than any other. Though Argentina has a rich literary legacy, it also has a history of state censorship. The military junta that governed the country between 1976 and 1983 banned and destroyed many books. Although Gordín is not a political artist, it is hard not to see in these works subtle references to the era of cultural repression in which he was raised.

'When you sell a man a book, you don't sell him 12 ounces of paper and ink and glue – you sell him a whole new life.'

Christopher Darlington Morley
(1890–1957)

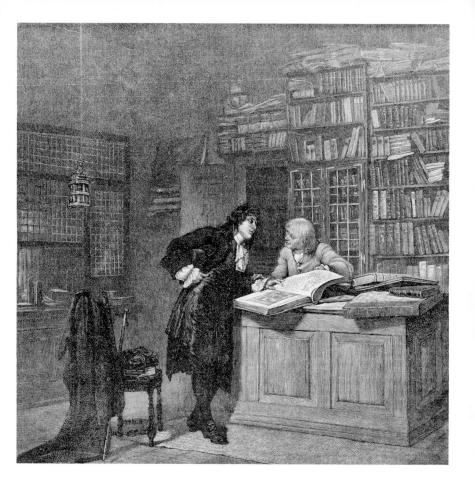

**Antiquariat in Antwerp
(after painting by Albertus Wirth)**
Artist unknown
c.1890, wood engraving
17.7 × 17.7 cm (7 × 7 in)

Street Bookseller
from the series 'China Shanghai'
Henri Cartier-Bresson
1949, gelatin silver print

A Chinese youth dressed in T-shirt and shorts is enjoying the summer sun while engrossed in a book at a Shanghai street market. His chosen reading matter provides him with a moment of solace in the midst of the political turmoil and social upheaval unfolding all around him. Cartier-Bresson (1908–2004) took this image whilst working as a photojournalist covering the end of the Chinese Civil War. After documenting Beijing on the eve of its fall to forces loyal to Chairman Mao, he flew to Shanghai, where his camera recorded the takeover of the country's largest city by the People's Liberation Army. This

was a significant turning point in the history of modern China and Cartier-Bresson captured many momentous events, such as the panic unleashed by the currency crash, and the Communist Party's celebratory parades. But he also documented everyday activities. For the youth in this photograph life was about to change significantly, not least in the matter of censorship. In fact, it was not long after that the new regime began to ban and suppress literature that did not conform to the official government view. Later, many books and even entire libraries were burned and destroyed.

The Prisoner of the Book No. 1
Zhang Xiaogang
2013, oil on paper
40 × 30 cm (15 ¾ × 12 in)

In this dream-like painting a man wearing blue trousers sleeps precariously on an armchair. He appears to be fettered by a large open book, which restrains his head and hands like medieval stocks. The man has ostensibly been so influenced by the book that its contents have captured his mind. The bright yellow light shining onto his face suggests that an interrogation is about to take place, though it is unclear to whom, or what, the man might be answerable. The surreal scene is one of several similar paintings by Zhang (b.1958) exploring the theme of subversive literature. Books can be entertaining, enlightening and even liberating, but can also contain ideas that, if consumed uncritically, have the power to enslave one's mind. Zhang, who today is one of the most influential contemporary artists in China, spent his youth in a Communist 're-education camp' during Chairman Mao's Cultural Revolution. This was the era between 1966 and 1976 when books not meeting with state approval were banned and destroyed. It was also the period when Chinese citizens were expected to own a collection of Mao's quotations known as the Little Red Book, which became the country's most visible and influential publication.

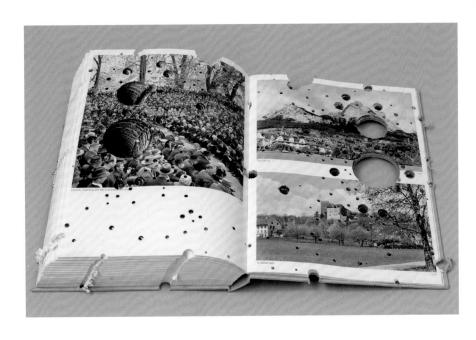

The EU
Jonathan Callan
2006, paper
44 × 31 × 6 cm (17 ⅜ × 12 ¼ × 2 ⅜ in)

Like a geologist extracting core samples from the earth's crust, Callan (b.1961) has drilled right through this book, peppering it with holes so that it appears like Swiss cheese. Though the volume is structurally compromised, it is still possible to turn its pages. Here it is seen open at a spread containing photographs of Switzerland, ironic considering the work's title: the country is one of the few eligible states not to have joined the European Union (EU), the political and economic union of nearly thirty nations. While the holes can be interpreted as an attack, they can also be seen as a unifying process, connecting each page with a shared history. Callan produced this sculpture partly in response to fierce debates about the EU's strengths and weaknesses. These arguments continue today, reflected most acutely by the UK's 'Brexit' decision, taken a decade after this work was made. Nevertheless, Callan, who is not a political artist, considers these issues to merely be subtexts since his interest lies primarily in the material properties of books. He cuts, drills, scratches and corrodes all manner of published literature in order to emphasize the physicality and limitations of the printed book.

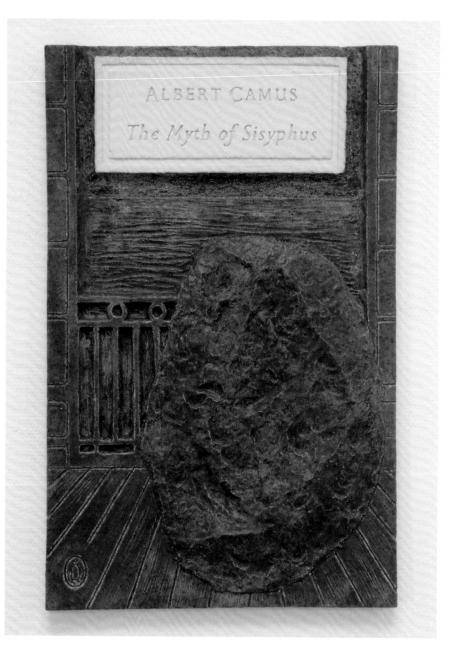

Mont Ventoux
William Cobbing
2014, glazed ceramic
74 × 49 × 3 cm (29 ⅛ × 19 ¼ × 1 ⅛ in)

Saint John Devouring the Book
from 'The Apocalypse'
Albrecht Dürer

1498, woodcut, 39.6 × 28.7 cm (15 ¾ × 11 ¼ in)
National Gallery of Art, Washington DC

With his mouth wide open, Saint John receives a book from a radiant angel's hand and begins to eat it. This woodcut illustrates a passage from the Book of Revelation (also known as the Apocalypse), which records the saint's extraordinary and nightmarish vision of the end of the world. In chapter ten the author writes that he was commanded by Christ to take a scroll from an angel who instructed him to 'eat it up; and it shall make thy belly bitter, but it shall be in thy mouth sweet as honey'. The meaning is that John is to internalize and then communicate the angel's words regarding the fate of humankind. But Dürer (1471–1528) interprets this metaphorical language literally, depicting the saint cramming the pages into his open mouth. The Revelation became an increasingly popular subject in the years before 1500, when it was widely believed that the world would end. Published in 1498, Dürer's 'The Apocalypse' comprised fifteen vivid and at times terrifying woodcuts illustrating various episodes from the divine vision. Capturing the fears of the age, it sold incredibly well and is today regarded as one of the most important works in the history of printmaking.

Art and Culture
John Latham

1966–9, leather case containing book, letters, photostats
and labelled vials filled with soot and burned paper
closed: 7.9 × 28.2 × 25.3 cm (3⅛ × 11⅛ × 10 in)
Museum of Modern Art, New York

A copy of Clement Greenberg's *Art and Culture* (1961), the anthology of the American art critic's writings, rests on top of an open briefcase containing glass vials, letters and photocopies. These are the remnants of a radical action that cost Latham (1921–2006) his job. He was opposed to Greenberg's view of modern art, especially the critic's emphasis on the formal content of painting and his claim that British art was too tasteful. In 1966 Latham borrowed a copy of *Art and Culture* from the library of St Martin's School of Art in London, where he was teaching. He organized an event at his home titled *Still and Chew*, where guests were invited to rip out pages from the book, chew them up and deposit them into a flask. Declaring Greenberg's writings to be tasteless and indigestible, Latham took the masticated pulp and, adding chemicals and yeast, fermented it for a year. When the school's library issued an overdue notice for the book, he returned its remains in a glass vial labelled 'Art and Culture'. His teaching contract was not renewed. Beginning with this conceptual piece, books and their destruction emerged as a significant theme in Latham's work.

The Parthenon of Books
Marta Minujín
1983/2017, metal scaffolding, books, plastic, c.10 × 70 × 30 m (c.32 ⅞ ft × 229 ⅝ ft × 98 ⅜ ft)
installation view at documenta 14, Kassel, Germany

Thousands of censored books have been used to create this full-size replica of the Parthenon. For Minujín (b.1943), the classical Greek temple on the Acropolis in Athens is a powerful symbol of the political ideals associated with the world's first democracy. The books, which were donated by the public, have all been banned in different parts of the world at various times. Among the many authors included here are Bertolt Brecht, Albert Einstein, Anne Frank, Franz Kafka, Harper Lee, Karl Marx, George Orwell, Mark Twain, Leo Tolstoy and Salman Rushdie. Many of them are now considered classics of world literature, but wrapped in plastic, hanging from the vast steel structure, they serve as a reminder that censorship remains a reality for many today. Minujín chose to erect this monument to democracy and free speech in front of the Fridericianum, the world's oldest public museum and once Kassel's city library. On this very spot in 1933, some two thousand books were burned during the Nazi's nationwide campaign against 'the Un-German Spirit'. It is the second time Minujín has built such a temple of books. The first was in 1983 in her native Buenos Aires, where she used titles that had been forbidden by the military dictatorship of Argentina.

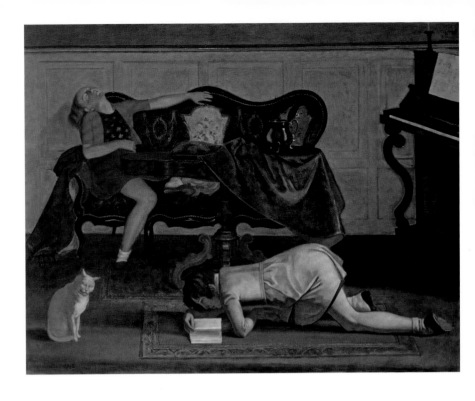

The Living Room
Balthus
1942, oil on canvas
114.8 × 146.9 cm (45 ¼ × 57 ⅞ in)
Museum of Modern Art, New York

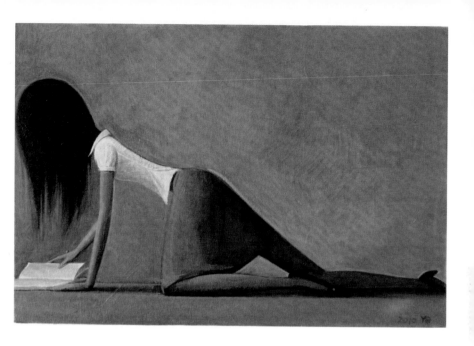

Banned Book 3
Liu Ye
2010, acrylic on canvas
20 × 30 cm (7 ⅞ × 11 ¾ in)

A young woman in a white blouse and green skirt is kneeling on the floor, absorbed in a book. Her pose is reminiscent of the girl reading in Balthus' *The Living Room* (1942). That painting includes many domestic details, but Liu's (b.1964) composition is pared down to simple forms. Children often adopt unusual reading positions, a phenomenon that Balthus playfully exploits. However, Liu's painting, as its title suggests, is more ambiguous. Few clues are given as to the location, with context stripped away, leaving a simple, saturated backdrop of blue and grey. The girl seems tense, poised as if ready to jump up at a moment's notice. The close cropping of the image adds to the sense of tension, while the girl's hidden face suggests that she too is perhaps hiding. Liu grew up during China's Cultural Revolution, a period when all art was controlled by the state and individual expression was strictly forbidden. On one occasion he discovered his father's secret collection of Western literature, which contained many banned books. That pivotal moment, which is referenced here and in many other works, greatly influenced the development of his art.

'There are worse crimes than burning books. One of them is not reading them.'

Joseph Brodsky (1940–96)

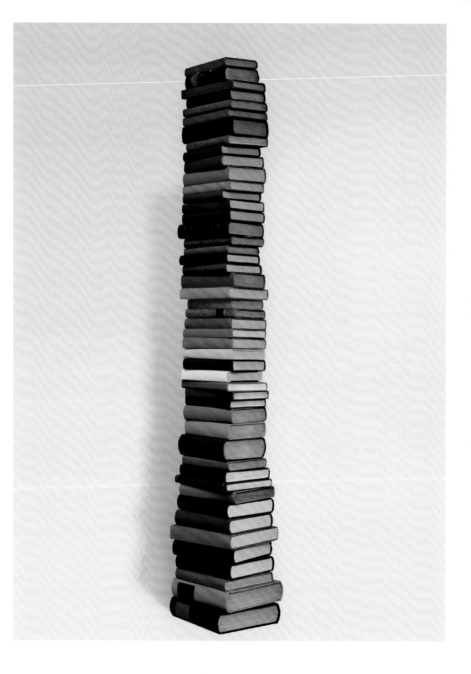

Ignorance
Phil Shaw
2013, wood, book cloth and acrylic
187 × 34 × 30 cm (73 ⅝ × 13 ⅜ × 12 in)

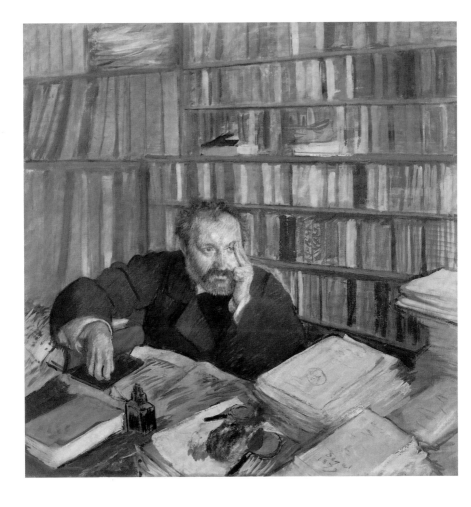

Edmond Duranty
Edgar Degas
1879, gouache with pastel on linen
128 × 127 cm (50 ⅜ × 50 in)
Burrell Collection, Glasgow

Bookcase from 'Full Stop'
Tom Burckhardt
2004–5, acrylic paint on cardboard, glue and wood
183 × 81.3 × 25.4 cm (72 × 32 × 10 in)
Collection of Adam Baumgold, New York

The Pinch of Snuff (Rabbi)
Marc Chagall
1923–6, oil on canvas
116.7 × 89.2 cm (46 × 35 1/8 in)
Kunstmuseum Basel, Switzerland

The Jewish Metaphysics of Death
Clegg & Guttmann
2004, dimensions variable, installation at Jüdischer Friedhof, Krems, Austria

These slender bookcases stand amongst the graves of a Jewish cemetery in the Austrian city of Krems. Founded in 1881, the graveyard was almost totally destroyed during the Nazi regime's rampant persecution of the Jews. The damage was so bad that it was abandoned, and it wasn't fully restored until the mid-1990s. Michael Clegg and Yair Martin Guttmann (both b.1957) installed these shelves as both a memorial and a functioning library for the local community. The cases, which mirror the form of the surrounding headstones, are stocked with books on the themes of Jewish history, philosophy, religious law, and death.

Visitors can borrow any that are of interest and can also donate their own books to the collection. The installation is part of the artists' 'Open Public Library' project, which, since 1991 has seen them establish several similar community libraries in Austria and Germany. Placed outdoors on street corners, urban wasteland, and other unorthodox locations, each is stocked with donated books from the local community and is open to all. The libraries are intended to stimulate social imagination and collective responsibility, and, with no formal membership, they rely solely on the honesty and goodwill of the general public.

'The paper burns,
but the words fly free.'

Akiba ben Joseph (AD c.50–135)

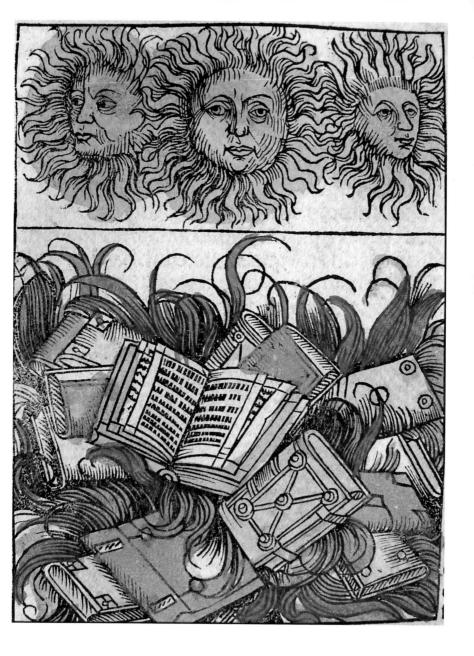

Burning Books in the Library of Alexandria
from the Nuremberg Chronicle
Michael Wohlgemut
1493, woodcut on paper, 14 × 11 cm (5½ × 4⅜ in)
University Library, Cambridge, UK

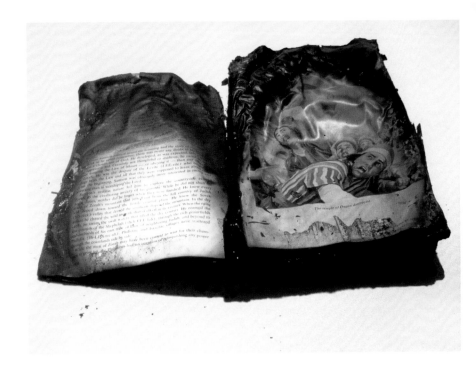

The Temple of Dagon is Destroyed
Cornelia Parker
1997, Bible retrieved from a church struck by lightning
3.5 × 36 × 22 cm (1 ⅜ × 14 ⅛ × 8 ⅝ in)

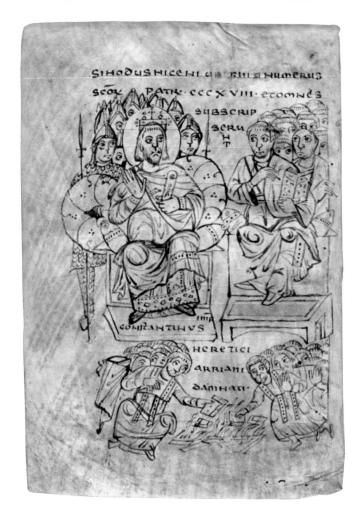

Constantine Burning Arian Books
Artist unknown
c.825, drawing on vellum, dimensions unknown
Biblioteca Capitolare, Vercelli, Italy

Constantine, Emperor of Rome, flanked by soldiers, presides over the burning of heretical writings at the Council of Nicaea (AD 325). More than three hundred Christian bishops attended the Council in Turkey, which was convened to address the controversial teachings of the Alexandrian church leader Arius. There was much unrest between those who believed that Jesus was fully divine and the Arians, who taught that he was created by God. Constantine, who had legalized Christianity then made it the official religion of the Empire, recognized that ecclesiastical unity was essential to social stability. It was therefore in his interest to help establish orthodoxy in the Church and root out different views as divisive heresies. Critics of Arius argued that if Christ was not God then his death for sin was ineffective, because only God could forgive sins. Consensus was reached, and belief in the deity of Christ has remained fundamental to orthodox Christianity ever since. After the Council, Constantine issued an edict against the Arians, which included the systematic burning of their teachings. This drawing on calfskin vellum shows codices – bound books – being thrown into the flames. However, Constantine is holding a scroll: a reflection of the evolution that books underwent during the first millennium of the Christian era.

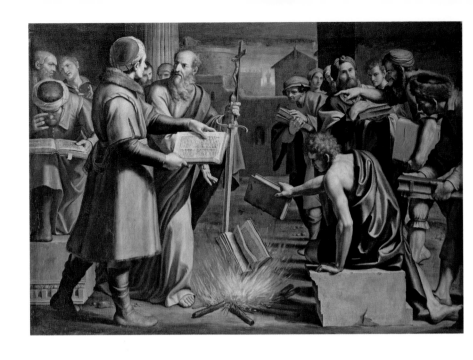

Saint Paul and the Burning of Pagan Books at Ephesus
Lucio Massari
c.1612, oil on canvas, 193 × 277.5 cm (76 × 109 ¼ in)
Private collection

Flames lick at the pages of a book as it is hurled into a fire. More volumes are waiting to be consumed as Saint Paul, sword and crucifix in hand, encourages the apparently wanton destruction. The subject of this painting is found in the biblical book of Acts (19:18-20). After preaching in the city of Ephesus for two years, Paul saw many conversions to Christianity. A number of converts were sorcerers and, recognizing the incompatibility of paganism with faith in Christ, they came forward to burn their occult scrolls. Massari (1569-1633) places Paul at the centre of the scene, overseeing the destruction. A crowd of converts surrounds him, each one bringing fuel for the pyre. Some on the left appear to be debating their texts, while a hunched, bespectacled figure gives his manual of incantations one final inspection. The Bible records that the value of the burned volumes totalled fifty thousand drachmas, a substantial sum considering that one drachma was an average day's wage. Although the burned materials would have been scrolls, Massari depicts them as books, with expensive bindings contemporary to the seventeenth-century viewer. The faith of the new believers is thus shown to be of far more worth than material possessions.

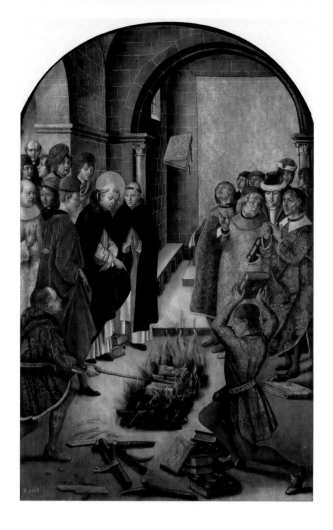

Saint Dominic and the Albigensians
Pedro Berruguete
1493–9, oil on panel, 122 × 83 cm (48 × 32 ⅝ in)
Museo Nacional del Prado, Madrid

Books are burning under the watchful eye of Saint Dominic. A servant stokes the blaze while another prepares to throw more volumes into the flames. Hovering in mid-air above the heads of the gathered onlookers is a lone book, which has leapt out of the fire miraculously unscathed. Berruguete (1450–1504) based this painting on an apocryphal account of a Dominican 'trial by fire', intended to be a means of establishing the truth. This scene depicts an encounter between Dominic and a Christian quasi-monastic sect known as the Albigensians, whom the Catholic Church had branded heretical. To test the veracity of the group's beliefs, books containing the teachings of both parties were cast into a fire; any book to survive the flames was deemed to contain the truth. According to the Dominican account, the literature of the heretics was totally devoured while the volume containing Dominic's words flew from the fire three times unharmed. The miracle therefore proved to the Albigensians that their doctrine was in error. In reality, such alternative groups represented a threat to the hegemony of the Catholic Church and consequently were mercilessly persecuted throughout the Inquisition.

Table with the Law
John Latham
1988, table with glass and ten books
75 × 33 × 76 cm (29 ½ × 13 × 29 ⅞ in)

The severed remains of several large hardback books sit on top of a wooden dining table. They belong to a series of commentaries on the laws of England established by Henry John Stephen in the 1840s. Many of the red bindings are pinned down by large shards of broken glass, which ensure that none can be opened and read. With this sculpture and many similar works, Latham (1921–2006) highlights the fragility of human systems of knowledge, language and communication. From the mid-1960s, books and their destruction emerged as a significant motif in his work. Over the following decades he set fire to books, blew them up, chewed them to a pulp, glued them shut, painted over them, cut them, dissolved them in acid and even submerged them in a tank of piranha fish. His choice of texts was provocative too, focusing primarily on encyclopaedias, legal books and art historical texts, all representative of the establishment. But Latham's art was not about iconoclasm or destruction per se; rather, by subverting the material substance of books, he wanted to transform then into something new and distinct. In doing so he raised questions about the nature of art, knowledge and time.

Burning Books
Adrian Ghenie
2014, oil on canvas
189.9 × 129.9 cm (74 ¾ × 51 ⅛ in)

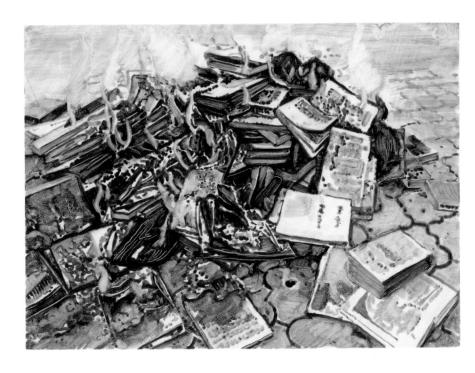

Burning Books
Greg Rook
2015, oil on paper
19.5 × 26.5 cm (7 ¾ × 10 ½ in)

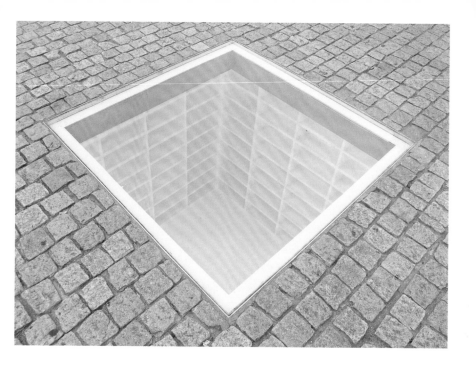

Library
Micha Ullman
1995, book burning memorial, Bebelplatz, Berlin
cement, glass, light, internal dimensions: 5.3 × 7 × 7 m
(17 3/8 × 22 7/8 × 22 7/8 ft)

A glass window set into the cobbled pavement of Berlin's Bebelplatz reveals a subterranean library. But its stark white shelves are completely empty; looking down into the void, not a book is to be seen. Ullman's (b.1933) underground memorial marks the spot where on 10 May 1933 some 40,000 people gathered to watch National Socialist students burn the work of hundreds of blacklisted authors deemed to be 'decadent' or 'un-German'. It is estimated that around 20,000 books were destroyed in the conflagration, which was part of a nationwide 'action against the un-German spirit'. The Nazi librarian Wolfgang Herrmann compiled the list of objectionable materials, and books were plundered from the city's libraries, bookshops and academic collections. Among the banned writers were Heinrich Mann, Ernst Glaeser, Erich Kästner, Rosa Luxemburg and August Bebel. Adjacent to Ullman's empty library is a bronze plaque bearing an inscription based on lines from Heinrich Heine's 1821 play, *Almansor*: 'Where they burn books, they will ultimately burn people'. This epigram is a reminder that the Nazi book burnings anticipated the mass extermination of entire populations. Ullman's memorial to the burning of inanimate objects is simultaneously one to the Holocaust itself.

Saint John on Patmos
Hans Baldung
c.1511, oil, gold and white metal on spruce
89.5 × 76.8 cm (35 ¼ × 30 ¼ in)
The Metropolitan Museum of Art, New York

Revelations, Divine Violence
Broomberg & Chanarin
2013, King James Bible,
Hahnemühle print, brass pins
framed: 79 × 79 × 5 cm (31⅛ × 31⅛ × 2 in)

When Adam Broomberg (b.1970) and Oliver Chanarin (b.1971) discovered the personal Bible of Bertolt Brecht, they were immediately drawn to the image of a racing car glued to its cover. Inside, they discovered the German playwright had pasted in more pictures and heavily annotated the text. Taking this encounter as a starting point, the artists produced their own illustrated Bible, combining underlined pages from the seventeenth-century King James translation with material from the Archive of Modern Conflict, one of the world's largest collections of war photography. Underpinning the work is the observation that throughout the Scriptures God reveals himself in acts of calamity and destruction. This is especially true of the Book of Revelation, in which Saint John the Divine describes episodes of great tribulation as world history approaches its climax. Juxtaposing apparently incongruous texts and images, the artists' selections exert the same terrifying fascination as the Apocalypse itself. The 9/11 terrorist attacks appear alongside verses describing the battle of Armageddon, while a B-29 bomber appears by a passage describing God's wrath. Treating each of the Bible's sixty-six books in the same way, the artists have published the entire project under the title *Holy Bible* (2013).

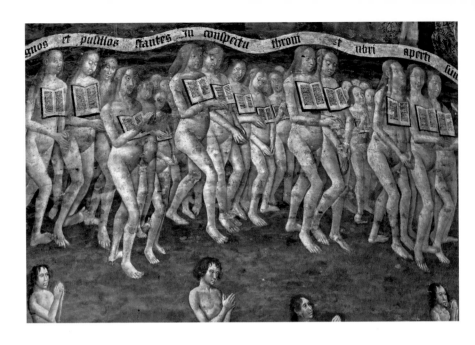

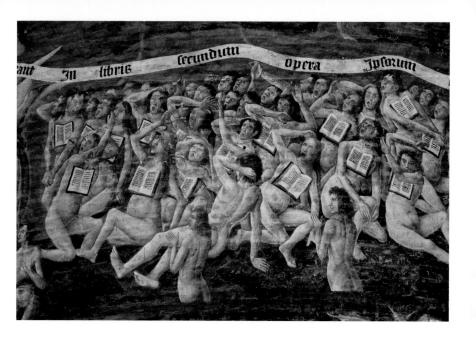

The Last Judgement
Artist unknown (Flemish School)
1474–84, fresco (details)
overall: c.16.4 × 15.6 m (c.53 ⅞ ft × 51 ⅛ ft)
Cathedral of Saint Cecilia, Albi, France

According to the Book of Revelation, all those who have died will face God's judgement at the end of time. Resurrected souls are depicted carrying open books on their naked chests in the largest medieval representation of the Apocalypse. The huge Last Judgement fresco covers both sides of the rounded west wall in the nave of this cathedral in southern France. The saved are shown on the left, processing towards eternal life, while on the right the damned cower in fear as they prepare to be thrown into the torment of hell. The centre of the fresco, showing Christ as judge, was destroyed at the end of the seventeenth century. Each book here is a record and vivid emblem of the person's earthly deeds, by which they are ultimately to be judged. The unfurled scroll that appears above the figures reiterates this message, reflecting the Catholic teaching that good works are essential for salvation (a view challenged by Martin Luther and the Protestant Reformers some thirty years after the fresco was completed). The inner secrets of all people are to be read like an open book, and their eternal fate decided accordingly.

A Christian Martyr
(Saint Lawrence or Saint Vincent of Saragossa)
Artist unknown

c.430, glass mosaic, dimensions unknown
Mausoleum of Galla Placidia, Ravenna, Italy

A saint clutching a Bible strides towards a blazing gridiron, the instrument on which he is about to be martyred. Beyond the flames is an open book cabinet containing the four Gospels of Matthew, Mark, Luke and John, all of which have been clearly labelled by the anonymous mosaic artist. The figure has no fear of death and shows little concern as the flames begin to lick his robe. His assurance of life after death is most certainly inspired by the holy books depicted so prominently here. The saint is traditionally identified as Saint Lawrence, who was martyred on a gridiron. However, the presence of books, which have no place in Lawrence's story, has led to the suggestion that this is in fact Saint Vincent of Saragossa. The Roman poet Prudentius recounts Vincent's martyrdom, explaining how the saint was put to death after refusing to disclose to the hostile Roman authorities the whereabouts of his Christian books. He was martyred around 304 AD, a decade before Christianity was legalized in the Roman Empire. Prudentius writes that the saint, filled with faith, rushed to the fiery gridiron 'with quick step, joy giving him speed'.

Untitled (Book)
Philip Guston
1968, gouache on illustration board
50.8 × 76.2 cm (20 × 30 in)

Time Table
Bill Woodrow
1999, bronze, gold leaf; edition of 10
c.59 × 106 × 85 cm (23¼ × 41¾ × 33½ in)

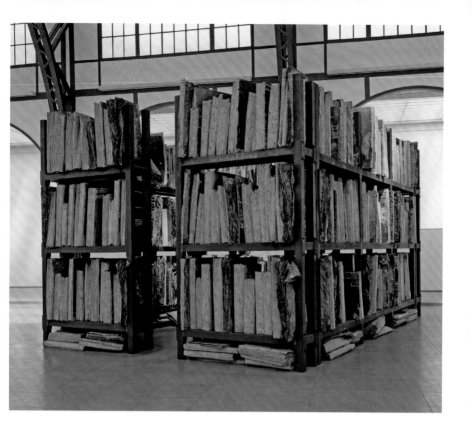

Census
Anselm Kiefer
1990, steel, lead, photographs
415 × 570 × 800 cm (163 ⅜ × 224 ⅜ × 315 in)
Hamburger Bahnhof, Staatliche Museen zu Berlin

The huge books in this imposing library are too heavy to lift, their pages impossible to turn. Made from lead, they speak to the gravitas and weight of history, specifically *Vergangenheitsbewältigung* – the German people's struggle in coming to terms with the pain of their nation's role in the Second World War. Kiefer (b.1945) has been making oversized lead books since the early 1970s. The ones here are embedded with thousands of dried peas, each representing a citizen reduced to a number by an unnamed authoritarian state. The installation was created in the aftermath of the West German census boycotts of the 1980s.

Civil rights groups caused a public outcry when it was shown that the state was attempting to use the national census of 1983 to increase surveillance of its citizens and share personal data without permission. But there is a wider history in view here. The Nazis used censuses in their persecution of the Jews and other 'undesirables', culminating in their extermination in the Holocaust. By referencing this dark history, which was also evoked by the census boycott movement, Kiefer reveals the sinister aspects of mass data gathering and the inherent dangers of dehumanizing groups or individuals.

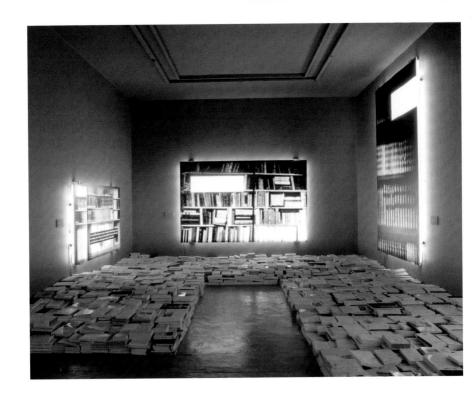

The Phenomenon of the Library
Joseph Kosuth
2006, silkscreened glass, neons and
philosophy books, dimensions variable
Installation view at Almine Rech Gallery, Paris

Virtually the entire floor of this Parisian gallery has been covered in books. Just enough room has been left to walk through the sea of volumes, which comprises titles by some of the twentieth century's most celebrated philosophers. On the walls are photographs showing the authors' personal libraries. Here we glimpse bookshelves belonging to Ludwig Wittgenstein, G. E. Moore, Jean-Paul Sartre and Roland Barthes, among others. The installation is a meditation inspired by Michel Foucault's 1977 essay 'Fantasia of the Library', which in turn centres on Gustave Flaubert's *The Temptation of Saint Anthony* (1874), a book exploring the hermit's experience in the Egyptian desert. For Foucault, *The Temptation* is not the product of a frenzied imagination, as some have supposed, but of meticulous erudition and a text that exists by virtue of its relationship to other texts: 'a phenomenon of the library'. The form of this installation recalls previous works by Kosuth (b.1945), such as *The Information Room* (1969), which consisted of a space with two long wooden tables on which piles of books from his own collection, on science, language and philosophy, were laid out for visitors to peruse. It is the act of reading that both informs and activates these works.

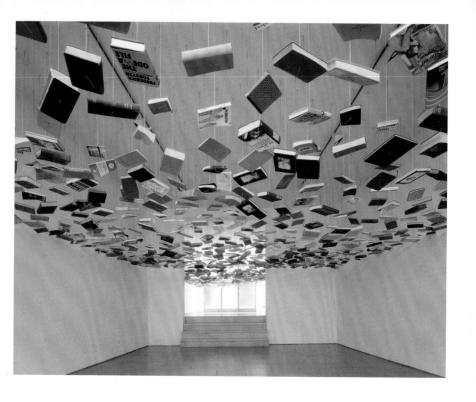

False Ceiling
Richard Wentworth
1995, books and steel cable, dimensions variable
Installation view at Lisson Gallery, London

A sea of books suspended from the gallery's ceiling hovers over the viewer's head. All manner of hardbacks and paperbacks, both fiction and non-fiction, large and small, dangle from slender cables. Some titles may be instantly recognizable, while others are obscure. The viewing experience is not unlike browsing in a jumble sale or thrift store. But by hanging the books from above, Wentworth (b.1947) intends to create a sense of wonderment, encouraging different ways of thinking about the books that surround us. The installation, a celebration of the freedom and diversity of literary culture, was inspired by the huge variety of books that the artist saw flooding the flea markets of Berlin soon after the collapse of the Wall. Books from all over Europe and America that had previously been unavailable were seemingly everywhere. This first version of the installation could only be viewed from below, whereas subsequent iterations have been installed in spaces where visitors can experience the work from different vantage points, including above. For Wentworth, books are extraordinary cultural artefacts, and his aim is to rekindle wonder and delight in these ubiquitous objects at a time when their presence is increasingly taken for granted.

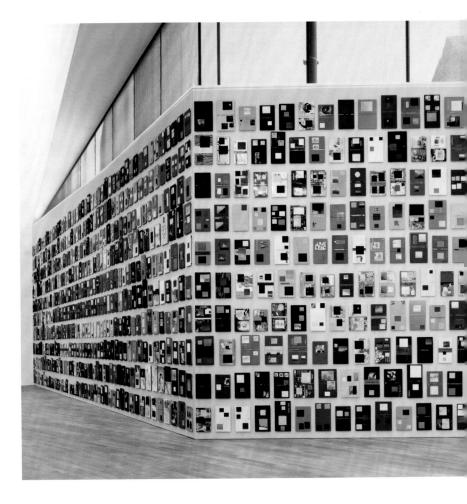

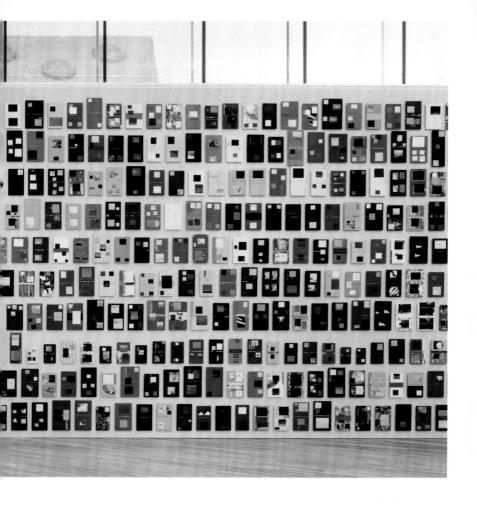

Volumes
Paul Chan
2012, oil on fabric, paper and cardboard
dimensions variable
Installation view of 'Paul Chan – Selected Works'
Schaulager, Basel, 2014

The covers of more than a thousand dismantled books have been repurposed as supports for paintings in this vast installation. In 2009 Chan (b.1973) announced his retirement from art and established an e-book publishing company. When an angry visitor at a book fair accused him and other electronic publishers of killing off printed, physical texts, it gave him an idea: if he were going to be accused of decimating literature, why not embrace actual destruction? Starting with Arthur Schopenhauer's collection of philosophical essays *Parerga und Paralipomena* ('Appendices and Omissions', 1851), Chan carefully removed its pages until he was left with just the cover.

Its surface and shape reminded him of an artist's canvas and so, after hanging it on the wall, he began painting. The process of engaging again with something physical was so satisfying that he repeated it, embellishing book after book with monochrome squares, rectangles and expressionistic marks. However, no attempt is made to conceal the identities of the old volumes, which include titles on art, history, geography, psychology and philosophy. In 2014 the project itself became a physical book: Chan's *New New Testament* documents all of the paintings in a single hardback volume, a reminder that reading, like art making, endures primarily as a tactile experience.

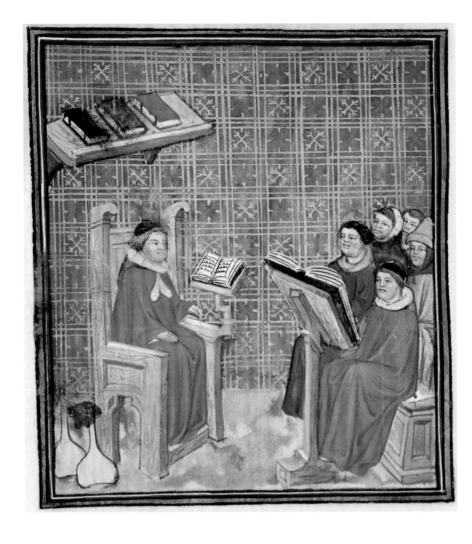

The Book of Properties of Things
Artist unknown
14th century, manuscript, dimensions unknown
Bibliothèque Municipale, Reims, France

Witchcraft Book
Jean Lowe
2015, Casein and inkjet on polymetal
137.2 × 95.3 cm (54 × 37½ in)

Books
Lisa Milroy
1991, oil on canvas
193 × 287 cm (76 × 112 in)

Meeting the Page Halfway
William Kentridge
2013, watercolour and coloured pencil on 'Shorter Oxford English Dictionary'
121.9 × 152.4 cm (48 × 60 in)

Untitled Film Still #13
Cindy Sherman
1978, gelatin silver print
25.4 × 20.3 cm (10 × 8 in)

The Library
Félix Vallotton
1915, oil on canvas
116 × 89 cm (45 ¾ × 33 ⅞ in)
Musée cantonal des Beaux-Arts, Lausanne, Switzerland

Untitled
Hans-Peter Feldmann
undated, five black-and-white photographs
overall: 200.5 × 652.5 cm (78 ⅞ × 256 ⅞ in)

Spread over five large panels, this life-size photograph documents Feldmann's (b.1941) personal book collection at his Düsseldorf home. The German artist is a compulsive collector, producing his art from all manner of found objects, images and cultural artefacts. This work is uncharacteristic in that it offers a rare glimpse into his private world. Traditionally, the library as an artistic subject is a showcase for rare and antiquarian books, whereas the majority of books here are contemporary to their owner. Volumes on art, music, travel, history, photography and film, among many other subjects, line the shelves as a reflection of the artist's personal interests; as such, the photograph can be considered a portrait of sorts. In casting the viewer as voyeur, Feldmann allows his possessions to be perused, but only at a distance. The life-size images tease those who stand in front of the work; upon spotting an intriguing title, it is frustrating that the books cannot be handled or read. With many of the books arranged by subject, the collection also reflects Feldmann's interest in typology. But, as with any domestic bookshelf, its organization is at times idiosyncratic and unplanned. Like Feldmann's wider practice, it is at once systematic and surprising, transparent and unpredictable.

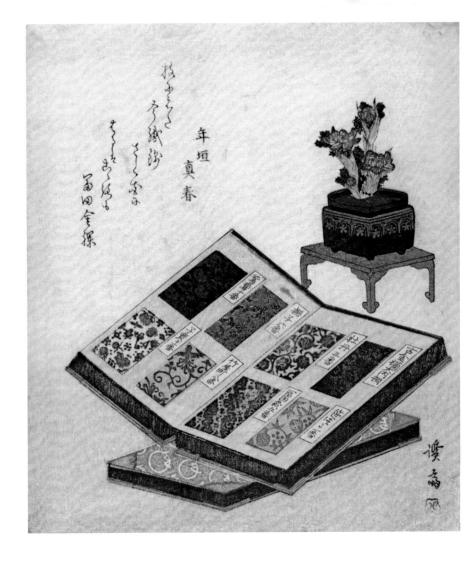

Sample Books of Brocade Designs
Keisai Eisen
19th century, woodblock print
20.6 × 18.1 cm (8 1/8 × 7 1/8 in)
Brooklyn Museum, New York

The British Library
Yinka Shonibare

2014 (detail), hardback books, Dutch wax printed cotton textile,
gold foiled names, five wooden chairs, five iPads, iPad stands, headphones,
interactive application and antique wind-up clock, dimensions variable

A kaleidoscope of colour fills the shelves of this dazzling library, which comprises several thousand variegated volumes. The books are covered with brightly patterned fabric and each spine is embossed with the name either of a first- or second-generation immigrant who has had a significant impact on British culture, or of a figure who has expressed opposition to immigration. Names as diverse as T. S. Eliot, Zaha Hadid, Noel Gallagher, Kazuo Ishiguro, Ruth Rendell, Hans Holbein and Hammasa Kohistani are included on the one hand, as are those of Enoch Powell and Nigel Farage on the other. The Dutch wax fabric that covers each book is popular with Britain's Afro-Caribbean communities, though the Indonesian-inspired designs were originally produced in Holland. These hybrid textiles, introduced to African countries by Dutch traders and now taken to be indigenous, are used by Shonibare (b.1962) throughout his work to highlight the impact that global movements of people and goods have had on modern life. For Shonibare libraries are a metaphor for culture at large, filled with humanity's stories, beliefs, philosophies and achievements. His installation explores the historical legacy of immigration in Britain whilst provoking debate regarding contemporary attitudes towards migrant communities and their contribution to society.

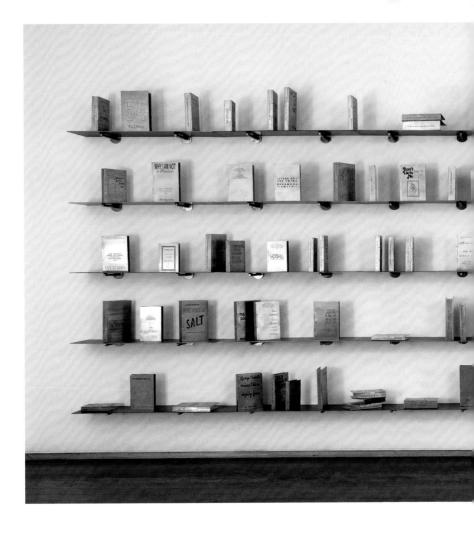

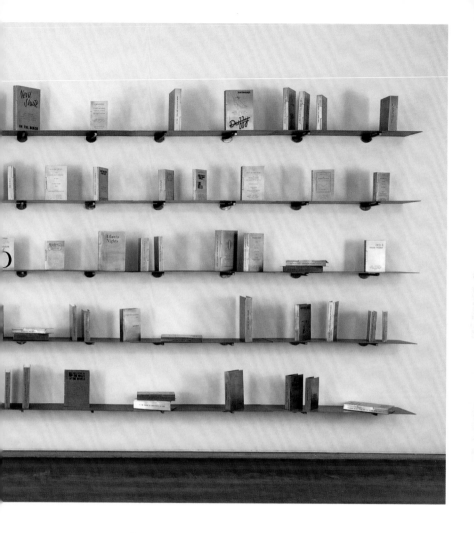

Someone Else – A Library of 100 Books
Written Anonymously or Under Pseudonyms
· Shilpa Gupta

2011, etched books, 488 × 22 × 190 cm (192 × 8 ½ × 72 in)

In this library the covers of one hundred books have been recreated in stainless steel, with just one small addition: each contains a brief text detailing why the author either used a pseudonym or remained anonymous altogether. As Gupta (b.1976) discovered when researching this project, there are many reasons why an author might choose not to reveal their name: to hide their identity for fear of political or religious persecution; to conceal their gender; to avoid jeopardizing their career; to spare family members from upset; or simply for the freedom to pursue different genres. Authors from all over the world appear in this collection of metal books, including Emily Brontë and Herman Hesse, who both published works under different names – Ellis Bell and Emil Sinclair respectively. Scanning the rows of titles, one learns that J. K. Rowling, author of the Harry Potter series, has used a pseudonym (Robert Galbraith) to conceal her gender, and that David Cornwell adopted the name John Le Carré in order to keep his day job at British military intelligence while writing spy thrillers. However, these volumes cannot be read, for Gupta only recreates their covers. With no pages, the metal shells appear like commemorative plaques, their lack of content symbolizing the absence of the authors' true identities.

ARTISTS WHO DO BOOKS
Ed Ruscha
1976, pastel on paper
57.8 × 73 cm (22 ¾ × 28 ¾ in)
Tate, London/National Galleries of Scotland

Confessions of a Crap Artist
Harland Miller
2013, acrylic and oil on paper
152.5 × 121.5 cm (60 ⅛ × 47 ¾ in)

In this painting the artist's own name is emblazoned across the front of a worn and dog-eared paperback that purports to be a play with a self-deprecating title. It belongs to a series that Miller (b.1964) began making in the early 2000s based on the iconic covers of Penguin books. In many of his works the publisher's famous logo and the classic orange and white design of its novels are combined with invented titles that are at once jarring, sardonic, humorous and irreverent. Here, however, Miller has based his striking yellow and purple composition on the lesser-known Penguin Plays series. Furthermore, the title is not invented but is that of a 1974 novel by Philip K. Dick, one of that author's non-science-fiction titles, an account of a messy marital conflict in 1950s America. Bold brushstrokes with spatters and drips of paint contrast with precise lettering on Miller's canvases, which appear somewhere between Pop Art and Abstract Expressionist paintings. Miller's imaginary books are depicted as old and tattered, just like the real ones that he collects from second-hand bookshops. Indeed, he is also an accomplished author and it is his love of literature that informs his art.

Student Nurse
Richard Prince
2005, inkjet and acrylic on canvas
193.7 × 137.5 cm (76 ¼ × 54 ⅛ in)

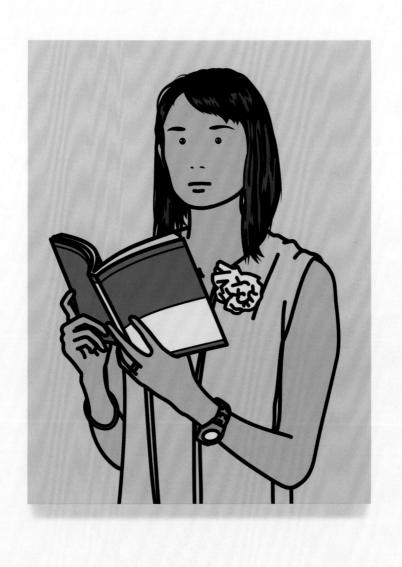

Hijiri with Book
Julian Opie
2005, silkscreen on painted wooden board
90 × 69 × 4 cm (35 ½ × 27 ⅛ × 1 ½ in)

'I do not feel like spending the rest of my life writing books that no one will read.'

Samuel Beckett (1906–89)

Untitled (Beckett Trilogy)
Steve Wolfe

1999–2001, oil, screenprint, lithography, modelling paste, paper and wood
left to right: 20.2 × 14 × 1.8 cm (7 ⅞ × 5 ½ × ⅝ in); 20.2 × 13.5 × 1 cm (7 ⅞ × 5 ¼ × ⅜ in);
20.2 × 13.7 × 1.3 cm (7 ⅞ × 5 ⅜ × ½ in)

Hanging on a wall are what appear to be three old paperback copies of Samuel Beckett novels. In fact, these objects are exquisite facsimiles, sculptures based on books found in Wolfe's (1955–2016) personal library. The originals are vintage Grove Press editions published in the 1950s and bought by the artist as a student in the mid-1970s. Using wood, oil paint, modelling paste and printmaking techniques, he has painstakingly recreated every exterior detail. From Roy Kuhlman's abstract cover designs to each crease, fold and tear, they faithfully capture the character of Wolfe's well-thumbed copies. The Beckett novels, *Molloy* (1951), *Malone Dies* (1951)

and *The Unnamable* (1953), are regarded as profound landmarks of twentieth-century fiction, but these versions cannot be read; as in the *trompe l'oeil* tradition they are all surface. Wolfe created many of these sculptures during his career, displaying them on walls or sometimes packed up in cardboard boxes (also fabricated by the artist). Other works reproduce books by William Burroughs, Gertrude Stein and James Joyce, with each author chosen for the influence they had on Wolfe both as an artist and as a person. Together, his collection of replicas forms a kind of self-portrait.

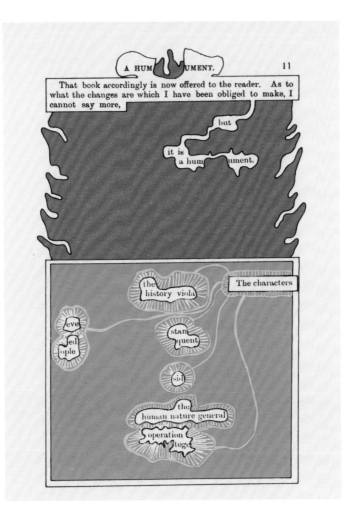

A Humument (1973 edition) page 11, version 1
Tom Phillips
1973, pen, ink and gouache on book page
17 × 12 cm (6 ¾ × 4 ¾ in)

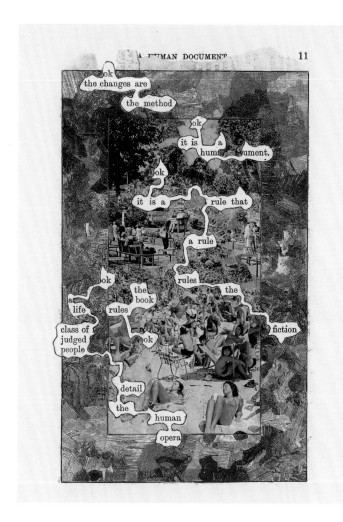

A Humument (2003 edition) page 11, version 2
Tom Phillips
2003, pen, ink, postcard and collage on book page
17 × 12 cm (6 ¾ × 4 ¾ in)

An obscure Victorian novel is the surprising inspiration behind this fifty-year work in progress. Since 1966, Phillips (b.1937) has been altering pages of W. H. Mallock's *A Human Document* (1892), painting intricate images onto its yellowing pages. The project began when he boasted to an artist friend that he would make a serious long-term art project from the first book he found for three pence. Phillips covers the pages with colour and pattern, picking out certain words or phrases to form new and surreal narratives. On some pages Mallock's text is completely obliterated by Phillips's designs, while on others it shows through like a ghostly presence. Although each page becomes a separate artwork, they are always kept in order. There is no definitive version of *A Humument*, and several editions of the work have been published in book form over the years. These two images show page eleven as it appears in the 1973 and 2003 versions; they are radically different save for one or two words that appear in both. The 2003 version incorporates collaged elements from picture postcards. In 2011 Phillips took the project into the digital realm, releasing the book as a mobile phone app.

· Cozneuns ·

Illustration from an edition of 'Le Roman de Troie'
by Benoît de Sainte-Maure
Artist unknown
12th century, Bibliothèque nationale de France, Paris

Lucidity and Intuition: Homage to Gertrude Stein
Susan Hiller
2011, Art Deco writing desk containing a collection of books
on automatism and related issues; dossier by the artist, round plinth
72 × 47.5 cm (28 ⅜ × 18 ¾ in)

The space underneath an Art Deco writing desk has been crammed with books, transforming it into an esoteric library. The desk is an approximation of the kind used by the American novelist Gertrude Stein. However, the books have nothing to do with her Modernist writings or, indeed, any of the interests for which she is celebrated. The collection is focused on the subject of automatic writing: the practice of writing with the conscious mind disengaged, the results of which are claimed to be either products of the subconscious or messages from the spirit world. It was a technique popular both with Surrealists and spiritualists during the early twentieth century and one that

intrigued Stein in the early stages of her career. Piling books under a desk suggests that they are not worthy of more prominent positions on a shelf; certainly they cannot be so easily accessed. Though Stein experimented extensively with automatic writing, once she achieved literary fame she denied any interest in this arcane activity, claiming to see no value in it whatsover. Hiller (b.1940), who has a keen interest in unexplained phenomena, wanted to draw attention to this suppressed aspect of Stein's work. She created this sculpture both as a homage to an acclaimed writer and as a reminder that texts can take shape beyond the limits of an author's control.

'What is more important in a library than anything else – than everything else – is the fact that it exists.'

Archibald MacLeish (1892–1982)

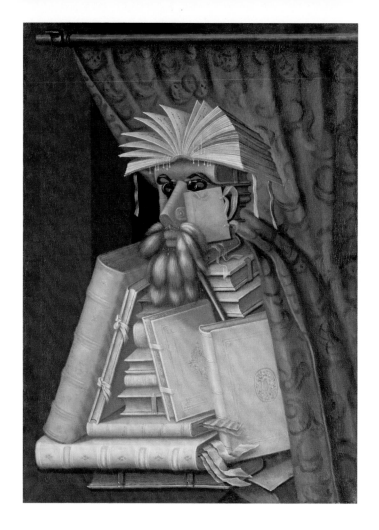

The Librarian
Giuseppe Arcimboldo
c.1566, oil on canvas, 97 × 71 cm (38 ⅛ × 28 in)
Skokloster Castle, Sweden

A half-length portrait is composed entirely of books and related paraphernalia. Large tomes form the upper body and arms, while the pages of an open book have become the hair. The face, created with a variety of smaller volumes, features book-chest keys for spectacles and a beard made of animal-tail dusters. Arcimboldo (1527–93) served as a portrait-ist at the Habsburg court in Vienna, though he is best known for his ingenious composite portraits assembled from everyday objects such as fruits, vegetables, and flowers. It is thought that this paint-ing is a derisive portrait of Wolfgang Lazius, the self-aggrandizing head of the imperial collections of the Holy Roman Empire. The canvas has also been understood as both a celebration and parody of librarianship and intellectualism. However, it is possible that Arcimboldo's joke was not targeted at those who love learning, but rather at materialistic collectors more interested in accumulating titles than reading them. This interpretation is supported by the fact that all of the books in the painting remain closed, except for the open volume on the figure's head, which is placed where it remains unreadable.

The Abbey Library
from 'De Universo' by Rabanus Maurus
Artist unknown (Italian miniaturist)
c.1023, illuminated manuscript, dimensions unknown
Abbey of Montecassino, Italy

The Library for the Birds of New York
Mark Dion
2016, steel, wood, books and birds
350.5 × 609.6 cm (138 × 240 in)

A large tree stands at the centre of a circular aviary, its branches providing support for a library of books. Twenty-two birds inhabit the cage, flying and chirping amongst the various volumes, whose subjects include geography, navigation, astronomy, ornithology and even cat watching. The zebra finches and yellow canaries show no interest in the reading material provided for them, as attested by the pile of books covered in bird droppings at the foot of the tree. Dion (b.1961) is well aware that a library for birds is an absurd conceit, but so too, he argues, is the hunting and capture of exotic birds for the amusement of humans. Since the mid-1980s, his sculptures and installations have explored humanity's obsession with collecting and its attempts to impose order on and make sense of the natural world through systems of categorization. The cage here reflects the human impulse to master nature, while the tree evokes both the biblical Tree of Knowledge and the evolutionary tree of life. Dion's library suggests that no matter how much knowledge is accumulated and recorded in books, humans can never fully comprehend the intricacies of the natural world or the innate intelligence of animals.

Thus thy left hand the Mighty Stagyrite
Supports, that thou mightst shield him wᵗʰ thy right:
Whose early Soul aym'd high yet allwaies hit;
The sharpest, cleanest, full, square, leading Wit;
The best Tymes Best; could'st farthest soonest pierce,
Of all that Walk in Prose or dance in Verse;
'Tis CARTWRIGHT in his shadow's Shadow drest;
He never is transcrib'd that once Writes best.

William Cartwright
Artist unknown (after Pierre Lombart)
published 1797, line engraving, 28.4 × 20.6 cm (11⅛ × 8⅛ in)
National Portrait Gallery, London

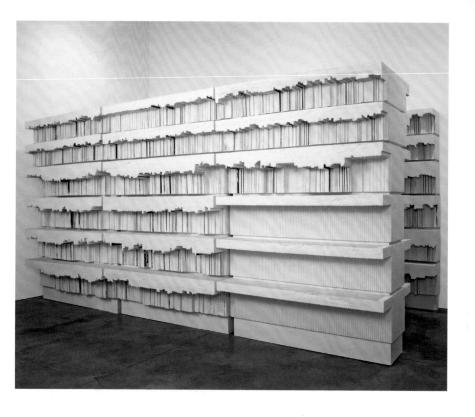

Untitled (Library)
Rachel Whiteread

1999, dental plaster, polystyrene, fiberboard, and steel
285.8 × 535 × 243.8 cm (112 ½ × 210 ⅝ × 96 in)
Hirshhorn Museum and Sculpture Garden,
Smithsonian Institution, Washington DC

At first glance, these large sculptural forms have the appearance of bookshelves, yet there isn't a single book to be seen. Whiteread (b.1963) is well known for giving solid form to negative space – the invisible voids inside, underneath or around objects. Her works typically take the form of casts taken from chairs, beds and staircases, or the interiors of rooms or sheds – even an entire terraced house. For *Untitled (Library)* she has made plaster casts of library shelves, recording the spaces around rows of books. Yet despite the total lack of readable literature, physical traces of the original volumes remain. The dimensions of each book and the texture of their pages have been recorded by the plaster, which also contains fragments of paper and residue from their bindings. Indeed, there are many subtle colours present here, as closer inspection reveals. But the titles of the individual publications remain unknown. The work is one of several similar pieces the artist made using books, including the *Holocaust Memorial* (2000) in Vienna's Judenplatz, an inverted library in which all the books are identical in size and shape and similarly nameless. It is, in common with Whiteread's other works, a meditation on absence and loss.

**Abu Zayd at the Library in Basra, where books are read and copied
from 'Al-Maqâmât' ('Assemblies')**
Yahya ibn Mahmud al-Wasiti
1236–7, manuscript, 37 × 28 cm (14½ × 11 in)
Bibliothèque nationale de France, Paris

Books on Books
Liu Ye
2007, acrylic on canvas
30 × 20 cm (12 × 7 ⅞ in)
Private collection, Shanghai

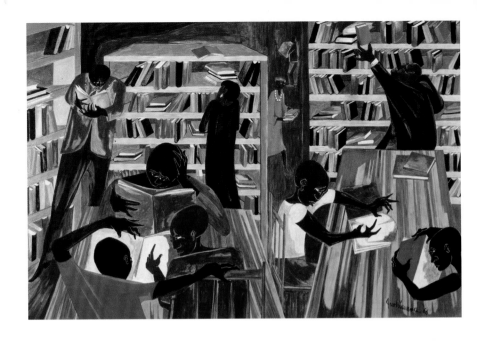

Students with Books
Jacob Lawrence
1966, egg tempera on hardboard
60.6 × 91.1 cm (23 ⅞ × 35 ⅞ in)
Private collection

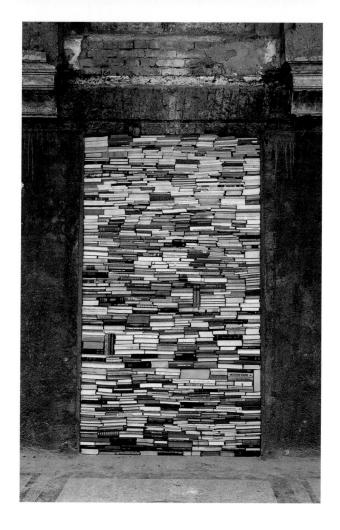

Untitled
Jannis Kounellis
2004, books, dimensions variable
Installation view at Gradska vijećnica, Sarajevo

A wall of books forms a barricade across one of twelve doorways that Kounellis (1936–2017) blocked up in the atrium of the National Library of Bosnia and Herzegovina. This historic building was badly damaged during the Siege of Sarajevo in August 1992. Serbian shelling set the building ablaze, destroying .over two million books, periodicals and documents, including thousands of rare antique volumes. The library's vaulted ceiling was completely destroyed along with most of its interior. During the siege librarians and citizens attempted to save the books, but sniper fire, which killed at least one person, made the task impossible. Kounellis's installation, produced during the building's renovation, takes these tragic events as its starting point. By 2004, the hexagonal atrium with its glass roof had been reconstructed, but the doorways had not yet been completed. The empty portals immediately inspired the artist, who filled them not only with books but also with stones from Sarajevo's shattered buildings, together with a variety of everyday objects, including clothes, shoes and sewing machines. The blocked doorways functioned like an act of defiance and also a way of memorializing the tragic events of the Bosnian War.

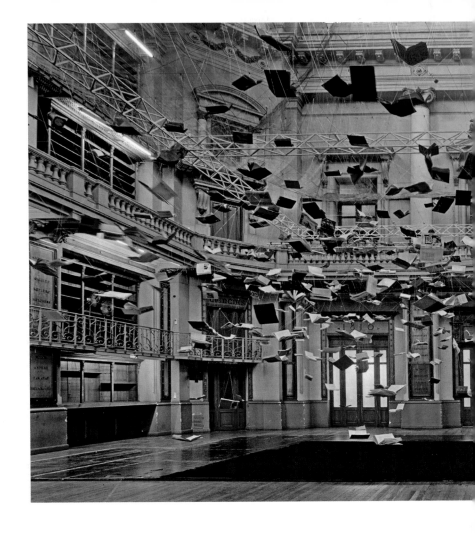

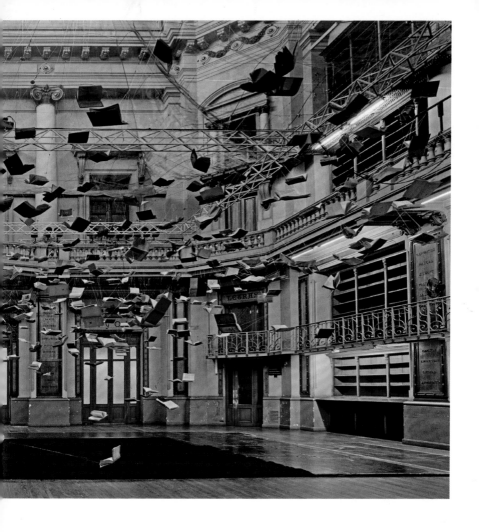

Flying Books (A Tribute to Borges)
Christian Boltanski
2012, books, dimensions variable, installation view
at Biblioteca Nacional de Buenos Aires

A cloud of books fills the central reading room of the former National Library of Buenos Aires in Argentina. Suspended at different heights, volumes of all sizes and colours hang open above visitors' heads. As the work's title suggests, the scene evokes a flock of birds launching into flight, a moment of action frozen like a photograph. However, the books are not totally still. They sway and turn in the gentle breeze, animating the cavernous space with subtle movement. The installation is a tribute to the celebrated Argentine writer Jorge Luis Borges, one of the most important literary figures of the twentieth century. Borges was appointed director of the library in 1955, working there for eighteen years. His short story *The Library of Babel* (1941) conceived of a universe in the form of a vast library in which sense is sought amid confusion. Boltanski (b.1944) reflects this through a chaotic and seemingly random arrangement of books, the antithesis of the neat and systematized arrangement one expects in a public library. Furthermore, the books cannot be read. Like the former library itself, they have been repurposed, a tribute not only to Borges but also to this historic place of reading.

'I have always imagined Paradise as a kind of library.'

Jorge Luis Borges (1899–1986)

Rijksmuseum Amsterdam II
Candida Höfer
2004, C-print, edition of 6
215 × 180 cm (84 ⅝ × 70 ⅞ in)

Index

Picture Credits

We would like to thank all those who gave their kind permission to reproduce the listed material. Every effort has been made to secure all reprint permissions prior to publication. In a small number of instances this may not have been possible. Phaidon apologizes for any inadvertent errors or omissions. If notified, the publisher will endeavour to correct these at the earliest opportunity.

All measurements in captions are given height × width × depth unless otherwise specified.

All images © the artist.

p.4: Bridgeman Images. Photo © Christie's Images. Private Collection; p.14: © Vanni Archive/Art Resource, NY. National Archaeological Museum of Naples, Italy; p.15: The Phillips Collection, Washington DC (Licence: public domain); p.16: © CNAC/MNAM/Dist. RMN-Grand Palais/Art Resource, NY. La Piscine, Roubaix, France; p.17: © RMN-Grand Palais/Art Resource, NY. Musée d'arts de Nantes, France. © Tamara Art Heritage/ADAGP, Paris and DACS London, 2018; p.18: Scala/Art Resource, NY. Pinacoteca Civica Francesco Podesti, Ancona, Italy; p.19: National Gallery, London (Licence: public domain); p.21: Scala/Art Resource, NY. Pinacoteca Civica Francesco Podesti, Ancona, Italy; p.22: © CSG CIC Glasgow Museums Collection/Bridgeman Images. Kelvingrove Art Gallery and Museum, Glasgow; p.23: Rijksmuseum, Amsterdam (Licence: public domain); p.24: Paul Fearn/Alamy Stock Photo; p.25: Bridgeman Images. Private Collection; p.26: classicpaintings/Alamy Stock Photo. Museo Nacional del Prado, Madrid; p.27: Museo Nacional del Prado, Madrid (Licence: public domain); p.28: Getty Images adoc-photos/Contributor. Bibliothèque nationale de France, Paris; p.30: Erich Lessing/Art Resource, NY. Rheinisches Landesmuseum, Trier, Gemany; p.31: Musée du Louvre, Paris (Licence: public domain); pp.32–3: Bridgeman Images. Galleria delle Marche, Urbino, Italy; p.34:

Scala/Art Resource, NY. Church of San Marco, Florence; p.35: © RMN-Grand Palais/Art Resource, NY. Musée Condé, Chantilly, France; p.36: Bibliothèque nationale de France, Paris (Licence: public domain); p.37: Bridgeman images. Birkbeck College, London; p.38: © David Hockney/Private Collection; p.39: Courtesy of the artist. Photo: Stephen White; p.40: © Carol Bove. Courtesy the artist, Maccarone New York/Los Angeles and David Zwirner New York/London; p.41: Art Collection 2/Alamy Stock Photo. Musées Royaux des Beaux-Arts, Brussels; p.42: San Brizio, Duomo, Orvieto, Italy, (Licence: public domain); p.43: Getty Images DEA PICTURE LIBRARY/Contributor. Palazzo Vecchio, Florence; p.44: Photo © Liszt Collection/Bridgeman Images. Harvard Art Museums, USA; p.45: Collection Museum Boijmans Van Beuningen, Rotterdam. © ADAGP, Paris and DACS, London; p.46: Getty Images Mondadori Portfolio/Contributor. Sistine Chapel, Vatican; p.47: Scala/Art Resource, NY. Cathedral of Santa Maria Assunta, Siena, Italy; p.48: Erich Lessing/Art Resource, NY. Musée national du Moyen Âge, Paris; p.49: Art Resource, NY. The Metropolitan Museum of Art, New York; p.51: Photo Scala, Florence . Musée du Louvre, Paris; p.52: Courtesy of the artist and Corvi-Mora gallery; p.53: Tokyo National Museum (Licence: public domain); p.54: Erich Lessing/Art Resource, NY. Fontevraud Abbey, France; p.55: © Mernet Larsen, courtesy of James Cohan, New York; p.56: Scala/Art Resource, NY. Collezione Chigi-Saracini, Siena, Italy; p.57: The Metropolitan Museum of Art, New York; p.58 & p.59: Liebieghaus, Frankfurt (Licence: public domain); p.60: Národní Galerie/Karlštejn Castle, Prague (Licence: public domain); p.61: Dumbarton Oaks, Washington DC (Licence: public domain); p.62: Getty Images Fine Art/Contributor. The Cloisters, The Metropolitan Museum of Art, New York; p.63: Saratov State Art Museum, Russia; p.64: Getty Images Josse/Leemage/Contributor. Bibliothèque nationale de France, Paris; p.65: Peter Horree/Alamy Stock Photo. Nationalgalerie, Berlin; p.66: Art Collection 2/

Alamy Stock Photo. Basilica of Santa Casa, Loreto, Italy; p.67: Victoria & Albert Museum, London/The Stapleton Collection/Bridgeman Images; p.68: Scala/Art Resource, NY. Chapelle de St. Sebastien, Lanslevillard, Savoy, France; p.69: © RMN-Grand Palais/Art Resource, NY. Musée Magnin, Dijon, France; p.71: Photo Josse/Scala, Florence. Musee de Grenoble, France; p.72: Muzeum Narodowe, Kraków, Poland (Licence: public domain); p.73: Rijksmuseum, Amsterdam (Licence: public domain); p.74: Bridgeman Images. Toledo Cathedral, Spain; p.75: akg-images/Erich Lessing. Musée d'art moderne, Troyes, France; pp.76–7: Courtesy of the artist; p.78: Museo Nacional del Prado, Madrid (Licence: public domain); p.79: © CNAC/MNAM/Dist. RMN-Grand Palais/Art Resource, NY. Musée national d'Art moderne, Centre Georges Pompidou, Paris; p.80: Private Collection (Licence: public domain); p.81: J. Paul Getty Museum, Los Angeles (Licence: public domain); p.82: © Maya Lin Studio; photo: G.R. Christmas, courtesy Pace Gallery; p.83: Courtesy The Estate of Ken Kiff. Courtesy Pippy Houldsworth Gallery, London; p.84: © the artist; p.85: Bridgeman Images. Musee national d'art moderne, Centre Georges Pompidou, Paris; p.86: © Josephine Halvorson, courtesy of Sikkema Jenkins & Co., New York; p.87: Image courtesy the artist & Mary Mary, Glasgow; pp.88-9: Courtesy of the artist; p.90: Bridgeman Images. Museo internazionale e biblioteca della musica, Bologna, Italy; p.91: Courtesy of the artist; p.92: Photo: Larry Lamay. Courtesy the artist and greengrassi, London; p.93: Paul Fearn/Alamy Stock Photo. Private Collection; p.94: Museo Nacional del Prado, Madrid (Licence: public domain); p.95: Getty images DEA/G. DAGLI ORTI/Contributor. National Museum of History, Chapultepec Castle, Mexico City; p.96: City of Detroit Purchase/Bridgeman Images. Detroit Institute of Arts, MI; p.97: Bridgeman Images. Private Collection; p.99: © RMN-Grand Palais/Art Resource, NY. Chateau-Musée, Nemours, France; p.100: Getty Images Fratelli Alinari IDEA S.p.A./Contributor.

Phaidon Press Limited
Regent's Wharf
All Saints Street
London N1 9PA

Phaidon Press Inc.
65 Bleecker Street
New York, NY 10012

phaidon.com

First published 2018
© 2018 Phaidon Press Limited

IBSN 978 0 7148 7627 6

A CIP catalogue record for this book is available
from the British Library and the Library of Congress.

We are also grateful to Sophie Kullmann and
Guy Tindale for editorial services.

Commissioning editor: Rebecca Morrill
Editorial Assistant: Catalina Imizcoz
Production Controller: Adela Cory
Design: Studio Chehade

Printed in Hong Kong

Author biography

David Trigg is a critic and art writer based in Bristol, UK.
He is a regular contributor to Phaidon books and has
written articles and reviews for publications including
Art Monthly, *ArtReview*, *Frieze* and *Art Papers*. He has
a PhD in Art History from the University of Bristol and is
a member of the International Association of Art Critics.

Cover image

Liu Ye, *Books on Books*, 2007, acrylic on canvas,
30 x 20 cm (12 x 7 ⅞ in). Private collection, Shanghai.
Courtesy the artist.